CREATIVE
BLOCK

GET UNSTUCK

CREATIVE BLOCK

DISCOVER NEW IDEAS

Advice and Projects from 50 Successful Artists

Danielle Krysa

CHRONICLE BOOKS

SAN FRANCISCO

**This book would not have been possible
without the fifty amazing artists who
generously shared their own insecurities,
inspirations, and advice. I am truly grate-
ful to each one of them. There is also no
way this book would have happened if it
weren't for the very loving, patient, and
supportive men in my life: my husband,
Greg, and my little boy, Charlie. Love you!**

Text copyright © 2014 by Danielle Krysa.
Artworks and photographs copyright © by the
individual artists, unless otherwise noted.

Library of Congress Cataloging-in-Publication
Data available.

ISBN: 978-1-4521-1888-8

Manufactured in China.

Designed by Dinah Fried.

10 9 8 7 6 5 4 3

Chronicle Books LLC
680 Second Street
San Francisco, California 94107

www.chroniclebooks.com

To every creative person that has ever felt blocked. So . . . to all of us!

CONTENTS

INTRODUCTION

Have you ever heard that people who study psychology are often trying to work through issues of their own? Yes, well, perhaps that's why I decided to write a book about creative blocks!

All of this began a few years ago, shortly before I wrote the very first post on my art blog, The Jealous Curator. I am an artist myself, with a bachelor of fine arts in painting and printmaking, and a minor in art history. As much as I loved making art, I had a really difficult time in art school—I just did not fit in. After I graduated, I decided to study graphic design, which was a much better fit for me. I went on to have a very successful career as a designer, and then as a creative director. I was totally immersed in my design work, but never stopped loving and making fine art. I did it quietly and alone in my home studio, but rarely showed anyone what I was creating. As a designer, I was full of confidence, but as an artist—well, not so much. I spent a lot of time looking at other artists' work. Whenever I found something I truly loved, first I would feel a rush of cheek-flushing inspiration—the kind that made me want to run out and buy ten new canvases so that I could become the next great artist of my time. But only moments afterward, I'd feel a wave of soul-crushing jealousy—the kind that made me think, "Who am I kidding? I could never make something like that." Negative and destructive? Yes.

Luckily, at that same moment, someone very close to me gave me a bit of advice. He said, "Jealousy that is kept inside becomes toxic, and it will eat you alive. But if you say it out loud, you can turn it into something positive: admiration. You need to do this." And so I did. I launched The Jealous Curator in February of 2009, and haven't looked back. I write a daily post about an artist whose work "makes me jealous," but in a good way. Now when I find an artist that I love, I don't feel that awful, jealous ache. I feel inspired, ready to get into the studio, and happy to have tomorrow's post! I have learned that there is a place for everyone to make whatever it is they want to make.

What matters is that you enjoy the process of making. There is pure joy in that. Remember when you were little, and you just made stuff because you had a fresh box of crayons, or some colorful thread, or a feather that you found on your way home from school—you knew you had to make something! Anything! Those were the glorious days before the pressure of trying to sell, or trying to get a rep, or wanting a show in a gallery. That's what all of us have to reconnect with—the joy. I'm getting better at this, but I won't lie: There are still plenty of days when I am blocked. Totally and completely blocked.

Creative Block is for me and for you—for everyone who's ever felt blocked. I wanted to make something beautiful—a contemporary art book filled not only with stunning images, but also inspiring words, advice, and tips to help amateurs and professionals alike find their way through those days when the ideas just won't come. I wrote this book to show you that if you're feeling this way, you're not alone. I've written hundreds and hundreds of posts about successful working artists who seem to have this whole "creative thing" figured out. But surely they have blocks from time to time! How do they get through them? Where do they find fresh inspiration? How do they handle negative feedback? Does it stop them in their tracks? These full-time artists don't have the luxury of not finishing or giving up on a project—not when they've got a gallery or art buyer waiting for them! So *how* do they push

themselves through those moments when the ideas just aren't there? Or when the ideas are there, but their hands or materials will not cooperate?

So I asked, and fifty incredibly talented artists from around the world—working in all different mediums—have thoughtfully, honestly, and often quite wittily, answered. I asked all of them very similar questions, and here's why: I had originally planned on individual interviews for each artist, but then I realized that I wanted to know if someone with an MFA would answer the same way that a self-taught artist might. Do painters have the same kinds of blocks as photographers? Would an artist from New York have a different place to find inspiration than someone from a small town in Australia? Does someone who is well known internationally hear their inner critic just as loudly as someone who is still getting established?

Some of their answers made me sad, some struck me as funny, and all of them made me want to get into the studio and start making art immediately. I hope their words have the same effect on you.

But where to start? No problem—I asked them that too! On top of getting insights into their creative minds, each artist has come up with a creative *un*block project meant to push us out of our comfort zone and, most importantly, get us moving forward. There are thirty-day challenges, nature walks, and trips to the thrift shop. There are assignments to make you draw or collage or hand-letter your favorite quotes. There. Now none of us have an excuse not to start.

I hope you enjoy reading the advice and thoughts shared by these amazing artists as much as I enjoyed gathering them. And good luck with the challenges—I'm going to do all of them too! See you on the other side.

DANIELLE, A.K.A. THE JEALOUS CURATOR

** ART NOTE: The three pieces shown here are mine. They are all from a series titled, "Alleglory: Stories from the Glory Days." The thought of showing you my work makes me feel vulnerable, and frankly, a tiny bit sick. But, if I'm going to make you take that big leap off of the creative high dive, then I suppose it's only fair that I jump, too. There. Now we're in this together.*

ARIAN BEHZADI

COLLAGE/MIXED MEDIA

USA

ARIANBEHZADI.COM

Not every artist has a traditional art school background. Take American artist Arian Behzadi, for example. He has a bachelor of science in neurobiology, physiology, and behavior. Seriously. He graduated in June of 2012, and now spends his days working as User Interface-User Experience (UI/UX) designer at a start-up in California. In his "spare time," however, he makes collages. Perfectly composed, bold, found-image collages that have been featured in *Juxtapoz*, *Beautiful/Decay*, and countless other publications, sites, and blogs. Where does he find the time? Let's find out.

JC—Do you have any advice for someone who wants to be making art but is studying, or working, in an entirely different field?

AB—If you want to make art, find time for it. For many years I was studying something else full time and working at a lab. I reserved time from when I got off work until the middle of the night to make things. If you're not suffering from lack of sleep, you're not doing it right.

JC—Why do you make art?

AB—I've found that it's easy to critique something, but to critique something and *provide a better alternative* shows that you're good at it. I think it's really neat when I can do that with visual design.

JC—Describe the first moment that you felt like an artist.

AB—When I was a lot younger, a friend of mine saw something I had made and said he would buy a T-shirt with that design on it. It was the first moment anyone had seen my work and, thankfully, the first moment that I was complimented on it. A few years later, shirts with my designs hang in boutique shops around the world. It's a very cool feeling.

JC—A lot of your collages are digital. Is that your favorite way to work?

AB—I definitely prefer digital, more than anything. It's far less destructive. That being said, I often do go back to X-ACTO collage when I'm feeling confident.

JC—Where do you find inspiration?

AB—I find inspiration in old books and magazines. Libraries and scanned material are a goldmine for my creative process. I might find a particular texture I like, a color combination, or an element that I'll isolate and put in a new setting.

JC—Which artist's work/life/career are you most jealous of and why?

AB—Comparison is the thief of joy! But I do think Dan Matutina is one of the most incredible illustrators I have ever seen.

JC—What do you do if you're having trouble with a piece?

AB—Listening to different kinds of music while working definitely has varying effects on my work. Music and visuals are paired very strongly in my mind, and a few of my previous projects have a lot to do with that relationship. It's always neat when someone can guess what sort of music I was listening to while creating a particular piece.

JC—Do you face criticism very often?

AB—In my day job, I have to handle all sorts of criticism on my projects. At first, I saw it as a roadblock, but I've since learned to trust the eyes of others and view it as part of the process.

JC—Are you friends or enemies with your inner critic?

AB—My inner critic is the only voice that I trust fully. In my experience, I have never tried to ignore it because it has always steered me to something better. The trick is to view your inner critic as a guide rather than an enemy.

JC—What do you do when you're feeling blocked?

AB—When I have a creative block, I give as much as I can to it, then completely stop and throw it away. Then if that idea lingers in my mind, I try to recreate what I threw away. In the process of recreating it, I often find a way to do something that hadn't occurred to me the first time around.

An extremely important part of my process is recognizing a bad idea and not wasting time on it. An even harder part of my process, however, is recognizing when something is done!

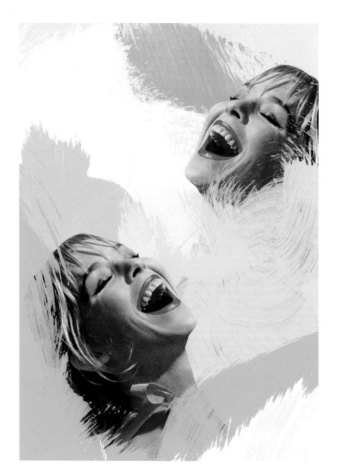

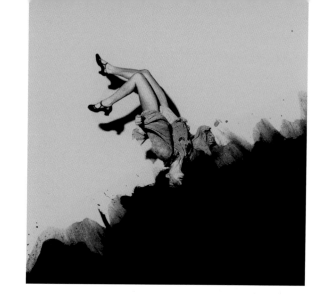

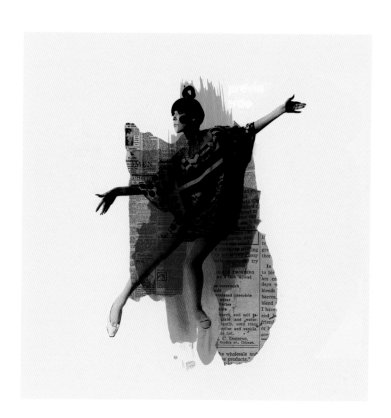

Comparison is the thief of joy!

If you're not suffering from lack of sleep, you're not doing it right.

Creative *un*Block
Project No. 01

Draw something on a piece of paper. Stare at it. Trash it. Draw it again on another piece of paper. Stare at it. Trash it. Repeat. Once you feel you're done, uncrumple all the pieces of paper and line them up in order.

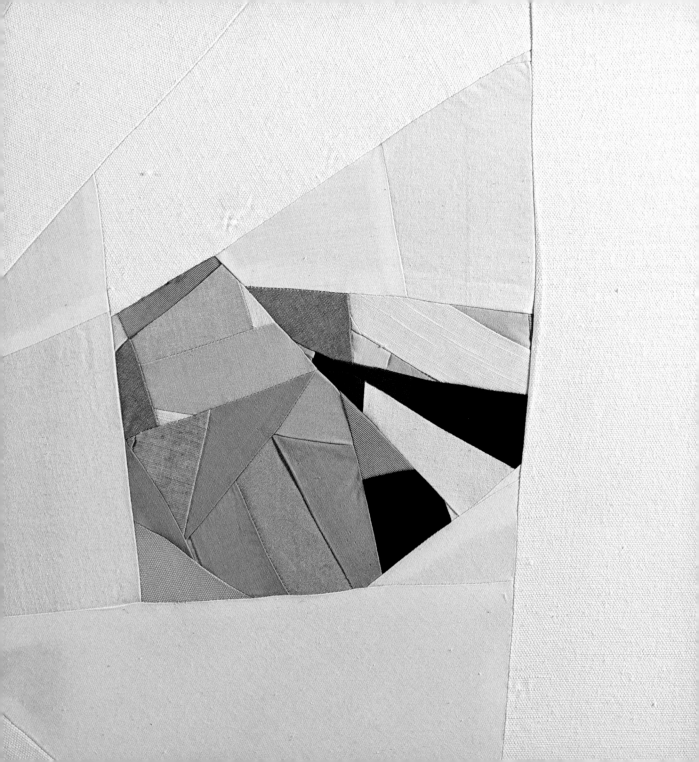

JESSICA BELL

FIBER ARTS/MIXED MEDIA

CANADA

JESSICABELLMADETHIS.COM

Vancouver-based artist Jessica Bell has an art history degree from the University of Calgary. When it comes to her current work, she is completely self-taught, attributing her love of textile art to the talented women in her family. She has a creative toolbox filled with bits of paper, paint, fabric, and thread. All of her work is lovely, but her textile assemblages are simply exquisite. They are made up of little pieces of perfectly chosen fabric that have been sewn together to create a final, fabulous piece . . . even the back of this work is beautiful!

JC—How do you feel about describing yourself as an artist?

JB—The "feeling" that I am an artist is still pretty elusive to me, rather like the feeling of being a grown-up. But other people tell me that I am an artist, and I tell myself that I am an artist, regardless of how I feel.

JC—Why are you an artist?

JB—Because I can't not be. I tried.

JC—Which artist are you most jealous of, and why?

JB—I am crazy jealous of Hella Jongerius. I read an interview with her where she said she sees herself purely as a designer, but when I look at her body of work I see her as a hybrid; there seems to be so little restriction in terms of how she works and what she makes. She thinks big thoughts and her voice somehow manages to be crystal clear while always breaking the rules.

In the realm of textile arts, I am wildly jealous of Sergej Jensen. His work is incredibly beautiful and incredibly brave. He is making paintings from fabric.

JC—What causes your creative blocks? How do you get past them?

JB—When I can't make progress, it is often because I am mentally scattered; this happens when I am overcommitted or have a schedule without any breathing room in it. I have to have a lot of space and quiet in my head to think my best thoughts. An artist I admire told me a few years ago that "you can't make art in the cracks." Carving out a block of time devoted to nothing else but the pursuit of new work has never steered me wrong.

JC—Do you have a trick you use if you're having trouble with a piece?

JB—Yes. If I am having trouble with a textile or paper piece, I always cut it up. I love cutting things up. It restores the potential to the materials again.

JC—Do you ever equate your self-worth with your artistic successes?

JB—Absolutely. Being an artist is very intertwined with my identity as a human being; I think of this as a good thing and a privilege. What has been helpful for me, so that I am not destroyed at my core when successes are elusive, is being able to think of myself as someone who has an art practice as a purpose and an art practice as a vocation. The professional art failures or successes in my vocation don't have to touch my purpose.

JC—What is your view on criticism—positive versus negative?

JB—Truthful criticism is an asset and it is really hard to come by. When it happens, I am actually really thankful for it. Unkind judgment is really just a distraction. I can usually eat some potato chips and sleep it off.

JC—So, is your inner critic truthful, or unkind?

JB—My inner critic is a total jerk, and almost always wrong. He is constantly telling me what I "always do," trying to diminish the value of an idea, telling me that what I am working on is nothing particularly special. The danger of my inner critic is that he tempts me to inaction—a kind of paralysis. He makes me hesitant, and my best work has been made when I have been recklessly willing to fail.

The best cure for my inner critic has been to crowd him out with other voices. Other artists have been the greatest assets to my creative practice. I have a stellar group of artist friends whom I can show work to and who consistently give me truthful criticism. I cannot overstate how important it is to me to be able to show what I am doing to people I know and respect, and be in dialogue about it. For me, that very dialogue validates the work's existence in itself.

JC—How do you feel when your creativity is truly flowing?

JB—When it happens for me, it is always characterized by this overwhelming feeling that even if I was able to live until I'm a hundred years old, there wouldn't be enough time to make all of the things I want to make.

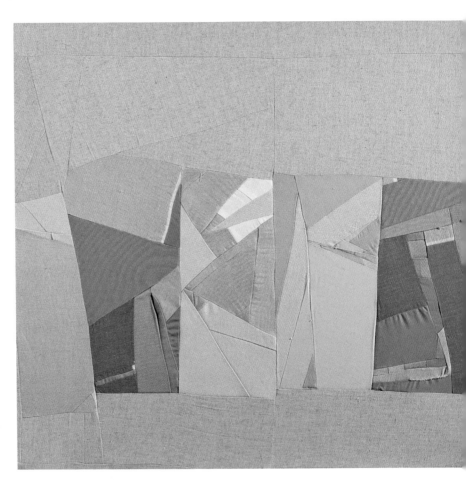

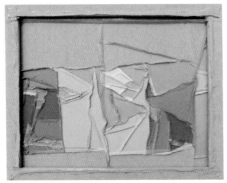

(Back view)

I love cutting things up. It restores the potential to the materials again.

Creative *un*Block
Project No. 02

Consider deliberately destroying that which you feel like you can't lose and see what happens to the piece and to your vision for it in the process. In a collage on paper or in a textile piece, for example, take your scissors and cut directly through the center of the element that you are afraid to lose; disassemble it in service to the possibility of reassembly. Perhaps you might want to cut it in more than one place. Survey the new parts you have just created and take stock of them as entities unto themselves. Take pictures of "the parts" in this stage; give yourself permission to play only with the components: this can give you freedom, if only momentarily, from the pressure of a compositional whole or achieving something that is properly "finished." Give yourself permission to create something that is merely temporary.

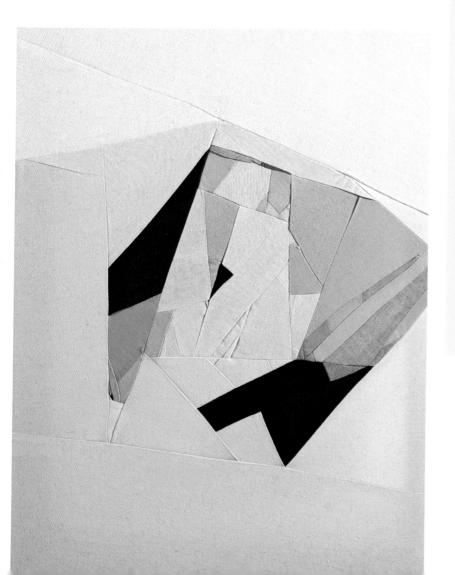

ARIS MOORE

MULTIDISCIPLINARY

USA

PEEKADOO.BLOGSPOT.CA

Aris Moore was born in Texas, but now calls New Hampshire home. She graduated with her BFA in painting from Montserrat College of Art in 1998, and received her MFA in drawing from the Art Institute of Boston in 2012. She has been a middle-school art teacher for over fifteen years, and is the mother of twins. At the same time she's also constantly making new work; in 2012 alone she had two shows in New York. And when she's not busy with all of that, Aris's other passion is being outside—gardening, observing nature, and, apparently, spending hours charming bullfrogs out of a swamp. Yes, she is multitalented.

JC—Teaching, taking care of twins, creating art—how do you make time for everything?

AM—I stay up late at night and work while my children are sleeping. I also draw with my students in class sometimes. I draw during lunch, during movies, in waiting rooms, during meetings. Drawing is part of my daily routine and has been for as long as I can remember.

JC—You draw, paint, and make lovely collages—but is drawing your first love?

AM—Yes. I love paper, lines, and the immediacy of drawing.

JC—Which artist do you admire most, and why?

AM—Agnes Martin, for her purity of thought, and her peace.

JC—Why are you an artist?

AM—Because I am obsessive, unquenchably curious, often excited, but rarely satisfied.

JC—What else would you want to be?

AM—I'd like to be an entomologist. Insects are as fascinating as people.

JC—When did you truly feel like an artist?

AM—I think I'm not quite there yet. But I will say that as early as five, I realized that drawing was the one thing I enjoyed doing alone. I could sit still for it, and I didn't need anyone else around to make it enjoyable. That might mean something.

JC—Do you still like to be alone when you're drawing? Since you're the mother of twins, do you ever get that chance, or have you adapted?

AM—I love to be alone when I am drawing, though I am able to feel alone (which is bad and good) when I am with people. I get completely absorbed. I don't work a lot when my kids are with me, unless we are all drawing together.

JC—Do you ever equate your self-worth with your artistic successes?

AM—No. Having children has cured me of that. They put everything in perspective.

JC—Does being a middle-school art teacher drain your creativity or fuel it?

AM—It fuels me. I say that I am a partially self-taught [artist], because teaching has made me a better artist. In many ways I have learned more from teaching than I have from being a student. My students are full of energy, excitement, humor, talent, drama, and possibility, and though these qualities are sometimes exhausting, it is a very fueled exhaustion.

JC—What do you tell the kids in your class if they're getting frustrated with a project?

AM—When my students get frustrated I usually try to give them inspiration, show them things, ask them what they don't like/what they do like, and then we go from there. They usually turn it around and surprise themselves, and delight me. It is so nice to see them happy with their work and themselves.

JC—What do you do if *you* get frustrated with a project? Do you experience creative blocks?

AM—I always have blocks. When I am stuck I try a new approach, I stop drawing and work with collage, finding images rather than making them, and allow myself to make messes. I also take photographs of different combinations during the process. I just search for excitement, but not too hard. It is when I find myself playing more than trying that I find my way out of a block.

JC—When do your best ideas come to you?

AM—When I'm cleaning or sifting through things. Like when you were a kid, cleaning your room—suddenly everything seems so much fun to play with!

JC—How do you feel about criticism?

AM—I devour it. I love it when someone cares enough to give suggestions. It is much more nourishing than them just saying they love your work.

JC—Do you ever discuss things with your inner critic?

AM—We are in constant conversation. Our relationship has changed over the years. She is no longer a bully—or I've just gotten strong enough to stand up to her.

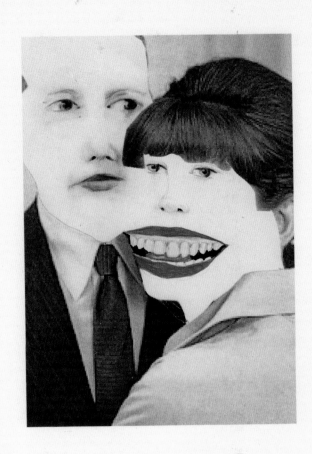

It is when I find myself playing more than trying that I find my way out of a block.

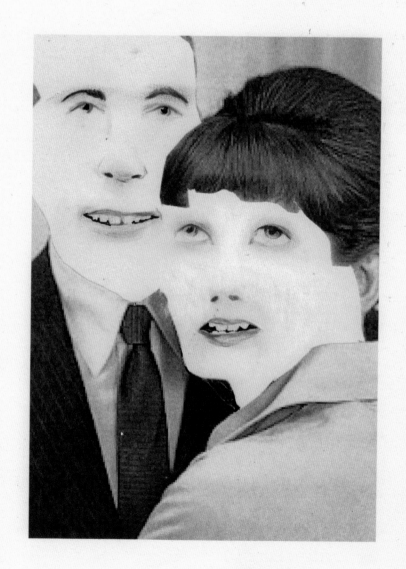

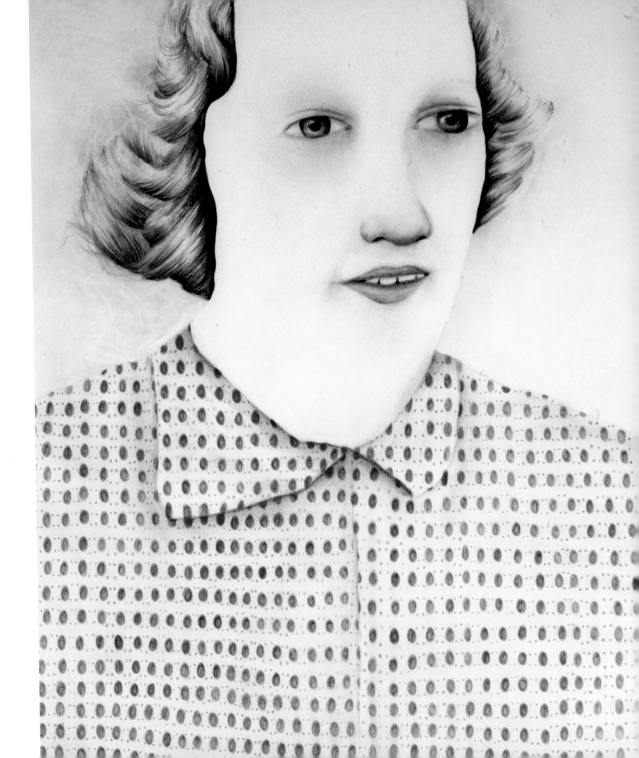

Creative *un*Block
Project No. 03

A collage self-portrait.

Do blind contour drawings of your eyes, nose, and mouth. If you are likely to erase, draw them in pen. Choose the ones you feel best about and collage them together. Draw your face around them and your neck, shoulders, and clothing, if there is room. Look closely in a mirror and shade your individual features and your hair, using whatever materials you like with as much detail as you need. After you feel good about your portrait, not because it looks exactly like you but because there is an honesty in it, begin writing. Surround your drawing with text, beginning each sentence with, "If you really knew me, you'd know . . ." Writing can be legible or illegible, whatever you need to be truthful. Lastly, remember that this is a drawing of you for you; there are no rules, just suggestions. Play and have fun.

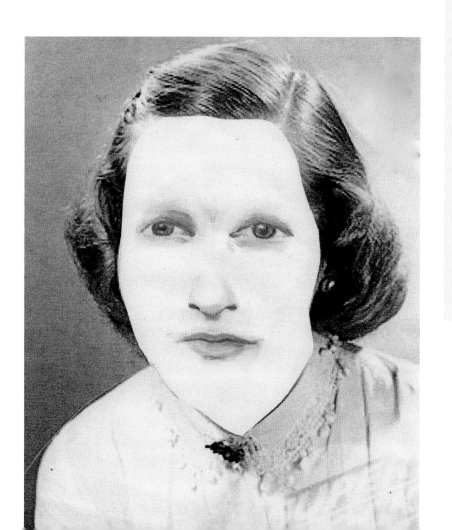

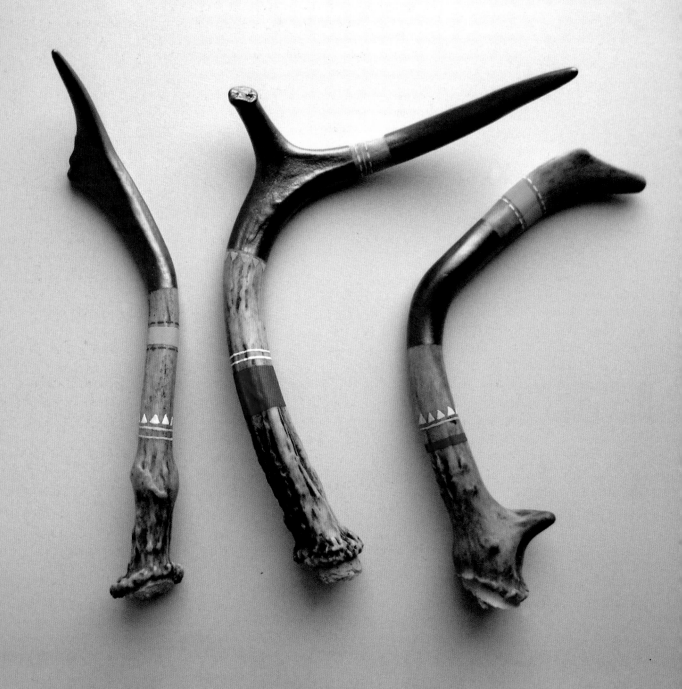

CASSANDRA SMITH

MULTIDISCIPLINARY
USA
CASSANDRA-SMITH.COM

Cassandra Smith is an artist and freelance curator working in Milwaukee, Wisconsin. She is also the co-owner and editor of *Fine Line* magazine, a quarterly, international fine arts publication. In 2006, she graduated from the Milwaukee Institute of Art and Design with a degree in sculpture. After graduating, Cassandra co-owned the now-defunct Armoury Gallery, which exhibited contemporary work by locally and nationally emerging artists. She has since curated several shows in the Milwaukee area. Among other places, her work has been shown at the John Michael Kohler Arts Center, the Milwaukee Art Museum, Hotcakes Gallery, Paper Boat Gallery, the Sharon Lynne Wilson Center for the Arts, and the Society for Contemporary Craft in Pittsburgh.

JC—**Your art supplies of choice—antlers, sequins, taxidermied creatures!**

CS—Yes! I love working with and manipulating found objects. I have never been one to create art entirely from scratch; even early in my artistic practice I preferred to start with a found object and build from there. The object (or objects) is what gives me the ultimate inspiration to make a piece of work.

JC—**Where do you typically find all of those amazing objects? Why do you choose what you choose?**

CS—With a lot of my early work (especially the work with taxidermy) I just chose whatever I could get my hands on! Through newspaper and Craigslist postings I was able to get random items of taxidermy that people were trying to get rid of. But getting taxidermy isn't easy, so I ended up doing two pieces using fake, plastic replicas. That was really fun because I could work in multiples without worrying about the moral implications of working with that many dead animals. More recently, with the shed deer antlers, I have had to search eBay to find good-quality antlers in bulk.

JC—**If you weren't making art, what would you do?**

CS—I would pursue my other job as a magazine owner and editor full time. I co-own *Fine Line* with Jessica Steeber. Right now I spend about 50 percent of my time working on magazine business, but if I weren't making art (and had a magical source of income) I would do it all the time. I love our magazine and the opportunity we have to showcase amazing artists from all over the world.

JC—*Fine Line* **is filled with stunning work! How do you choose the artists that you feature?**

CS—First, Jessica and I started out by scouring the Internet for amazing art, and created a huge file of artists we wanted to work with. We also have a good amount of people submitting work to us. Now that we have a large stockpile of artists, we just go through and try to find artists who are speaking to similar themes. We usually start with a loose title, and then build the work around that idea. We also like to make sure that we touch on different mediums and styles in each issue.

JC—**Which artist's work/life/career are you most jealous of, and why?**

CS—So, this question just ate up the last hour of my life! It's so hard to choose just one artist because there are probably a hundred artists I'm jealous of.

Two works I truly wish were my own are Hervé Graumann's *Patterns* series and Patrick Jackson's *Tchotchke Stacks*. Hervé, whose work we are showing in our sixth issue of the magazine, creates meticulous pattern installations using mass-produced items. His photographs of them almost look like they are digitally made, until you see a farther-off shot and realize that he arranged all the objects by hand. Patrick Jackson makes these towers using sheets of glass and found tchotchkes, which I'm guessing he gets from thrift stores or garage sales. They are so fantastic.

JC—Do you ever find yourself stuck in a creative block?

CS—Right now I am fortunate enough to not be faced with many creative blocks, but that's mostly because I'm doing nearly the same thing over and over again! I currently spend all of my art-making time creating my hand-painted deer antlers, which don't frustrate me very often. When I was creating larger pieces I would often get creatively blocked—I would just stubbornly keep working on my original idea until I either liked it again, or came up with an idea I liked better.

JC—Criticism—do you listen to it, or ignore it?

CS—I'm really good at ignoring criticism, sometimes to a fault. I actually have to stop and acknowledge that my critics might have valid points that I could learn from. When I was in school we had critiques all the time, and that's where the most learning and growing occurred.

JC—Does your inner critic ever get to you?

CS—Sometimes. My solution is to take it to a friend for a second opinion, before I really let it get to me. I could easily go around in endless circles with myself, questioning whether or not I'm on the right track with something. I just have to stop myself, and ask for help.

JC—How do you feel about calling yourself an artist?

CS—I have always felt like an artistic person, and I have called myself an artist ever since graduating from college, but this is the first time I have made money from my work, and the first time I have considered myself an Artist with a capital "A." I just had my dental hygienist ask me what I do for a living, and after a little pause and some mumbling, I finally realized (and told her) that I am an artist, and it felt awesome.

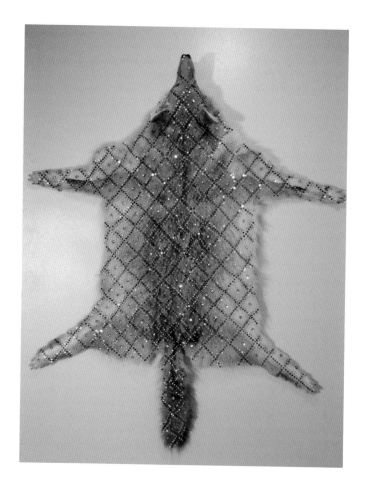

Make a little sculpture using a found object. Find something around your house, at a thrift store, a wacky junk store, anywhere! An object that is about as big as your hand or smaller is probably the best size to start with, so it's not overwhelming. And make sure it's something you don't mind ruining. This is just supposed to be fun, after all! And then transform the heck out of it! Paint on it, glue things to it, cut it in half and glue it back to itself, or glue it to something else. Use the object's color and shape to inspire you.

I could easily go around in endless circles with myself, questioning whether or not I'm on the right track with something. I just have to stop myself, and ask for help.

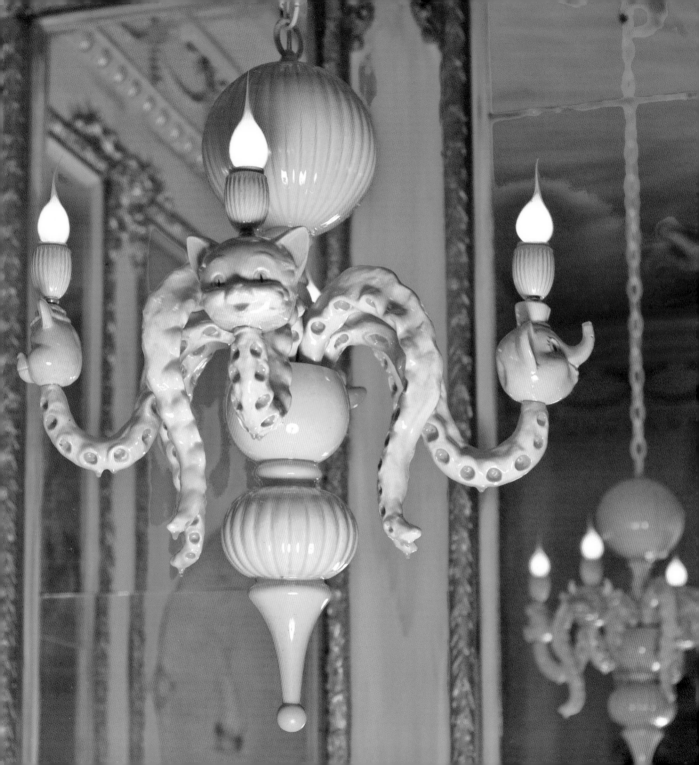

ADAM WALLACAVAGE

CERAMICS/SCULPTURE

USA

ADAMWALLACAVAGE.COM

Inspired by an obsession with the ocean and a fascination with extravagant interiors of old churches, Adam Wallacavage transformed the dining room of his South Philadelphia Victorian brownstone into something from the pages of a Jules Verne novel. Teaching himself the ancient art of ornamental plastering, Adam evolved his newfound skills into making octopus-shaped chandeliers as the final touch to his underwater-themed room. Not content with leaving the chandeliers to his own home, Adam continued his experimentation by making more and more. He changed the shapes and colors and themes, moving on to bats, snakes, elk skulls, wall sconces, and some rather silly castings from his old collection of rubber squeaky toys. Adam has been showing his chandeliers all over the world, including places like São Paulo, Rome, Vienna, Bristol City Museum of Art in the U.K., and, most recently, at La Gaîté Lyrique in Paris.

Beyond making chandeliers, Adam Wallacavage is also an accomplished photographer, documenting artists, musicians, daredevils, and all things weird and wonderful. His first book, *Monster Size Monsters*, was released in 2006 through Gingko Press, and spans fifteen years of his photography.

JC—Are you formally trained or self-taught?

AW—Pretty much the latter. I mean, I went to school for photography and took classes in mold-making, sculpture, silk-screening, and stone carving, but unless you are going to be doing only the one thing you discovered in art school, everything else is going to be self-taught to some point.

JC—Which materials do you like working with the most?

AW—Stuff. Vintage lamp parts, Magic-Sculpt, epoxy resins, spray paints.

JC—What's your first memory of feeling like an artist?

AW—I remember making a painting for Santa Claus and leaving it out for him, only to find about three months later that my parents stole it and hid it in the attic. I was so mad at them.

JC—Why are you an artist?

AW—It's an excuse.

JC—If you weren't an artist, what would you be?

AW—Boring.

JC—Where do you find inspiration?

AW—It used to be by exploring libraries and looking for stuff at flea markets, but now I have so much going on at my house/studio that I just feed off the energy here.

JC—What's happening in your house?

AW—I'm trying to get rid of all the junk that causes my mind to get cluttered up. I want to continue to keep the energy that inspired the octopus chandeliers by creating another room to rival all the other rooms. I'm thinking of a Gothic Bollywood-themed room for the second floor and an opium den-themed room as well. I don't really like the word "theme," only because it directs the inspiration to something existing or from the past, so I use it loosely.

JC—How do you feel about the egos and insecurities of the art world?

AW—I've been fortunate to realize how unimportant it is to think too highly of yourself. I've known a lot of artists, and I know about ego and insecurities and all that. Basically, you need to be comfortable with yourself and find confidence in what you do and not really care about what others think. I try to make things that make people happy and excited, especially kids. It's an easy formula because I'm not trying to challenge anyone with some heavy internal political opinion or ideal beyond just appreciating the mysteries and beauty of nature. It's an easy way to make people smile, and that's all the compliment I need.

JC—So, how do you feel about receiving criticism?

AW—I'm critical of myself first, so there's nothing anyone could say that I didn't realize myself first—and if it is something I didn't realize, it's probably healthy that I know.

JC—Does your inner critic ever have an opinion?

AW—Not really. My biggest criticism is the fact that I'm making too many octopus chandeliers and I need to move on from it, but then I make another and it still makes me happy, so whatever.

JC—How do you get unstuck, when you're feeling stuck?

AW—I've always had many different jobs and passions: I'm a photographer, sculptor, builder, ornamental plasterer. I just switch to a different thing I like to do when I'm stuck on one thing. I can always make tentacles if I want. I got kind of good at that, or just photography. I shoot a lot, and I create things to be photographed.

JC—When do you get your best ideas?

AW—Probably walking, since I seek a lot of inspiration looking up at buildings to see the ornamental designs.

JC—How do you know when you're truly in a "creative zone"?

AW—I normally work until I'm ready to go out, and if I work so late that I can't go out, it's usually an indication that I'm in the right spot.

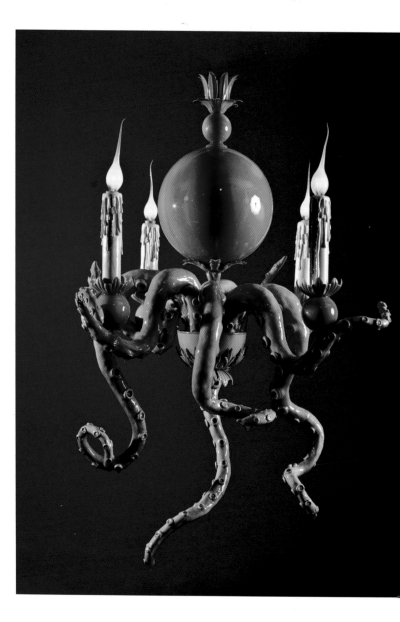

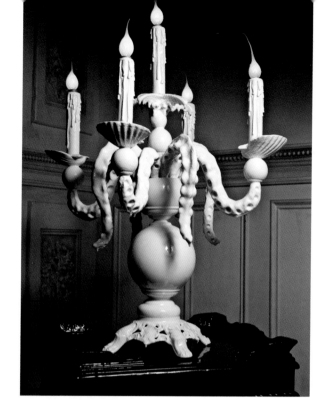

You need to be comfortable with yourself and find confidence in what you do and not really care about what others think.

AMAZING THINGS WILL HAPPEN

MARY KATE MCDEVITT

HAND-LETTERING

USA

MARYKATEMCDEVITT.COM

Amazing things will happen. **Yes, yes they will. Originally from Philadelphia, now based in Brooklyn, New York, Mary Kate McDevitt is a hand-lettering master. She studied graphic design at Tyler School of Art in Philadelphia, with just a few illustration classes. Outside of class she discovered her love for hand-lettering while exploring vintage type—and the rest is history! Her projects are incredibly varied (journals, book covers, greeting cards, editorial, packaging, ad campaigns), but none of them are short on hand-crafted elegance and playful charm.**

JC—**Which artist's work/life/career are you most jealous of and why?**

MKM—I'm jealous of Louise Fili because of her acclaimed vintage design collection. Not to mention her successful design studio and the work with the amazing Herb Lubalin (my design idol). The books she has worked on introduced me to vintage design and how it can still apply to design today.

JC—**Describe the first moment that you truly felt like an artist.**

MKM—I have always been interested in art, since as long as I can remember. I tried to keep diligent sketchbooks, and would paint the wildlife in my boring suburban backyard, but I would get pretty frustrated that I couldn't paint realistically. I also felt I couldn't truly flourish as an artist if I wasn't living the life of Laura Ingalls. I kept up the drawing and painting, and in middle school I had a teacher who encouraged my drawing skills and gave assignments that I really enjoyed—including calligraphy and hand-lettering. One assignment we had was to make a pattern that was more illustrative and abstract. I spent a lot of time on mine, and in the end my drawing was picked to be framed and hung in the school, where I believe it still hangs. I definitely felt like a true artist at that time.

JC—**Is there anything else you'd want to be?**

MKM—Along with making art my whole life, I was also known to rearrange the furniture and would bring paint samples to my mom and hint at our need to redecorate. I think I would be an interior decorator.

JC—**What inspires you most?**

MKM—I'm inspired by vintage design. Old advertising packaging is chock-full of interesting lettering borders and designs. I also enjoy the idea of the "simpler times" and love collecting trinkets from the '30s.

JC—**When do your best ideas come to you?**

MKM—When I'm trying to sleep. When I get to bed at a normal hour (any time before 2 a.m.) I usually lie awake thinking about work. I don't do yoga very often, because when the instructor says to "clear your mind," I think, "This is a great opportunity to think about my work!"

JC—**If a drawing isn't working, do you get frustrated?**

MKM—No, if it's not working, I move on. Oftentimes there are fragments of the drawing that are working, so I usually trace the design and start over on the area that isn't working.

JC—**Does your inner critic tag along on your projects?**

MKM—I can't ignore it; when I'm working on some intense lettering I have to critique my work along the way. But I do sometimes have the inner fan cheering me on that it's working: that is the best feeling. But when my inner critic starts getting fussy, I do have to step back, take a breather, and realize that it is just a project and not the end of the world if it's not perfect.

JC—Does your day job as an illustrator tend to be a creative drain or fuel for your personal projects?

MKM—When I have a chance to work on personal projects, I'm usually excited to get started, and the project goes smoothly. I think it's important to work on personal projects, as it usually informs your skills and teaches you more than most client projects. You can be more experimental.

JC—What is your advice for pushing through creative blocks?

MKM—Diverting your attention to another activity can help you through creative blocks. Most of the time client deadlines prevent me from activities like cooking and reading, which are great ways to get past creative blocks, so stepping away from the project to make a cup of tea or just start doodling something else can shake the creative juices loose.

JC—How do you feel when you're on a "creative roll"?

MKM—I could be working without headphones, with someone right next to me trying to get my attention, and I am completely oblivious to anything but the task at hand. I really like getting in those grooves! One minute it's 8 p.m., the next minute I've finished my project and it's 3 a.m. That's pretty magical.

I do have to step back, take a breather, and realize that it is just a project and not the end of the world if it's not perfect.

Creative *unBlock*
Project No. 06

A daily hand-lettering challenge: Pick a quote you heard that day, either from the news, your favorite TV show, or any quote that inspires you, and jot it down in a notebook. Seeking information that inspires you philosophically and intellectually will help you stay motivated making art—and what better way to remember these words than to draw them beautifully? Draw one quote every day for thirty days!

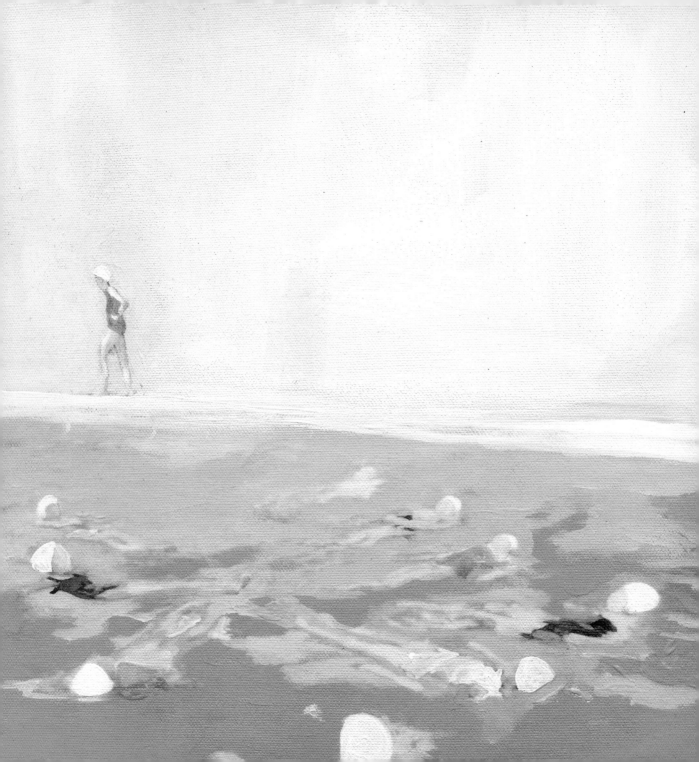

LISA GOLIGHTLY

PAINTING

USA

KIKIANDPOLLY.COM

The dreamy acrylic paintings of Lisa Golightly immediately stir up a rush of childhood memories. Foggy, pastel-hued childhood memories of swimming, climbing, and daydreaming. Lisa majored in photography at the University of Arizona, but eventually found her way to painting. Apparently she had always been intimidated by it, but clearly (and thankfully) she found her way past that! Her subject matter comes from her own memory, and also from the memories that she is watching her own children create. Her Etsy shop and website are known by the name "Kiki and Polly"—which was inspired by her daughter's love of a bird she named Kiki, and for her daughter's imaginary friend Polly. Polly no longer visits as she once did, but Lisa keeps the spirit of childhood, wonder, and imagination alive in her Portland, Oregon, home studio.

JC—**Describe the first moment that you truly felt like an artist.**

LG—It's hard to pinpoint an exact moment. I remember the first few times I introduced myself as an "artist" at parties or dinners (somehow that seemed like a huge thing, being able to say it to strangers), but really "feeling" like an artist was more of a slow build that came from making work I was really proud of.

JC—**Why are you an artist?**

LG—I am an artist because I love to create. Even if I wasn't making a living at it, I would still be painting. I have a very clear memory of being a child and thinking that being an artist was the ultimate thing to do with your life. A lot of kids might think being a doctor or astronaut would be the dream profession, but for me it was always an artist.

JC—**What inspires your work?**

LG—The concept for most of my work comes from my life, memory, and then the circle of watching the same sort of memory being created in my kids. The physicality of my work can be inspired by even a color combination that gets my heart beating faster. I spend a good amount of time on my computer, but sometimes that can backfire into overload. So I *try* to not live on the Internet.

JC—**Do you have a trick you use if you're having trouble with a painting?**

LG—I tend to remove or simplify and then rebuild a painting if it is giving me trouble. A lot of times the pieces that give me the most trouble are the ones I'm happiest with in the end.

JC—**Would you ever give up on a painting, or do you always push yourself through?**

LG—I've done both. Sometimes I lose interest in a painting or just see that it's not going to be what I thought it was, and we part ways. For me, if it's truly not working, I'd rather put my energy into a new piece than continue to be frustrated with one that just isn't working.

JC—**Does being a full-time artist fuel or drain your creativity for personal projects?**

LG—It definitely fuels it. I get a lot of inspiration when looking around that doesn't necessarily relate to my art, but finds its way into my home. It's nice to have that space to create just for yourself, or your family, without the pressure of it mattering or being seen by anyone else.

JC—**Do you ever equate your self-worth with your artistic successes?**

LG—Guilty. I remind myself that I would be doing this regardless of any success or failure.

JC—**Are you able to ignore your inner critic?**

LG—Well, I try to ignore it. If I'm having a "not great" day painting, for me, stepping away is usually best thing to do. Getting some space, taking a break, and then coming back usually helps me shut down those negative thoughts.

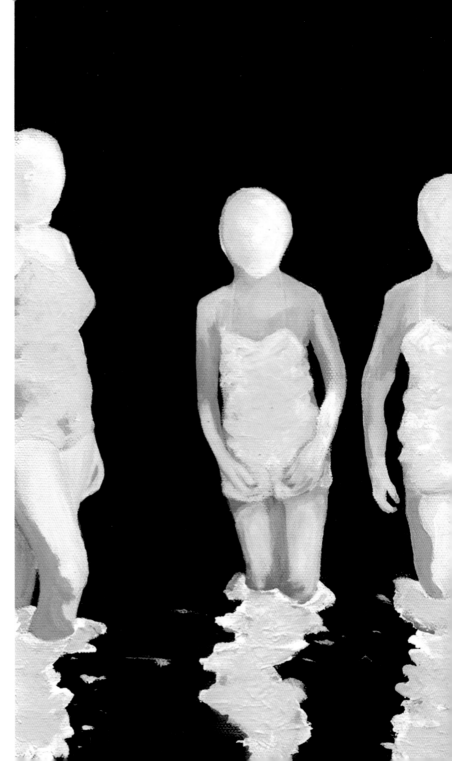

JC—What do you do in order to get through a creative block?

LG—I give myself permission to just make for the sake of making without any thought to the outcome, which can be surprisingly hard. In the past I've tried a new medium to sort of get out of my own head. I started creating abstract pieces using fabric dye on paper, and loved it so much that I've started working on abstract pieces much more. I realized I'd created these rules for my work, that it had to be a certain thing. Of course, there are no rules in art, but it took pushing my comfort zone to understand that.

JC—How do you feel when you experience the opposite of a creative block—when things are truly flowing?

LG—I think those are the moments you live for as an artist! Getting in that zone where ideas and technique and subject all come together. It's a rush; I usually crank up the music and enjoy it while it lasts.

JC—What have you learned during your art career that you wish you'd figured out a long time ago?

LG—I'm still figuring things out. I wish I could hear my advice to myself ten years from now! What I would tell my younger self is this: There is no "right" way to make art. The only wrong is in not trying, not doing. Don't put barriers up that aren't there—just get to work and make something.

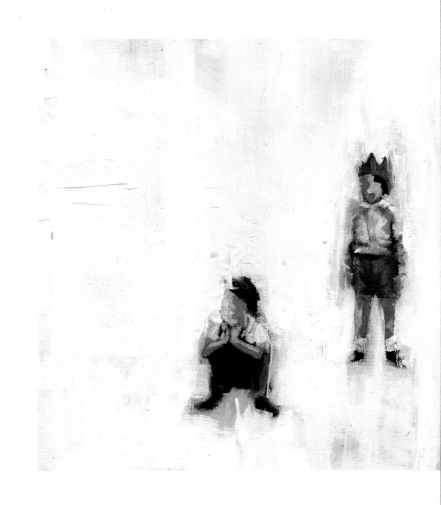

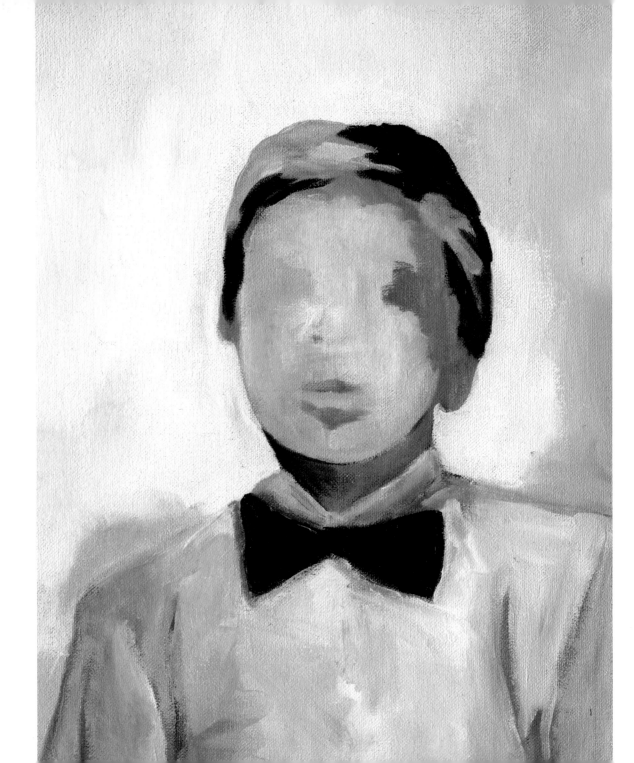

Don't put barriers up that aren't there—just get to work and make something.

**Creative *un*Block
Project No. 07**

Fear is a big motivator for me. A college professor once told me that if I was afraid of something, that meant I had to do it, and that has basically shaped my life. So, make a list of the three things you are most afraid of trying (artistically). For example, if you're afraid of painting on a large scale, buy a huge canvas or paper and go! Do those three things, no excuses.

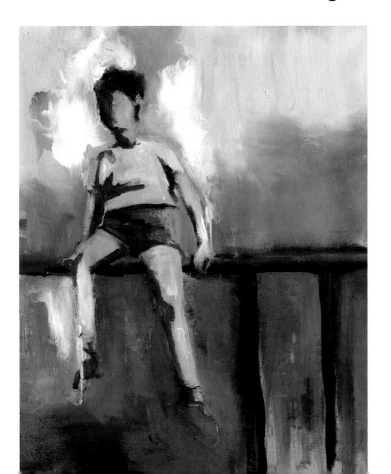

ANTHONY ZINONOS

COLLAGE/MIXED MEDIA

UK

ANTHONYZINONOS.COM

Anthony Zinonos is a full-time freelance collage illustrator in Norwich, England, and is also the proud owner of two pugs. Anthony makes collage look so easy—but it's not! He received his BFA at the Norwich School of Art and Design, specializing in printmaking and photo media, and the evidence of both can be seen in his collages. Anthony's work is bold, graphic, filled with witty humor, and his use of white space is fantastic. He exhibits his work around the world, and has been commissioned by some amazing clients like Kate Spade, Chanel, and Alfa Romeo, just to name-drop a few.

JC—Why did you end up focusing on collage?

AZ—Nothing beats old books or magazines, scissors, and some UHU glue!

JC—Why are you an artist?

AZ—I love creating and sharing what I have made. If someone is willing to pay me for doing something that I adore, what more could I ask for?

JC—If you weren't an artist, what would you be?

AZ—Probably a chef or baker or something working with food. It has the same creating hands-on approach. I worked part-time as a cake baker through art school, and that wasn't too bad. Kitchens always attract a bunch of weirdos, which is always entertaining, and a good laugh.

JC—Which artist do you admire the most?

AZ—My lovely wife, Gemma Correll. She's achieved so much and never stops drawing or thinking of ideas. Her drawings always make me laugh too.

JC—Do you have any "go-to" tricks for getting out of a rut?

AZ—Working in a sketchbook always helps me through a rut. I feel free working in a sketchbook; there isn't the pressure of having to produce a "final piece," so loads of great ideas develop.

JC—You do so much amazing commissioned work—do those projects drain or fuel your personal work?

AZ—They fuel each other. Commissioned work can be really easy sometimes because there is a brief, a deadline, and someone saying yes, no, maybe a bit more. However, after doing loads of commissioned work it feels great to just create and experiment and not have to worry about what it's for or when it has to be completed by.

JC—Do you ever equate your self-worth with your artistic successes?

AZ—Definitely—it's unavoidable. I think I'm always quick to forget what I've already done, and achieved, so it's good to stop, recap, and look at the bigger picture.

JC—Criticism—do you see it as a friend or foe?

AZ—Criticism is actually your *best* friend. It helps you develop and see your work through someone else's eyes. It's just not always easy to hang out with them, though!

JC—How about your inner critic? Are you friends with him?

AZ—The inner critic is like that old friend from school that you wish would just leave you alone, but keeps calling and leaving messages. Eventually they catch you off guard and you get sucked into their misery.

JC—What advice would you give to your younger self about getting out of a creative block?

AZ—I've learned to reassure myself that all I have to do is sit back and patiently wait, or step away from all things art related for a while. It is so easy to get caught up with what you're working on. By stepping away, it gives you a chance to put things into perspective, and realize that it's not actually the end of the world. So, I would tell the younger me, "Don't worry or stress about it; take some time out and do or think about something totally different. The block will always pass, leaving behind some magical inspiration."

JC—Where do you find that magical inspiration?

AZ—Photographs, old books and magazines, films, animation, nature, architecture, the way buildings cut up the sky . . . there is so much inspiration everywhere—you just have to take the time to stop, look, and think.

JC—Which books or magazines do you usually reach for when you're starting a new piece?

AZ—Old travel books and magazines from the late '60s and '70s. That is my favorite era for printed matter, so anything from *National Geographic* to *Good Housekeeping.*

JC—How do you feel when you experience the opposite of a creative block—when things are truly flowing?

AZ—Being "on a roll" is when I have total clarity and nothing but great ideas bubble up in my head. It's like being on a creative high; you're on top the world and work seems to be just pouring out of you.

The inner critic is like that old friend from school that you wish would just leave you alone, but keeps calling and leaving messages.

**Creative *un*Block
Project No. 08**

Visit a thrift store and buy an old magazine and an old book. Take them home, chop them up, and make five new collages.

MATTHIAS HEIDERICH

PHOTOGRAPHY

GERMANY

MATTHIAS-HEIDERICH.DE

In 2008, Berlin-based artist Matthias Heiderich received his university degree in computational linguistics and phonetics. After seven years in university, and a lot of mathematics, logic, and programming, he wanted to do something different—so he bought his first camera, and in 2010 he became a full-time artist. His first print magazine feature was in *Grafik* from London, a magazine that he often read himself— he was thrilled! He has gone on to exhibit all over Berlin, and has begun showing internationally.

JC—What a jump, from computational linguistics to photography! How did you make the transition?

MH—To train my photography and photo-editing skills, I completed internships and worked as a photo editor and event photographer. I learned a lot from colleagues during that time and spent a lot of time teaching myself the basics of photography. Photography is something I really enjoy, but I can't be sure I will always be able to make a living from it, so I guess it's good to have a university degree in another field.

JC—Do you now consider yourself an artist?

MH—It's still new to me to think of myself that way, but I have felt like an artist during exhibitions—when I see my own pictures up on a wall, people standing in front of them discussing and asking questions. The first time this happened, I was twenty-eight years old.

JC—Your view of the world is spectacular—do you keep your camera with you at all times, just in case you find the perfect rooftop?

MH—I have my phone camera with me all the time—that allows me to take a quick shot, then I can come back with a "real" camera later. Whenever I have time to go outside, I have one of my professional cameras with me. It really can drive me crazy to see beautiful things without being able to capture them. One of my recurring nightmares is about standing in front of a really weird building, and not being able to remember where I put my camera. I don't want this to happen in real life!

JC—What inspires you?

MH—Architecture, electronic music, and photography are my main sources of inspiration. Luckily, in Berlin I can find plenty of all of this. I also find inspiration online. I love to browse blogs, portfolios, bookmark sites, etc. Seeing the work of other photographers inspires me, and helps me evaluate my own work. I'm sure it was mainly the Internet that brought me here.

JC—What are some of your favorite spots to visit on the Internet?

MH—Blog.iso50.com (always inspiring); networkawesome.com (I love the documentary section); triangletriangle.com (a collection of some of the best portfolios); butdoesitfloat.com; bldgwlf.com; ffffound.com.

There are also some really good Tumblrs, Pinterest boards, and Behance profiles out there—too many to mention, actually. Unfortunately, I easily forget time and space as soon as I start procrastinating. But I guess I'm allowed to call it "research" in this case.

JC—Is there a specific artist that you admire/envy/are jealous of?

MH—I recently saw a documentary on Andreas Gursky. I must admit, I became jealous when I saw his work space, his equipment, and what his general working day is like. Being able to travel the world with the best cameras ever made—and making a living from that—is definitely a dream scenario for me. Yes, I'm definitely jealous.

JC—Do you ever equate your self-worth with your artistic successes?

MH—The answer is yes—although I know this is a very bad idea. Artistic jobs are more vulnerable to ups and downs than many other jobs, and it might become a problem if these ups and downs are always linked to one's self-worth. Sure, success is an ego boost, but the opposite of success shouldn't kill you, your relationship, friendships, etc. I hope one day I'm able adopt this myself. In the meantime I keep repeating my mantra, a quote by Charles Horton Cooley: "An artist cannot fail; it is a success to be one."

JC—Does your inner critic ever have anything to say?

MH—My inner critic is a loud talker. It's almost impossible to get it to shut up or to ignore it. Whenever I work on something, it's like one of those small devils on my shoulder. It really gets to me—I often only see the mistakes in my photographs, and not the positive parts. Talking with close friends often helps me to direct my thoughts in a less destructive direction, so that I can see what's good, and what could be better.

JC—What causes your creative blocks? How do you push through?

MH—For me, a creative block is a sign of overthinking. When my brain feels blocked, I try to distract it by doing something completely different—usually that's riding my bike or swimming. A positive side effect is that I've become much more sporty lately!

I keep repeating my mantra, a quote by Charles Horton Cooley: "An artist cannot fail; it is a success to be one."

One of my recurring nightmares is about standing in front of a really weird building, and not being able to remember where I put my camera.

Creative *un*Block
Project No. 09

My challenge is called "Once Around the Block." The name is inspired by a song title by Badly Drawn Boy and the word "block" is ambiguous in this case. Sometimes the reason for a creative block is not being able to stay focused on one thing, your brain feels like a big knot, and you only think of your kitchen that needs a cleaning, etc. It makes sense to stop working then, and to re-sharpen the senses. Trying to see the banal objects around you in a new light can be a good brain boost. What's more obvious than exploring the neighborhood, the houses, the balconies, the sidewalks, the shop windows, the gardens on your block, instead of being locked up in your studio?

Take your camera, or sketchbook, and examine banal objects around you, photographing or drawing them. It's not about the result; it's about the process. Your photos or drawings don't have to be high quality, but they should present a new side of three or four objects in your neighborhood you haven't paid much attention to before. This shouldn't take you more than an hour—it's just a bit of fuel for your blocked thinking device, and not your actual piece of work.

MATTHIAS HEIDERICH **59**

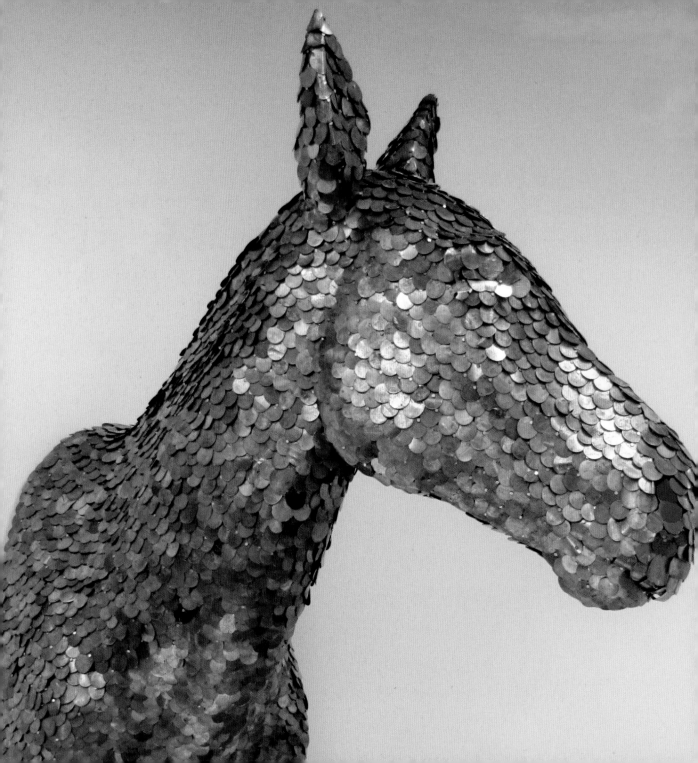

RACHEL DENNY

FIBER ARTS/SCULPTURE

USA

RACHELDENNY.COM

Portland-based artist Rachel Denny grew up in a very rural setting, and spent much of her time outdoors. She collected bits and pieces from nature, went hunting with her father in the fall, and then spent the long winter months busily making various craft projects with her mother. Since childhood Rachel has been interested in the mystery of the natural world, and that is very evident in her work. In her words, "We surround ourselves with elements from nature in the form of manicured lawns, sculpted trees, and our domesticated companions. We bend it to our tastes, and create a comfortable place from which to appreciate its unpredictable beauty. I am inspired by the elegant forms found in the natural world and the time-honored action of trying to depict these forms in an interesting way that is relevant to our modern times. My sculptures weave everyday objects with the animal form to create new layers of information." Well said.

JC—Are you a formally trained or self-taught sculptor?

RD—I am an art-school dropout and would say that I am mostly self-taught. I learn from looking and working through the puzzle of trying to figure out how to make a sketch into an object.

JC—Why did you leave art school?

RD—I left because I was very young, and couldn't afford the tuition. The first year used up every cent from years of summer jobs, and my financial aid fell through. In that brief time though, I did make a few connections with gallerists, and learned a lot.

JC—What do you love about sculpture?

RD—I find sculpting challenging and satisfying. I have tried just about every medium, and like that I can use methods from all of these experiences with sculpture. I love working with tactile materials like wool, wood, clay, and whatever else catches my fancy.

JC—Which artist are you most jealous of (in a good way, of course!), and why?

RD—Louise Bourgeois has an incredible body of work and was always pushing herself to create something emotionally tangible. I fell in love with her back in art school and every interview I have seen with her makes me like her even more. I am jealous of how smart, talented, honest, and charming she was.

JC—What inspires you?

RD: I am inspired by my surroundings—news stories about animals, others' artwork, and nature. I love the websites Boooooooom! and Beautiful/Decay; it is exciting and inspiring seeing other people create something I would never have thought of. Also I love to read, as books are one of my favorite ways to relax, and they always inspire new ideas.

JC—Are there any books that directly influence your work?

RD—I enjoy Hemingway's lush descriptions of Africa, have a few antique animal almanacs from the 1800s that treat wildlife like mystical creatures, and Virginia Woolf's *Orlando* has beautiful settings and mood.

JC—Your sculptures are often large, and always meticulous—after so much work, would you ever give up on a piece?

RD—I try to finish the work, and keep going even when I am frustrated. I have worked for months on a piece (for instance, a little boy with hand-sewn feathers covering him), just not been happy with it, and so it gets shelved in the back of the studio. I hope there will be a eureka moment when the lost boy has found his purpose. And sometimes I just take a break from the troublemaker. I always have several pieces in process in the studio, so I can work on something else that will give me some time to think out the problem.

JC—Do you care what critics think or say?

RD—When I first began showing, I was very fixated on what critics thought. A flippantly bad review would become a serious thorn in my side that I would fixate on for weeks. I have

gotten over this as I've grown older and had more experience with my work and the art world. I think criticism is a good thing and can challenge you to make better work, but it is good to know that everyone has a different idea about what art should be.

JC—Does your inner critic whisper in your ear? What does it say?

RD—Yes—I think about great works of contemporary art by artists I admire and wonder if my work stacks up, if the intellectual content is strong enough, if the craftsmanship is good enough, etc., etc.

JC—What is your favorite piece of contemporary art—an example of one of those great works that you're measuring your work against?

RD—I don't have a single favorite, but I'm always blown away when the content of the work and the crafting are of equal caliber. I love Kiki Smith's *Lilith*, Al Farrow's *Reliquaries* series, Xavier Veilhan does clever and meaningful work, and the Lalannes make simply beautiful pieces with a playful outlook.

JC—What's the best way for you to get through a creative block?

RD—I get antsy when I'm not working, but over the years I have learned to let myself take a break when things just aren't coming together. It is best to have a clear head when in the studio. I tend to get clumsy when frustrated, and things go from bad to worse. I find that having a big cup of coffee and drawing ideas all morning in my sketchbook helps. I can experiment with ideas on paper and make ridiculous things no one will see, but that might lead to a good piece later on.

JC—How do you feel when things are truly flowing?

RD—It feels like I've had about three cups of coffee (minus the jittery, making-you-sweat part) and everything is clear and calm in my mind. I love it when a piece is almost finished, and I can see what I've made coming to life.

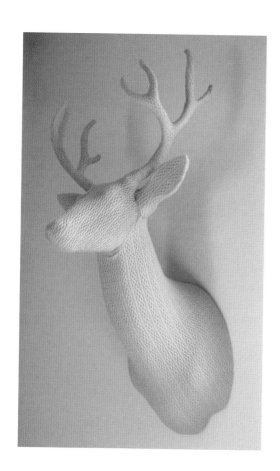

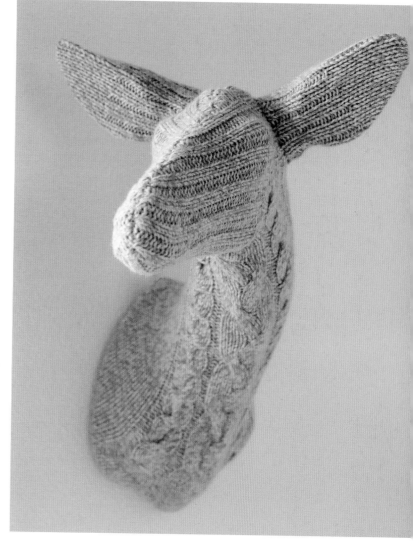

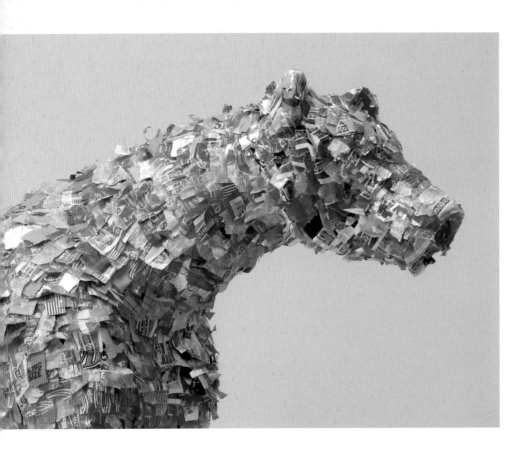

I love it when a piece is almost finished, and I can see what I've made coming to life.

Creative *un*Block
Project No. 10

Go outside and take a walk.

Listen to and look at your surroundings.

Find a natural object that you find interesting and take it home.

Try to replicate the object in an unnatural way.

Paint it realistically using text, sculpt it out of something in the kitchen (a potato, empty bags, etc.), or use colors that are not part of the original object. Use your imagination, and don't be afraid of failure.

You can't do it wrong.

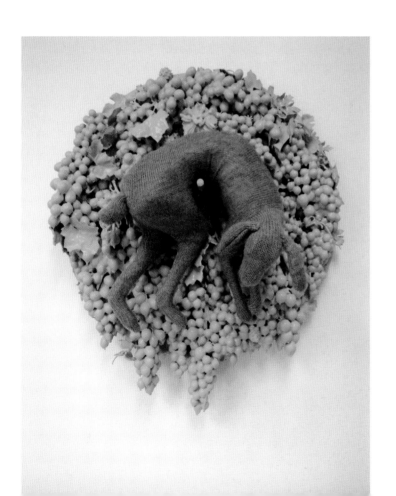

ASHLEY PERCIVAL

ILLUSTRATION

UK

ASHLEYPERCIVAL.COM

Ashley Percival is a freelance illustrator living in the U.K. In 2010 he graduated from the University College Falmouth, where he studied art and design. He then went on to study marine and natural history photography. As far as illustration goes, however, he is self-taught. He has been drawing and experimenting with materials since he was a kid and—don't tell his high school teachers—most of his drawing education occurred during math and English lessons! He gets some of his inspiration from wildlife and nature, and the rest from his quirky imagination.

Shortly after graduating in 2010, Ashley decided to open an Etsy shop, which proved to be a very good decision. His sales went through the roof, and led to Ashley having his artwork licensed by Urban Outfitters, Monsterthreads, Forever 21, iPhone, and several stationery and card companies.

JC—**Describe the first moment that you truly felt like an artist.**
AP—The first moment I truly felt like an artist was when I sold my first art prints from my Etsy shop. I was very shocked to wake up on the first morning after opening my shop to find that I had sold six prints!

JC—**Do you have any advice for artists who want to sell their work online?**
AP—My best advice is to be positive and don't give up—it's not easy at the beginning. Try to challenge yourself to come up with fresh and original ideas.

JC—**What do you have in your creative toolbox?**
AP—I like to use lots of different materials when making artwork. I never think too much about what medium to use; I like to grab the first thing I come across. The main materials I use to create my artwork are pencils, colored pencils, pastels, felt-tip pens, and watercolors.

JC—**Which artist's work are you most jealous of, and why?**
AP—I am mostly jealous of the work by Salvador Dalí. I love how surreal and strange his work is. I can look at his art for hours, but can never seem to work out what was going on in his head. I was lucky enough to see some of his original work in an art gallery in Edinburgh.

JC—**Why are you an artist?**
AP—I have always loved to be creative; making art is a great way to express how you feel and to show your imagination.

JC—**If you weren't an illustrator, what would you want to be?**
AP—I would love to be a wildlife photographer. When I'm not illustrating, I love to go out on adventures with my camera—you might even see me chasing butterflies, if you're lucky.

JC—**Do ever have creative blocks? How do you push yourself through?**
AP—Sometimes I get creative blocks—they are very annoying. When I feel like this, I love to go out walking to refresh my mind. I also find that visiting art galleries and museums is very interesting and inspiring.

JC—**Other than those galleries and museums, where do you find inspiration?**
AP—I find most of my inspiration in wildlife and nature. I would love to travel the world to see as many amazing animals and places as possible. I also get a lot of inspiration from myself—many of my characters wear similar clothes to me, most of them wear hats, like to skate, and try to look cool.

JC—**Would you ever throw one of your drawings away?**
AP—No, I don't tend to throw work away. I will work on a piece until I am happy with it. I treat every piece of work like a pet, and I would never throw a pet away.

JC—Do you take criticism personally?

AP—No, because you can't please everyone—people will have art that they like and dislike—the main thing is that you as an artist are happy with your work.

JC—Do you have an inner critic?

AP—Not really. I enjoy making art and am always thinking of new ideas. I don't think about how I can make a piece better, I just want to make *more* art.

JC—When do your best ideas come to you?

AP—Most of my ideas come to me quite randomly—sometimes when I'm drawing, an idea for a completely different piece will pop into my head. I spend a lot of time daydreaming—this can help with ideas. Oh, and right before I fall asleep.

JC—How do you feel when you're in a true "creative zone"?

AP—I don't want the day to end, because I need to be creative forever! Sometimes I forget to eat, then I realize that I must move from my desk—so I make breakfast at two in the afternoon.

Creative *un*Block
Project No. 11

A lot of people ask the question, "If you were any animal, what would you be?"

For my challenge I would like you to illustrate yourself as an animal. For example: are you a chilled-out, lazy sloth?

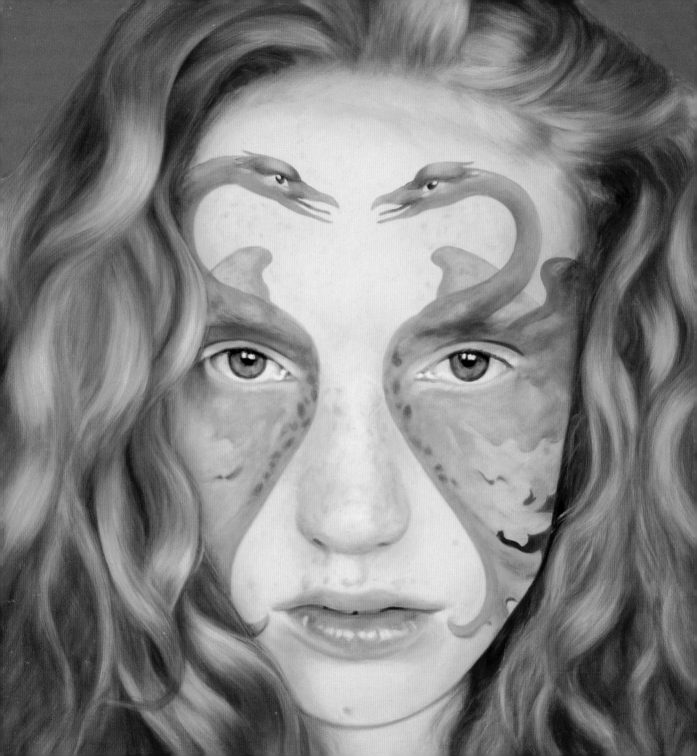

DEIDRE BUT-HUSAIM

PAINTING

AUSTRALIA

BUT-HUSAIM.ID.AU

Deidre But-Husaim is a full-time painter in Adelaide, Australia. Not only are her large-scale realist portraits stunning, but her studio is also amazing. Now converted into a series of art studios, the building in which it is housed used to be an incinerator designed by the famous architect Walter Burley Griffin in the 1930s. Deidre attended Adelaide Central School of Art, where she completed an associate degree in visual art, and Adelaide Centre for the Arts, where she received her bachelor of visual art. She's had several successful solo exhibitions in Melbourne and Sydney, and has many awards under her belt, including the Sulman Prize, Doug Moran Prize, Redlands Art Awards, John Fries Memorial Prize, and the RBS Emerging Artist Award, and she was a finalist for the Archibald Prize—just to name a few.

JC—Which artist(s) do you admire most, and why?
DBH—I love the master painters Rembrandt and Velázquez: Rembrandt for his wonderfully intense portraits that have such a tactile quality to the paint itself, and Velázquez for his economy of mark making, especially in his later works, where every mark appears to be so confidently placed.

JC—Have you ever experienced a creative block?
DBH—No, but I've experienced what could be referred to as creative confusion. Sometimes I have too many ideas at once, and can't decide which is the good one. Not everything we "think" is a good or interesting idea should be made into work.

JC—Do you have a process you turn to when you're having trouble with a painting?
DBH—Yes. I stop and spend at least twenty minutes just looking at my work. It's easy to get caught up in the act of painting and forget to step back and look. I locate my palette approximately three meters away from the actual work so that when I load my brush I have to step back and look at my painting from a distance. I also have a mirror hung on the wall opposite to my easel, allowing me to see the painting in the mirror when I turn to go to my palette. This is helpful, as it gives more viewing distance and a more overall and complete view.

JC—Do you have any qualms about throwing your work away if it's not working?
DBH—No. If a work fails, I have to get rid of it for it to be completely out of my thoughts. If it's truly not working I throw it out, but that's not until I have sliced it up with a box cutter. This resolves the problem extremely efficiently, and prevents a lot of wasted time working on a "problem child." Although it is a bit scary, it's very freeing, and allows you to start fresh.

JC—How do you handle criticism?
DBH—Not very well. I'm human. I think to myself, "What would John Lydon [Johnny Rotten] do?" . . . and then I get back to painting.

JC—You are a very busy full-time artist. Do you have any time for personal projects?
DBH—I don't usually have time for them outside of my exhibiting commitments, but currently I have made time for a body of work consisting of small paintings to raise money and awareness for Acid Survivors Foundation in India. This is an organization that works toward the elimination of acid and other forms of burn violence, and offers support for the survivors of this horrendous crime. You can learn more at AcidSurvivors.org.

JC—That is a wonderful way for you to use your talent! Are those pieces similar to the work you're known for, or are they quite different?
DBH—These pieces are small studies that allow me to "play" and explore ideas that are at times an extension of my ongoing body of work, and at other times completely different subject matter.

JC—Where do you find inspiration?

DBH—In the act of painting. I paint every day, and one painting leads to the next in a natural way. For me it's important to make work that is about now, about the time we live in, and what surrounds us. I think it's extremely important to evolve your practice and challenge yourself conceptually and technically. It would soon become tedious otherwise.

JC—And finally, if you weren't an artist, what would you be?

DBH—A trapeze artist, a sky diver, a martial arts specialist, a wild horse.

I think it's extremely important to evolve your practice and challenge yourself conceptually and technically. It would soon become tedious otherwise.

Creative *un*Block
Project No. 12

You will create a group of small paintings, nine or twelve, all of the same subject matter.

Set up your easel and palette so that there are at least three long strides between them. Once you have started painting, try not to make a mark if you doubt what you are seeing, and don't put marks down if you are confused. When you think you see the shape, color, and tone that you want to transpose onto your canvas, then make that shape with one mark.

Make these marks using a large paintbrush—much larger than you would normally use. This will force you to think more about how to make a mark or shape, and not to just "color in" an area. Use lots of large brushes, one for each color, to prevent muddying your colors. Step back again and look . . . rinse and repeat.

When you can go no further, stop, and move on and start the next fresh new work. Don't overwork it: if in doubt, stop!

This exercise is not about creating perfectly resolved individual works, but enjoying the painting process. You can possibly acquire a new and better method of working and, most importantly, paint your way out of that creative block!

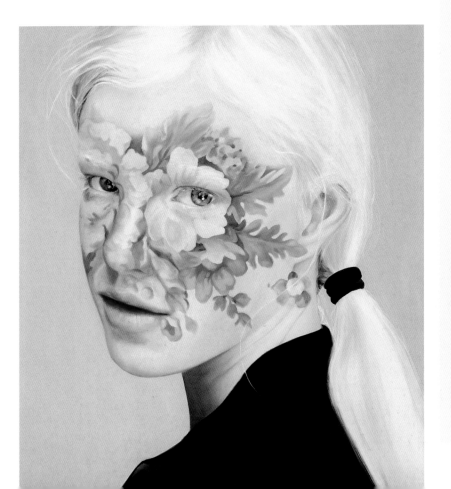

TREY SPEEGLE

MIXED MEDIA

USA

TREYSPEEGLE.COM

American artist Trey Speegle was originally a full-time, self-taught designer who learned the ropes by working for magazines from the age of seventeen. He is now a full-time, self-taught fine artist who uses one of the world's largest collections of vintage paint-by-number paintings as inspiration and raw material. Trey explores themes of hope, love, longing, and transformation using humor, affirmations, double entendre, and wordplay that resonates with a broad, pop appeal.

He has collaborated on projects with Fred Perry, Stella McCartney, and Anthropologie Home. He shows his originals on paper in Jonathan Adler shops across the United States and in London. His work is widely collected, and the Microsoft Art Collection recently acquired his iconic *You Are Here* painting for the lobby of their San Francisco headquarters. He divides his time between New York City's Meatpacking District and his converted barn in the Catskill Mountains—both of which he shares with his Brussels Griffon, Lamonte.

JC—Which artist's work/life/career are you most jealous of (dead or alive)?

TS—Warhol (dead), Koons (alive). *So* many people might say the same about Warhol . . . and Koons too, maybe: not his paintings, but I would like a studio setup like he has . . . with his nearly unlimited resources.

JC—Do you feel comfortable calling yourself an artist?

TS—I *never* called myself an artist until about eight or nine years ago. All of my friends were artists, but I felt I hadn't earned it. When I had a good idea and started making good work (good on my own terms, not anyone else's), then I could call myself an artist and not feel like a fraud.

JC—How did you make the hop from designer to fine artist?

TS—I worked as an art director for years, primarily for magazines. I'd been doing graphic word art for years, and after I inherited my paint-by-number collection, I had this idea to use paint-by-number as a visual vocabulary . . . the work is not *about* them, but I use them as raw material and transform them and, in the process, myself. Once I had this realization (I literally had a vision of twenty-five years' worth of ideas in front of me), I couldn't let it go. After having a certain level of accomplishment in the world, I realized that my ideas were just as good as other people's, and I should put my energy into my *own* work.

JC—Where did your amazing paint-by-number collection come from?

TS—I was given two hundred of them from my friend, the original head writer of *SNL*, Michael O'Donoghue, in '94. I've grown the collection to somewhere in the neighborhood of three thousand . . . kinda lost count, honestly.

JC—Are creative blocks ever a problem for you?

TS—I don't get blocked so much because I'm constantly creating new work in my head and also in digital mock-ups. But I did a workshop (which I'm not supposed to describe, but . . .) called How to Make Better Mistakes, conducted by artist and illustrator Laurie Rosenwald. It involves drawing without much time to think, and somehow the exercise unlocks and unblocks idea in a way that is hard to describe. A whole body of work *poured* out right after finishing the workshop.

JC—Where do you find inspiration?

TS—I find inspiration in living life, appreciating and paying attention to what I like and why. I can be inspired by a vintage paint-by-number, or a phrase someone says that triggers an idea. I can get inspired by looking at masses of artwork, not by the work but by the overarching ideas (or lack thereof) and the presentation. I never want to copy another's ideas, but the way it's framed or installed can give me an idea about my own work—very often the artwork itself has very little or *nothing* to do with my own work.

JC—What are your methods for working? Do you have any advice about process?

TS—Over time, I've developed different methods. Some work, take my word pieces, are very controlled and have endless variations (I choose the word or words, a font, and then an

image). I have the entire English language, and then *thousands* of vintage paint-by-number paintings. Just those variables are enough to keep me busy. Ultimately, you have to set up the narrow parameters that you work in, and then within those, give yourself just enough room to be free and play.

JC—Do you ever equate your self-worth with your artistic successes?

TS—When I worked at *Vogue* and *Vanity Fair* early in my career, I saw that people were impressed that a twenty-one-year-old had that kind of job. And part of me didn't like that, because I was basking in the reflected glow, so to speak. So I never stayed anywhere very long because I didn't want to be *too* associated with my employer, or any one job. It's the opposite when it's your own work. You *are* the work and vice versa—so if I toiled for twenty-five years without any recognition, I might feel worthless—but I just do what's in front of me and I don't take any perceived success *too* seriously. It's always on to the next thing.

JC—How do you feel about criticism?

TS—I'm OK with it, if people "get" where I'm coming from—but so often it's a knee-jerk reaction without knowing much. "Kitsch" is a word that is often applied to my work. I can see where that comes from, but I think they are stopping at the surface. I'm a bit like the girl with big boobs who likes to get noticed, but then is, like, "Hey, my eyes are up here!"

You have to set up the narrow parameters that you work in, and then within those, give yourself just enough room to be free and play.

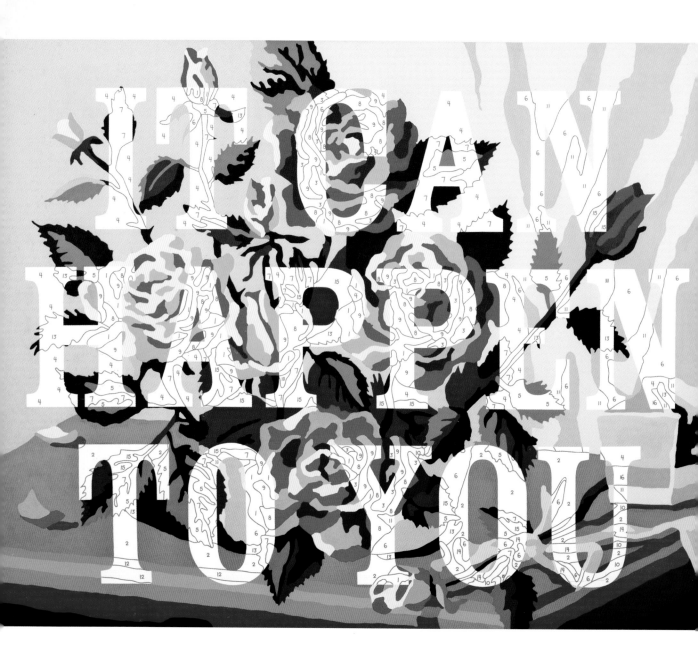

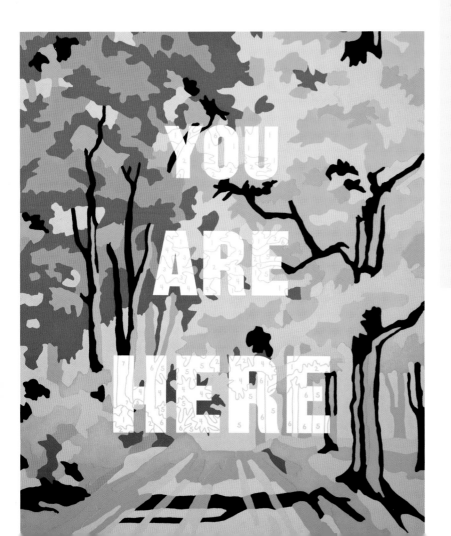

Creative *un*Block
Project No. 13

A Season for No Reason

Make a drawing in black and white and then photocopy the drawing fifty times on card-stock (or enough copies so that you won't "worry" about how many you've used).

Then "alter" the image in as many different ways as you can think of with colored pencils, paint, whatever. You can modify this idea and change it in whatever way you like, but the important thing is to turn off your brain and just play with a repeated form and let your mind see where no ideas or thought processes takes you.

Create your own tight parameters . . . then give yourself a *lot* of room to play. Have fun.

KRISTI MALAKOFF

PAPER-CUTTING/INSTALLATION

CANADA

KRISTIMALAKOFF.COM

Seeing the work of Canadian artist Kristi Malakoff in person is breathtaking. She creates large-scale installations that you have to see up close to truly believe that they are made entirely from cut paper. Kristi graduated with a BFA from the Emily Carr Institute in Vancouver, British Columbia, and also did a term at the Chelsea College of Art and Design in London. She has traveled extensively, and has been part of some amazing artist residencies in Berlin, Moscow, Reykjavík, Banff, and London. Kristi has exhibited all over the world, and her stunning work is held in private and corporate collections across Canada and the United States.

JC—Describe the first moment that you truly felt like an artist.

KM—I was thirty. It was the final year of my visual arts degree. It wasn't one moment in particular, but just a gradual understanding that this was exactly what I wanted to do, exactly what I wanted to be, and that I was going to go for this. People were receptive to what I was doing, and things started rolling along of their own accord. It seemed to be confirmation that I had made the right choice. After I graduated, I made a conscious decision not to get a paying job and to devote my life to art, which I did and continue to do years later.

JC—What is it that you love about working with paper?

KM—I love working with any and all mediums—especially everyday household materials like breakfast cereal, stamps, money, packaging, tape, etc., but yes, in the last few years, I've been working a lot with ordinary paper in a sculptural context. It's a big challenge for me, and goes against the grain of what paper is traditionally used for. Everyday paper pretends to be benign and neutral, but it's actually pretty feisty, and has infinite potential for doing amazingly bold and large-scale sculptural work.

JC—Describe what life is like as a full-time artist.

KM—Being an artist is one of the most difficult professions I can imagine on all levels; it can be grueling, isolating, and devastating. But being an artist can also be unbelievably satisfying, soul enriching, and can take you to places, real and metaphorical, that you never imagined for yourself.

JC—Where do you find inspiration?

KM—There is no end to the places where inspiration can be found: rituals, traditions, signage, theory, materials, architecture, music, sound, design, cakes, shoes, insects, the sky, Russia, miniature dolls . . .

JC—Your work is very elaborate—have you ever thrown your work away mid-process?

KM—I've never thrown a piece away before. Ever! I think it is really important psychologically to work through problems, and to find solutions. That said, I never start a piece until I have thought through every potential pitfall and am quite sure that it will work and be successful. My work is very labor intensive; I don't have the luxury of spare time or money or the luxury of being able to make a mistake—every piece I make must be show ready.

JC—Do you ever equate your self-worth with your artistic successes?

KM—Sure, it's hard not to equate my self-worth with my artistic successes (and failures)—and by successes, I mean in my own eyes and in the eyes of my peers who know me and whose opinions I respect. I put everything I have into my work—everything of me, and it is extremely disappointing, devastating even, to feel like I have not done my best, or that I have missed the mark somehow. It's an awful feeling. I don't know how to get past that—maybe it comes with time? With loving, and being patient with oneself more?

JC—How do you handle negative criticism?

KM—I can't take criticism too much to heart or that would just paralyze me and end everything. I am just a small human trying my best, spending my own money and time, and at

least I had the balls to put myself out there in the first place.

JC—Do you ever hear your inner critic?

KM—There will be one point in every project where I decide that my idea is absolutely stupid. It is incredibly difficult during this time to continue to pour money into the project and to get up every day to invest an obscene amount of time into it. But I do it every time, and I haven't regretted a project yet. It's just pure will power that gets me through these moments.

JC—Have you experienced a creative block?

KM—Actually, I can't remember ever having a creative block. Sometimes it takes longer than average to think of an idea, but the idea always comes. If I don't feel like being patient, I have a stack of sketchbooks where I've written down ideas for rainy days. And if all else fails, I have millions of small-material or conceptual experiments that I want to try. The important thing is to just keep moving.

JC—Your work is mainly elaborate, large-scale installation. How you feel when you finally see the finished piece?

KM—I install my work and see it for the first time only in the days before the exhibition opens. A lot of my work is made up of thousands of smaller pieces and repetitive modules, so in the months while I'm making it I am battling exhaustion and tedium. It is only during the installation period that I get to see what I've been working on all those months. And when I finally see the piece— wow! It's an incredible feeling! It is the most satisfying, rewarding, and euphoric experience that I can imagine. It feels like a miracle.

There will be one point in every project where I decide that my idea is absolutely stupid. . . . It's just pure will power that gets me through these moments.

Everyday paper pretends to be benign and neutral, but it's actually pretty feisty.

Creative *un*Block
Project No. 14

Find an interesting piece of writing—a novel,
a poem, fiction or nonfiction, etc. Re-create
in miniature and in three dimensions either
one of the settings or one of the objects
described in the writing. Construct it using as
many details as possible from the text itself.

SIDNEY PINK

ILLUSTRATION

USA

SIDNEYPINK.COM

Sidney Pink is an American artist who creates small, beautifully bizarre drawings. He has a BFA from the Maryland Institute College of Art, and now lives and works in Baltimore. However, it's not a surprise to discover that Sidney lived in Japan for several years—clearly, his pencil and watercolor drawings are inspired by his time there! He has exhibited in New York, Baltimore, Barcelona, Berlin, and Tokyo, and his work has been featured in various publications including *Fine Line*, Japan's *Artcollector*, and the *New York Times Magazine*.

JC—**Describe the first moment that you truly felt like an artist.**

SP—I remember creating plays based on the *Mr. Men* and *Little Miss* books when I was about eight. Do you remember those books? I would play all the characters by throwing on different wigs and hats. In high school and college I felt like I was pretending to be, or playing at being, an artist. The truth is I don't think I ever felt like "I made it." Once you realize "making it" is a fantasy, then one has to get to the hard work of becoming the person they really want to be. In that way, I guess I've always been an artist, I just didn't know it.

JC—**Which artist's work are you most jealous of, and why?**

SP—I'm most jealous of Tohl Narita, one of the lead artists on the original *Ultraman* television series. His drawings for the costume designs are these wonderful ink-and-watercolor works on paper. He was great at playing with texture, color, and proportion. Plus his technique was just so strong. I wish I could think of creatures like that.

JC—**Do you ever experience creative blocks?**

SP—Yes—all the time. I think for most artists, at least those who are being honest, you start to realize it's just a normal part of the process. When we are in school we have the luxury of assignments, which keep us producing and moving forward. It took me years after college before I could really discipline myself to work on a regular basis. It's still something I struggle with.

JC—**So, now that there are no teachers around, do you ever give *yourself* assignments when you're in need of a little discipline?**

SP—Yes. Setting up limitations, structures, and deadlines can really stimulate creative thinking. It's also a great way to break ruts and old habits. Being an artist is about pushing boundaries and trying new things.

JC—**Do you have any little tricks you dig out if you're having trouble with a specific drawing?**

SP—I have a drawer of reference photos and materials. I'll pull a handful out, and start mixing and matching. I always find some combination that gets my mind racing.

JC—**Where do find the images that you have stashed in that drawer?**

SP—I use myself as a model for reference photos. Many of the characters in my images are basically self-portraits, including the salarymen, schoolgirls, and spacemen. I guess all of my figures are a kind of self-portrait in a way.

JC—**How do you feel about throwing work away?**

SP—Part of growing as an artist, and maintaining one's career, is creating crappy work—I mean a lot of crappy work. It's very common for my drawings to end up at the bottom of the drawer, or sometimes in the trash. I was very precious with my art when I was in school, but one advantage of selling work is that you can't covet old work; it's always time for the next image or project. When I'm not selling much I try to focus on keeping my output up.

JC—Do you ever equate your self-worth with your artistic successes?

SP—I do that all the time. I think, I hope, it's something everyone deals with. I've gone through many failed attempts at "Once I get that, or once I do that then I'll be happy. Then I'll be content, and I can really do my best work." But with every success (or failure, of which there are many), I'm always left back at the same place, which is to make more work and to make better work.

JC—What does your inner critic say to you?

SP—My little voice is always telling me what's wrong with my work. The trick is to ask yourself, "Does this image excite me?" You're never going to please everyone, but if you're passionate about your work then someone else will be too. As soon as I start creating something because "this is what the market wants" or "this is what sold before" I get bored, and the quality of my ideas plummets.

JC—How do you feel when you're in a "creative zone"?

SP—For me it's like meditating or running. My inner critic turns off and I'm not worried about my work selling or people liking it. It becomes all about the process and living in the moment. I'm still making choices and focusing on quality, but I'm not thinking about the result of my work. The biggest problem with "the zone" is the light of day. What might have felt like divine inspiration in the heat of the moment can come crashing down to earth the next day. That's when you sharpen your pencil, open the tube of paint, or boot up the computer and get back to work.

JC—Is there a trick to becoming a successful artist?

SP—The idea of divine inspiration and an aha moment is largely a fantasy. Anything of value comes from hard work and unwavering dedication. If you want to be a good artist you need to look at other artists, make a lot of crappy art, and just keep working.

Being an artist is about pushing boundaries and trying new things.

Creative *un*Block
Project No. 15

Creativity thrives when we are given restrictions. Ask someone to write a story about anything and they'll wallow in indecision. Ask them to write one page about their first pet in less than three minutes, and the story will start to flow. Create an original image in less than thirty minutes based on one of the metaphors below, one from Shakespeare's *As You Like It*, and one attributed to Groucho Marx. Don't worry about the outcome, just get it done.

"All the world's a stage, and all the men and women merely players. They have their exits and their entrances."

"A hospital bed is a parked taxi with the meter running."

Go.

EMILY BARLETTA

EMBROIDERY/FIBER ARTS
USA
EMILYBARLETTA.COM

It's like a biology textbook and a ball of yarn fell madly in love, got married, and had a few babies. New York-based artist Emily Barletta is the very talented matchmaker who got these crazy kids together, and the reason is that as a youth, Emily was diagnosed with a spinal disease that altered her life, but ultimately led her to art. (In fact, most of her crochet hangings and objects are meant to represent diseased cells!) In 2003 she received her BFA from the Maryland Institute College of Art, and now creates work that beautifully blurs the line between science and art, not to mention art and craft. Crochet, clay, beadwork, and embroidery on paper. Absolutely gorgeous.

JC—Clearly it doesn't define you, but could you talk about your illness, and how it has impacted your life, and art career?

EB—When I was twelve years old I started to grow a hunchback and was diagnosed with Scheuermann's disease. I had a severe case that required having reconstructive spinal surgery when I was fifteen, and two other surgeries after that. I was in a great deal of physical pain throughout my teenage years. There is a certain amount of emotional isolation that goes along with having a deformity and living in constant physical pain. However, having Scheuermann's disease is the thing that brought me to art. When I was a young teenager, and my body was out of my control, making art became a way for me to express the emotional and physical trauma I was experiencing. As I developed into an adult artist, making art became the way that I processed and expressed all of my feelings, not just the ones about physical pain. It's the filter through which I see and record all of my life. But when I was young it was therapeutic, and it saved me.

JC—Incredible. Was it during those teen years that you started to feel like an artist?

EB—Yes. When I was sixteen or seventeen I had a goofy, unrealistic idea of myself as an artist. I wanted to go to art school and learn to illustrate children's books. This was a very short-lived dream. During art school I thought I would work at a bookstore and draw privately in my sketchbooks forever. About a year or so after I graduated, thanks to some positive encouragement, I realized that the objects I was creating privately could be art.

JC—Where do you find inspiration?

EB—I enjoy learning and reading. When I work I listen to audio books and a great deal of podcasts. I like going to museums to see art, but the American Museum of Natural History, New York Aquarium, and the Brooklyn Botanical Gardens are among my favorites. I like going out into nature, especially near water of any kind. In the city I like to take long walks, and just look.

JC—Which artist's work are you most jealous of, and why?

EB—Louise Bourgeois. Her work makes me feel so much, and I strive to create work that could hopefully have a moving emotional experience for the viewer.

JC—Would you throw a piece away if it's not working, or would you just keep going until you're happy with it?

EB—I'm a huge fan of throwing things away, or taking them apart. At art school there wasn't enough emphasis on the idea that it was OK to make bad art. In my own practice I had to learn that I don't like everything I make. Not every beginning is going to be a finished work. Now I'm good at realizing when it's not what I want, accepting it, and just chucking it to begin again.

JC—But your work is so meticulous! What do you do if you're quite far along with a piece, and you "make a mistake"?

EB—The embroidery on the paper can be more forgiving. I have been known to spend forty hours embroidering something only to rip out all the stitches and start over again, working with the holes already in the paper. I tend not to view specific stitches as mistakes; I think they add a bit of personality to the work. For me it's sort of all or nothing that way: I'm usually satisfied with the overall look—or not at all.

JC—Do you ever equate your self-worth with your artistic successes?

EB—It's impossible not to feel a bit of an ego boost when success comes. Then after a show, when everything has slowed down again, it's hard not to feel a bit lower. When I'm in the studio, working, I tell myself that everything I make will have a home or a purpose someday. Then when I'm done making it, I just pack it up and put it in the closet. I make art because the process of making art makes me happy. Being successful with it and doing it for personal fulfillment are separate ideas.

JC—Do you ever hear your inner critic?

EB—My inner critic is judgmental and opinionated. On John Cage's "Some Rules for Students and Teachers," number eight is "Don't try to create and analyze at the same time. They're different processes." I struggle with this a great deal, and try to remember this rule and stick to it.

JC—Have you experienced creative blocks?

EB—Yes, some have lasted for months or even a year, which was painful!

JC—How do you push yourself through something like that?

EB—I look for inspiration outside myself. I push myself to keep making things, even when I'm aware that the thing I am making is going to end up in the trash. Sometimes I stare at the wall, but I find it's more helpful to just keep drawing and sewing and moving my hands and hoping for a breakthrough: eventually one comes—usually. I think they pass on their own, and it's just a matter of time.

Not every beginning is going to be a finished work.

I make art because the process of making art makes me happy.

**Creative *un*Block
Project No. 16**

Find that piece of clothing you've been holding onto for sentimental reasons, but you don't wear any more. Cut it into two pieces that are the same shape (any shape you want), sew them together, and stuff it like a pillow. Now you can do anything you want to create a fetish object that memorializes why you've held on to this fabric for so long—paint on it, wrap it in yarn, embroider on it, sew things onto it. Cover the entire surface, or work with the existing pattern and leave some of the surface visible.

I
TOOK A.
DEEP BREATH
AND LET IT
GO.

JEN GOTCH

PHOTOGRAPHY

USA

JENGOTCH.COM

Jen Gotch is a self-taught photographer based in Los Angeles, California. Her work is beautiful, warm, and oh so dreamy. Her series *Defaced* introduces text and scribbles on top of Polaroids. Not only are they gorgeous, but they manage to stir up emotions and memories almost immediately. Some of them are clever, some of them are introspective, and others are laugh-out-loud funny! Jen claims that she "is not an artist," that she simply "takes pretty pictures." Perhaps that's because her daily focus is as the creative director and cofounder of ban.dō—a hugely successful online accessories company that creates cheerful, modern sparkly accessories for women around the world. Not an artist? Hmm.

JC—**What's your favorite camera to work with?**

JG—Polaroid. Most of my work was shot using a 680 SLR with 600 film. Those days are kind of gone, which is terribly sad. And I'm not sure if I am happy or sad to say that my iPhone has quickly become my medium of choice.

JC—**Which artist's work/life/career are you most jealous of, and why?**

JG—I know this probably doesn't fit with the theme, but I have always prided myself on not getting jealous . . . ever. That being said, I was highly influenced by the work of Uta Barth and Laura Letinsky. Also, I wouldn't have minded having the career of Slim Aarons, because his photo life seemed really swell.

JC—**Where do you find inspiration?**

JG—Everywhere. Outside, inside, in my experiences, oh, and on Pinterest.

JC—**Do you consider yourself an artist?**

JG—I'm not an artist. I've never felt like one and I have always, *always* admired people with that true artist spirit. I just happen to be really good at taking pretty pictures. I consider it a skill, not really an art form. I don't mean this to be self-deprecating; it's just what I know to be true. Also, I'd be flattered if people disagree, but I'm also quite stubborn, so you probably won't get me to change my mind.

JC—**Why are you an artist, or perhaps I should ask, why do you take photographs?**

JG—Yes, well, after my last answer, this one *is* a bit hard to answer. That being said, I take pictures because I find it's the best way for me to communicate (that coming from an English major). I feel like I have an interesting viewpoint, and I really enjoy sharing it with others.

JC—**What would you be if you weren't a creative director/photographer?**

JG—Being the creative director and cofounder of ban.dō takes up most of my time. Now if I were able to develop a new set of skills . . . definitely a chef, or a jazz singer.

JC—**Do you ever shoot any of the photography for ban.dō? If so, do those shoots influence your personal work, and vice versa?**

JG—I do shoot the product shots for ban.dō and I also creative-direct all of the fashion shoots. I would say that my personal work has always influenced ban.dō. I'm always trying to take a slightly unconventional viewpoint on commercial photography. Getting to work with other photographers like Max Wanger inspires my personal work too. It is always interesting to see how someone else goes about their process.

JC—**Do you experience creative blocks? How do you push through them?**

JG—I think any artist would be lying if they said that they never had creative blocks. I have found that mine usually come when I am overtired, or sad. So, I try to avoid both of those feelings, and that has worked out quite well! Also, when these blocks do happen, I just give myself a break. I don't try to force it or add too much pressure on myself . . . that never, *ever* works.

I think any artist would be lying if they said that they never had creative blocks.

I'm not sure if I am happy or sad to say that my iPhone has quickly become my medium of choice.

**Creative *un*Block
Project No. 17**

Take a trip to a local swap meet or antique store, and rummage through a box of old photographs. Find five of your favorites and then write a short story (just a paragraph) about each photo. Don't be afraid to be funny or fantastical.

CHLOÉ FLEURY

PAPER-CUTTING

FRANCE/USA

CHLOEFLEURY.COM

Known for her very unique paper-cutting illustration style, Chloé Fleury is a French artist/illustrator who is now based in the United States. She studied visual communication at École de Communication Visuelle (ECV) in Aix-en-Provence, France, but as for her paper art, she is completely self-taught. Her education began during childhood. She made boxes, origami, and tiny folded worlds entirely out of colored paper. It's not surprising given her family, though. She looked on as her very precise, scientific father crafted models of boats and cars (perhaps that's where she gets her extreme patience for the detailed work she creates). Chloé's mother and grandmother loved the arts, décor, and fashion, always taking special care to help Chloé with her art projects for school, and her grandfather owned an art gallery. They spent hours together, visiting the museums of France—a very special education, indeed.

JC—Why are you an artist?

CF—Since I was a child, I have felt a need to create. I've been making things for as long as I can remember! I've always been a collector of nice images, ribbons . . . a space arranger, a dreamer. I've always been curious and really attracted to textures, papers, fabrics, colors, and nice clothes, cool packaging, and book covers. I see things that make me want to create all the time.

JC—Where do find those things that make you want to create?

CF—Everywhere! Nature, food, magazines . . . music inspires me a lot. I love going to shows and festivals. Fashion, window shopping, and visual merchandising. People, my lovely friends, and travels, definitely. I'd love to see South America, Japan, and India. The cities I've been living in (Paris, Montreal, San Francisco) have had a strong effect on my work, and I just can't wait to see how it is going to evolve in the future!

JC—Did you feel any self-doubt at the beginning of your illustration career?

CF—There's a moment when you leave school to start your career and you say, "OK, so I have a diploma in art, but will I ever be really an illustrator?" This moment lasted a couple of years for me. I was still in France, and I sent my portfolio to book publishers, magazines . . . and I didn't receive any answers. It was really hard. I was working as a graphic designer, but every day I couldn't wait to leave—I just wanted to keep working on my own projects so that I could improve, discover my own style, and at some point find success.

JC—When did you start to find that success? When did you feel like this was really happening?

CF—It was a few years ago when a well-known design blog wrote about my work. I started to receive e-mails from people all over the world to compliment my work, and tell me how I inspired them. That was very encouraging and touching! Then my first exhibition followed, as well as my first client. People were asking for "my style." I have a stylist friend who told me, "I love how easy it is to tell it is your work!"—that felt really good!

JC—Which artist's work/life/career are you most jealous of, and why?

CF—This is probably my love for fashion, but I've been jealous of the illustrators using embroidery. I'm obsessed with it. So I love Kat Macleod, Caroline Hwang, Megan Whitmarsh, Lorena Marañón, and Maricor/Maricar. When I was at school, I used to experiment a lot with fabric and thread, then after graduating I found myself working with paper . . . only paper. I'd really like to introduce embroidery into my work in the future—find a way to mix it with paper.

JC—Does criticism affect you?

CF—It depends on how it is formulated. Criticism can hurt my feelings sometimes, but it also helps improve my work. You spend so many hours on a piece that sometimes it's good to step back and have other people give feedback.

JC—Do you ever hear your inner critic?

CF—All the time! It's horrible, but that's what makes my work evolve too. You have to criticize and challenge yourself.

JC—Do you ever have creative blocks?

CF—Of course, yes, it's really hard to deal with. When this happens, I ask myself so many questions, and it's impossible to produce anything. The less I do, the more I have time to doubt my work and the purpose of my career. I hate those days! But they are also good because I can step back from my work, and return with fresh ideas!

JC—Would you ever force yourself to finish a piece?

CF—It really depends on my mood. Some days, I force myself to keep working on it until I'm happy. There are other days when I feel like if it doesn't look good from the start, it will never look good. So I just throw it away and go watch TV shows, eat chocolate, and hope that tomorrow will be a better day!

JC—And finally, do you have any advice for an artist who is considering making a move to the United States?

CF—The advice I would give is to really believe in it, and if you want something it will happen. I made it happen by coming for three months as a tourist, which gave me time to decide that I wanted to live in San Francisco. I worked hard to find an internship, and then got hired. You just have to be super motivated and patient because there's a lot of paperwork, and it costs a lot of money too—but it's worth it! It really is the American dream!

**Creative *un*Block
Project No. 18**

Create your self-portrait by folding one piece of paper (8½" × 11"). Pick the solid color of your choice. No scissors, no glue, no crayon. Just fold!

Since I was a child, I have felt a need to create.

AMANDA HAPPÉ

PAINTING

CANADA

HAPPE.CA

Toronto-based artist Amanda Happé is a multidisciplinary designer by day, which explains a lot about her amazing paintings. Beautifully composed neon rainbows, bold text, birds, and boxes that she has painted with perfect precision onto wood panels. She is very involved in both the art and design communities in Toronto. As a designer, she works with students from Ontario College of Art and Design (OCAD), bringing them into the studio to experience new methods, practices, and ideas. She has also given guest lectures, written articles, and every day she works with fabulous clients—like the Indianapolis Museum of Art! As an artist, she has a studio at The DepARTment in downtown Toronto, and her work has been exhibited in several spaces including Lennox Contemporary, Gallery DK, the Gladstone Hotel, the Arts & Letters Club of Toronto, and Nuit Blanche. Multidisciplinary, indeed.

JC—You have a career in design, but were you formally trained in fine art?

AH—Yes, I majored in printmaking and painting—it was an intensive and small studio program at Queen's University in Ontario. I wish I'd made more of my time there. I didn't grasp the luxury and freedom of being responsible only for making good art for four years.

JC—When did you start to feel like an artist?

AH—I think I first felt the truth of being an artist while I was moving to Toronto when university was over. I was twenty-three. I had no job prospects, was moving in with strangers, had about one month's rent, knew next to no one in the city, and had no idea how to do this. I felt a whole new fear. I also felt there was no alternative but to keep moving. That state sums up the whole artist deal for me—trucking on through the fearfully uncertain with your stash of unwarranted conviction.

JC—Which artist are you most jealous of (in a good way of course), and why?

AH—David Shrigley. His humor is like a laser. Before you even realize what's happening, he has sliced open some terribly petty and universal and tragic and joyful human vulnerability. A single scribble can level you. It's devastating comedy in the most unassuming form. I envy that wit and most unadorned execution.

For years, I didn't entirely get it. Then I saw his drawing *Mushrooms*, and it flipped the switch. Maybe start there if you're unfamiliar with his work.

JC—Do you ever hit creative roadblocks?

AH—I think I might get creative blocks all the time, but I haven't thought of them that way. I frequently have nothing interesting to say. Those strike me as great times to keep creatively quiet. I think we're too hard on ourselves if we expect an uninterrupted procession of meaningful creation. Let it be. But lay in wait. Keep your ears perked and your soul soft for that new impulse, and save the guilt for when you really blow it in life.

JC—All right, so now I have to ask—have *you* ever really blown it in life?

AH—Yes. A short while ago, I really did. Part of the fallout was my sense of creative direction being busted apart. I had started a large painting and I couldn't continue it. The scale and even the medium seemed too absolute and too confident for my new husk of a self. Eventually I got it together enough to make art that a husk could handle. I got some markers and watercolor paper that I cut up postcard size, and started making things that didn't matter. They were numerous and small and private and un-precious and immediate—and ended up feeling more true and important than anything I'd been doing.

I had never worked that way before and it was an unexpected lesson about liberation. I was free to be as honest as I could because I wasn't thinking about how the work would exist when I was done. It became about the act, not the outcome.

JC—So then, would you feel comfortable tossing a painting if you weren't happy with it?

AH—No need for hypotheticals here . . . I find myself knee deep in some real duds. My approach is to keep going, but it frequently isn't "until I'm happy with it." It's more "until I'm really sure I've authored the most horrible thing eyes have ever suffered." I should probably abandon ship earlier or more often, but if you're already taking on water you might as well try some of that risky stuff while the whole thing sinks.

JC—Do you ever equate your self-worth with your artistic successes?

AH—Oh, boy. I find it almost impossible not to judge myself on how well I do at the things that I really care about, but I think that's probably OK if you've got the right definition of success. If your self-worth is tied to success that depends on validation from others, you're out of control. If you work to feel worthy by making things that you believe in, you can wield your desire to succeed as a constructive force.

JC—How do you handle criticism?

AH—Fisticuffs! No . . . direct criticism hasn't yet come my way. I suppose it takes the more passive and eroding forms of rejection and indifference—which I don't find too difficult to walk away from (there's that stash of unwarranted conviction again). It's one of the most beautiful things about doing this—you don't have to care. No one gets to have their say and have it stick. No one can wrestle the pencil out of your hand. You get to keep going in absolute defiance.

GOOD DEEDS DONE RIGHT

It's one of the most beautiful things about doing this—you don't have to care....No one can wrestle the pencil out of your hand. You get to keep going in absolute defiance.

**Creative *unBlock*
Project No. 19**

I challenge you to make something and leave it somewhere public—somewhere it might be found. Something not too grand or careful, but honest and perhaps lovely. When you're creating it, think about one person happening upon it. Make them a message. If you enjoy this feeling of caring about something without feeling precious about it, do it again.

JUSTIN RICHEL

ILLUSTRATION

USA

JUSTINRICHEL.COM

Justin Richel was raised in an artistic family, where his creativity was encouraged and allowed to flourish. He received a BFA from Maine College of Art (MECA) in 2002, and in 2004 he briefly studied the technique of icon painting with two Franciscan monks from Lithuania. Quite the education! He is now a full-time illustrator/painter based in Rangeley, Maine (and happens to be married to paper-artist Shannon Rankin, who is also featured in this book). Justin has sold and exhibited his work all over the world.

JC—Most of your paintings are beautifully complex compositions of stacked objects. Why?

JR—The stacks and columns are about perfection, balance, fragility, and the impossible. I began thinking of them as a parallel to the Greek Corinthian columns from which Western society has gleaned its visual, moral, and political aesthetic. They also allude to other traditions of this form, such as the totem pole.

JC—Your chairs, and birds, and furniture—do they come from your imagination, or do you source images to use as inspiration?

JR—The imagery starts in my head, and I then look for source imagery to build the image from a thought to a sketch. I use source imagery because I want the work to have a strange sense of the familiar; I also don't trust the direct expression of my hand. By that I mean it is too direct when I work from thought to hand: I am looking for that distance. I like to allow the found imagery to shape the outcome.

JC—Which artists have influenced your work? In other words, who makes you "jealous"?

JR—There are so many artists whose life and career have shaped my own. I am so bad at making decisions, so here are my top six. I'll start with who makes me the most jealous, and work down:

1-2. Andy Warhol or Hokusai—not sure which is first.

3. Joseph Beuys, because he created a mythology and was transformed (like a shaman) through the process of art-making.

4. Marcel Duchamp, because in his later years he gave up making art to play chess.

5. Brancusi, for his pursuit of form and physical harmony inherent in the material itself.

6. The artist who placed the first paintings on the cave walls in El Castillo, Spain, some forty thousand years ago.

JC—Considering how detailed your paintings are, would you ever throw one out if you weren't happy with it?

JR—There was a time when I would make a single mistake and throw an entire painting away. It's taken me a long time, but I have finally embraced my mistakes as learning experiences. I now take the "failed paintings" and cannibalize them: cut them up into collage material and recycle them back into my work. I realize how much time goes into a single work, and to throw it away now just seems ridiculous.

JC—Do you feel pressure, as a full-time artist, to be creative all of the time?

JR—The daily requirement to be creative can be difficult to manage. I have several series that I work on and this can be helpful to switch back and forth between series to keep myself interested and engaged. However, I find that I am always craving some form of creative outlet, yet creating art doesn't always fulfill that need. Thankfully, I have a garden to put my energy into. Gardening is a creative act, yet a different experience than art-making. It's a kind of collaboration with nature, where the gardener and nature can meet each other halfway.

JC—Is your inner critic allowed into your studio?

JR—My inner critic used to have a prominent and cushy seat in my frontal lobe; however, he has since been demoted to a consultation status only. My inner critic has no place in my studio while I'm working. I'll bring him in on the conversation once I have something to show him. I like my inner critic—he has his time and place, however, just not while I'm in a creative state of mind.

JC—What is your best advice for getting past a creative block?

JR—I like to call it "pushing through the pain." I need to finish one piece in order to know what's next. So even if things are going poorly I continue to work. Finding out what I don't like is just as important to discovering what works.

Also, it seems obvious enough, but it helps to keep your space clean. When I begin to notice my judgment cloud, or my productivity slow, it's typically because I need to clean up my space. After a good burst of productivity my work surface is covered in debris. This is important for productivity, but I don't want those things creeping into my periphery and influencing my decisions on new work.

And if all else fails, having a deadline can motivate like nothing else! It's that "all or nothing" feeling that can inspire you to pull it together. If you don't have a gallery exhibition or illustration deadline, ask a friend to give you an assignment. This will help get past the inner block that you have placed on yourself.

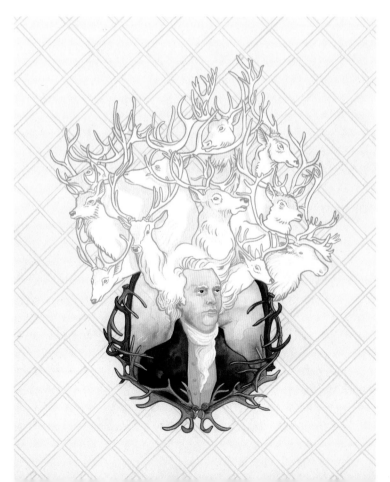

My inner critic has no place in my studio while I'm working. I'll bring him in on the conversation once I have something to show him.

Creative *un*Block
Project No. 20

Take a couple large pieces of paper and cut them down into smaller parts between 5" × 5" and 10" × 10" (12 cm × 12 cm and 25 cm × 25 cm). You should have somewhere between twenty-five and fifty small pieces of paper.

Without spending too much time on content, begin making marks or drawing loosely with your preferred medium on the paper. As you complete the marks, you may need to set them aside to dry; simply move to the next piece of paper and repeat until you have moved through the entire stack.

Once you have moved through the entire stack, sort the pieces into three different piles. Ones that *work*, ones that *don't work*, and ones that *need work*.

In no particular order, finish the ones that work by adding the final touches. Work on the ones that need work and continue by making the ones that don't work, work, by discovering what went wrong and how it can be "saved" if possible.

Continue to work on the pieces until all or most are finished. You should now have a pile of fun starts, finished pieces, and some failures to learn from.

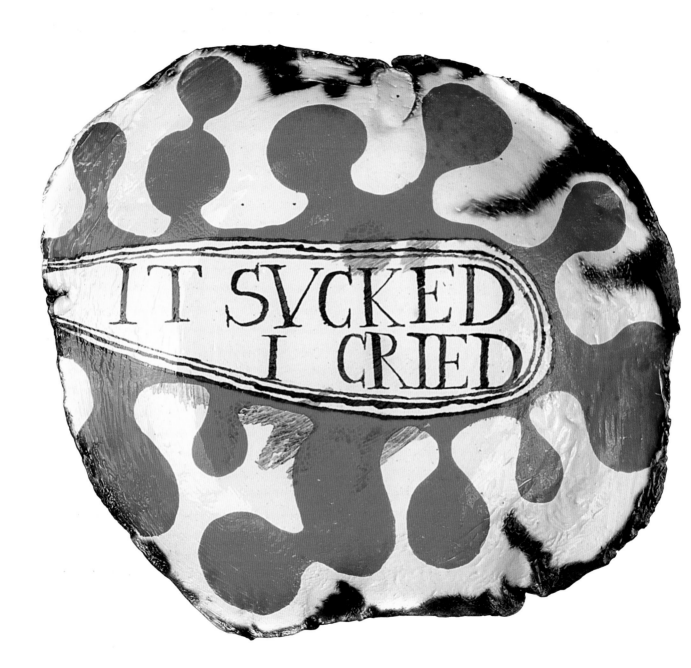

RUAN HOFFMANN

CERAMICS

SOUTH AFRICA

RUANHOFFMANN.COM

Ruan Hoffmann studied at the University of Pretoria, South Africa, and graduated in 1990. Even though he works in several other mediums, he has become very well known for his unique, and edgy, ceramic work. Type, photography, metallics—Ruan has an amazing way of transforming a rough chunk of clay into a stunning piece of art. He is a full-time artist who has exhibited his work all over the world—from Belgium to the Netherlands, New York to London, and, of course, in his home country of South Africa.

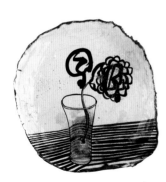

JC—Have you always felt like you were an artist?

RH—It was a feeling I was aware of very early in my life. Of course I didn't know this was, but it was always there.

JC—Why are you an artist?

RH—This is the only way for me, really.

JC—And if you weren't an artist?

RH—I'd be a criminal.

JC—Which artist's work/life/career are you most jealous of, and why?

RH—I'm not jealous of any, but there are many whose work I admire.

JC—Could you give us a short list of those artists that you admire?

RH—Well, I don't have a "short" list, but I do have a really long list! Different artists' work appeals and opens up to you at different times in your life. Here goes, in no order of preference: Edward Burra, Pablo Picasso, Francis Bacon, Louise Bourgeois, Robert Hodgins, Alice Neel, David Hockney, Henri Matisse, George Baselitz, Frank Auerbach, Paul Klee, Auguste Rodin, Émile Gallé, Chaim Soutine, Santiago Calatrava, Lucie Rie, Rembrandt van Rijn, Nature, Marlene Dumas, Beatrice Wood, Grayson Perry, the Bamiyan Buddhas, Clément Massier, Frederico Fellini. . . .

JC—Why do you work with ceramics?

RH—It was never a conscious decision or choice; I happened upon it through pottery classes I took in high school. I can't say that I fell in love with the medium at this stage, but it was something that gradually developed. I respond well to this medium and vice versa.

My debut only happened late in my life, and this was with a show comprising just ceramic pieces, so a certain decision was made to focus on ceramics. However, my interests are varied and changing—I'm also doing designs for rugs, textiles, wallpaper, etc.

JC—Where do you find inspiration?

RH—Everywhere, and also when I am away from the country I live in. I find it enormously rewarding to travel, and even though I don't sketch or do work while I'm away, these images and experiences find their way into my work when I resume my regular life.

JC—Do you have a "go-to" material that you use if you're having trouble with a piece?

RH—No. Trouble can come to you in any medium.

JC—Would you throw a piece away if it's not working, or would you just keep going until you're happy with it?

RH—I destroy it.

JC—You are a full-time artist—does this daily requirement to be creative drain or fuel you?

RH—This is a 24-hour job. I do not *not* think about my work—to the frustration of the people around me (and myself).

JC—Do you ever equate your self-worth with your artistic successes?

RH—No, as this is not my primary concern. I make the work because I have to, and then other people start their involvement with it. I'm not sentimental about my work, and if people like or dislike it, the relationship is over once the final piece is there. The important part for me is what's happening during the making of the piece—success is a very arbitrary term.

JC—How do you handle criticism if it comes your way?

RH—It comes, and I don't listen. Camille Paglia said that neither art nor the artist will ever conform to bourgeois decorum or tidy moral codes, and originality is by definition groundbreaking.

JC—Do you have an inner critic?

RH—It's a very loud clear voice within me, and I can't ignore it. I'm forty, so I have to deal with it.

JC—When do you get your best ideas?

RH—I do not—nor does any artist, I think—have a set time for this. They happen and un-happen. Sometimes one starts to work, things inevitably change and can then become very bad ideas. Or an initial good idea develops into something completely different, which then turns out to be a good idea for another work.

JC—How do you get through a creative block?

RH—I work. This is the only way for me. I work through, or around, a "block."

JC—How do you feel when your creativity is truly flowing?

RH—"The creative process is a cocktail of instinct, skill, culture, and a highly creative feverishness. It is not like a drug: it is a particular state when everything happens very quickly, a mixture of consciousness and unconsciousness, of fear and pleasure; it's a little like making love, the physical act of love."—Francis Bacon

Yes.

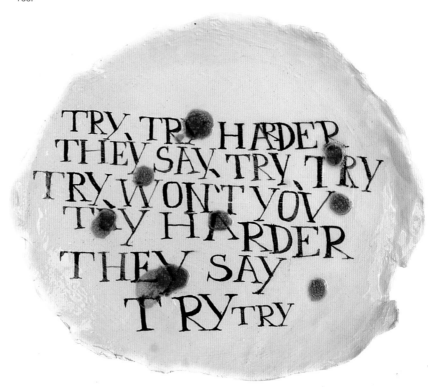

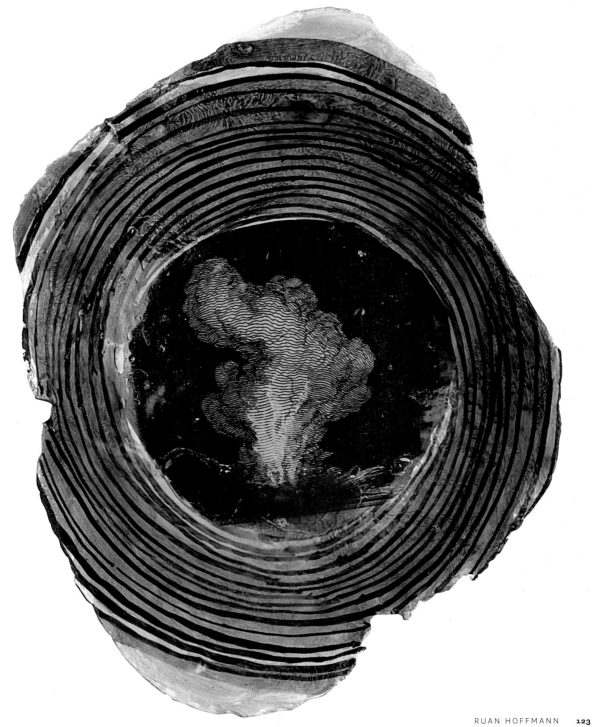

I work. This is the only way for me. I work through, or around, a "block."

Creative *un*Block
Project No. 21

I would love to think of a block remover, but it would not be the honest truth for me. My truth is to work—no excuse—just to work every day like the manual laborer that I am. Through work comes new ideas, and the spark to either follow and develop, or develop and then abandon.

I have no cure, but I do have this:

"The advice I like to give young artists, or really anybody who'll listen to me, is not to wait around for inspiration. Inspiration is for amateurs; the rest of us just show up and get to work. If you wait around for the clouds to part and a bolt of lightning to strike you in the brain, you are not going to make an awful lot of work. All the best ideas come out of the process; they come out of the work itself. Things occur to you."—Chuck Close

Absolutely what I wanted to say.

LEAH GIBERSON

PAINTING

USA

LEAHGIBERSON.COM

Boston-based artist Leah Giberson is from an incredibly creative family. Her parents, both of whom are artists, converted a barn behind their old farmhouse into a studio for glassblowing, blacksmithing, pottery, woodworking, weaving, and jewelry making. In the house, Leah and her sisters always had access to painting, drawing, collage, sewing, crocheting—art was a part of every day and every space in their home.

Leah went on to receive her BFA in painting from Massachusetts College of Art and Design, but most of the pieces she made in art school involved gluing sewing patterns on top of found images, and she didn't truly gain confidence as a painter until ten years later.

Now Leah works somewhere between the worlds of photography, painting, and collage. She begins each piece with a cut-up pigment print of a photographic image, which she then adheres to a panel. She paints with fluid acrylics directly on the surface of the print and all exposed sides of the panel. By the time she is finished with the painting, only the tiniest bits of the photographic image remain.

JC—You come from such an artistic family! Have you always felt like an artist?

LG—In some respects, yes, but for almost a decade after graduating from art school my business card read "Senior Designer" or "Art Director" and then shifted to "Artist/Designer" when I left full-time employment for the life of a freelance designer. It was wasn't until 2008 that I really started trying to make a living from my artwork, and then about a year later, at the age of forty, I made it official when I turned down my final freelance job. Now my business card says, simply, "Artist."

JC—Which artist are you in awe of, and why?

LG—I come from a family of extraordinarily creative and hardworking artists, so I don't have to look far to find people that I am truly in awe of. My youngest sister, Petrova Giberson, never ceases to astound me with her inventiveness and unbridled creativity that she brings to every single thing she touches. She earned her MFA in sculpture at Yale, where she combined work with fiber, video, text, photography, glass, and found objects to transform spaces and audiences alike.

JC—How do you get inspired?

LG—For about eight years after graduating from MassArt, I was part of an art-crit group that met once a month. The six other artists in the group worked in very different ways from one another, but were all so talented and insightful that I always left the meetings with new ideas to take back to my own work. Unfortunately, we became so busy with our personal lives and careers that we finally disbanded. I really miss the experience of being part of a rigorous and constructive critique and would love to find another group at some point.

It's not the perfect substitution, but for now I usually turn to the Internet for inspiration. I love to start the morning with a peek at sites like Pinterest or Flickr while I'm drinking my coffee, in the early hours before the rest of my family wakes up.

JC—Do you find any of your starting images through this early morning browsing?

LG—Yes. Roughly two-thirds of my paintings since 2009 have used someone else's photograph as the starting point, and I've found most of these images on Flickr. Since I always contact the photographer first to request their permission, I've ended up making connections with people from all over the world, and many of them have continued to follow my work over the years, even offering a kind of "virtual" studio visit at times.

JC—What is the biggest challenge you face as a full-time artist?

LG—I think what many of us struggle with is managing the stress of taking on more than seems humanly possible. My sisters and I (as well as most of my friends) are all trying to juggle raising our kids while also pursuing our careers—all while making sure the laundry still gets done, meals prepared, plants watered, pets fed, and so on, and so on.

I also tend to overcommit to art deadlines, so there's very little time left for "personal projects" in my studio. These days any paintings I make are usually slated for a specific show, so when there is any breathing space between deadlines, my personal projects tend to be in my home or garden.

JC—How do you navigate your way through a creative block?

LG—I usually have at least five to ten pieces in various stages of progress, so if something isn't flowing with one, I just switch to another. Sometimes it helps to hang the piece on a wall farther away from me to get a different perspective or put it away entirely for a bit. If that doesn't do the trick, I adhere a new image on top and start over.

JC—Do you ever hear your inner critic? What does he or she say?

LG—Sometimes my inner critic is informed by what I imagine my friends and relatives, who are conceptual artists, think of my work, but never tell me. I assume they would say that my paintings are too "pretty" or designed or conventional—that they aren't risky or experimental enough to be interesting. That they are too literal and commercial and aren't relevant or "real" art. So, yeah, I've got an inner critic who can really go on the attack at times. When that happens, I turn the music up and work through it.

I love to start the morning with a peek at sites like Pinterest or Flickr while I'm drinking my coffee, in the early hours before the rest of my family wakes up.

Sometimes it helps to hang the piece on a wall farther away from me to get a different perspective or put it away entirely for a bit.

Creative *un*Block
Project No. 22

Years ago I kept a visual journal, which I filled with little collages, altered found paragraphs, and how-to diagrams. I've always had trouble following written directions and found it was more fun to turn these long paragraphs or step-by-step guides into visual poetry.

1. Find a how-to diagram from a magazine or print one out from the Web and then glue it down to a larger piece of paper. Acrylic gel medium or bookbinding glue are both good choices because they are less likely to wrinkle the paper.

2. Decide which elements you find most interesting and want to keep, then, using gesso or acrylic paint, paint over anything you want to cover in order to obscure and alter the original activity being described.

3. With pen or collage or thread, etc., etc., you can then embellish what remains, extending or adding lines that might already exist so they become something else entirely.

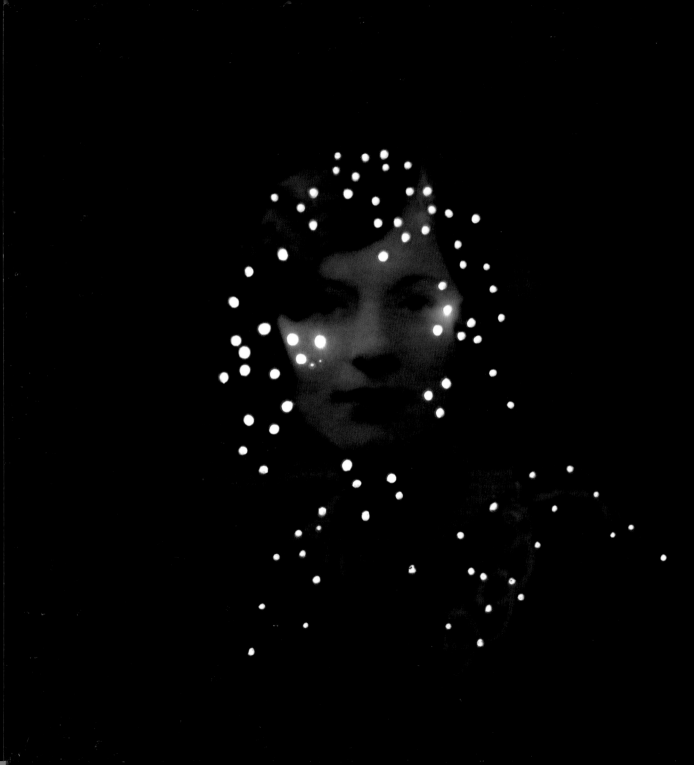

AMY FRIEND

PHOTOGRAPHY

CANADA

AMYFRIEND.CA

Amy Friend studied photography at York University in Toronto, and then received her MFA at the University of Windsor. This is where she learned the rules of photography—and then she learned to break them. Her work is quite unconventional, and, clearly, she loves exploring photography in new and different ways. Her series *Daré alla Lucé* (select pieces shown here) are deliberate interventions—vintage images that she pierced, allowing light to pass through. (After all, photographs are made possible with light.) She then re-photographed them with the light streaming through—like a thousand stars twinkling back at the viewer. In a literal and somewhat playful manner, she aimed to give the photographs back to the light, hence the title of the series, which is an Italian phrase that literally means "to give to the light," used to describe the moment of birth. Beautiful.

JC—**When did you know that you were an artist?**

AF—I think I had this moment a few times in my life, and it held specific significance each time I recognized that "moment." When I was eleven, I was obsessed with mermaids (slightly embarrassing to admit now), but I drew them over and over. One day I decided to paint them in watercolor and had a "preteen" breakthrough. I painted a mermaid holding her bloody heart above the water (again embarrassing). That felt like my first "real" piece of art. In fact, I think I still have it.

JC—**Why have you chosen this artistic path?**

AF—It may sound clichéd but I don't think I had much of a choice. Being an artist chose me. I always gravitated toward the arts. There is a level of infiniteness to the arts that always impressed me—the possibilities are endless, and I love that. I also want people to have those "chills" when they experience art that resonates for them. Hopefully, my work will do that one day!

The arts are also in my blood; my Nonno [grandfather] was a creative fella, building an incredibly odd and wonderful round house that I spent many years in. He invented new ways to build all sorts of things.

JC—**If you were feeling blocked, what kind of advice do you think your Nonno might give you?**

AF—He would say just try, try, try, and work, work, work, *and* work some more. My Nonno was a workaholic who loved "doing."

JC—**And so how do you push through creative blocks?**

AF—When I have my creative blocks, I try to accept them as "break time." I step back and get to the basics, back to what I love and what continues to grab my attention. These "empty times," as I call them, are invaluable. To me they are a time to clean the slate and relook at all the things I have interest in. Which road I take will open itself. I love the journey of this process.

JC—**Which artist(s) are you most jealous of, and why?**

AF—Well, this could potentially be a huge list.

There are many artists I am jealous of, but more often I am struck by a specific piece of work. I remember being in Paris and encountering Giuseppe Penone's work *To Breathe the Shadow*, at the Centre Pompidou. The large room's walls were lined with bay leaves in wire cages. They cocooned the space and softened the sounds. The scent from the leaves was incredibly acrid; it took your breath away. At the center of one wall was a small pair of brass lungs. It was an incredible piece, as it stimulated your senses and established an atmosphere of hushed reverence.

While I do not envy the suffering Frida Kahlo endured, I greatly admire her tenacity, passion, talent, and verve for life! I love the visceral quality of her work. It breathes! Sally Mann is also close to the top of my list. She has been a force in contemporary

photography for many years and, in my opinion, maintained a steadfast approach to her image-making. Her work is personal, universal, and utterly haunting.

JC—How do you find inspiration?

AF—I am a bit of a scavenger, a magpie if you wish; I love the scraps left over from memory and our personal histories, our stories, and the artifacts of life.

JC—Have you discovered the best place to find those "scraps of memory"?

AF—Yes—vintage shops, antique stores, attics, people's stories, and, most importantly, all that is mysterious . . . all that shines in the dark a little.

JC—Would you ever toss out one of your photographs?

AF—I would toss it, no, keep it, no, toss it. Sometimes both.

JC—Do you ever feel overwhelmed by being a creative person?

AF—Yes, there are times when art overwhelms my life. It invades my thoughts and my sleep. A part of me loves this, while it can be stifling when you hit roadblocks. I remind myself that there are ups and downs with anything. There are moments of success and failure. You keep your eye on your goals and once in a while allow yourself a break. Remove yourself from self-induced stress.

JC—How do you handle criticism?

AF—I would love to say I handle it perfectly, but there are times when it is discouraging. After I "lick my wounds" I move on and regard it as a challenge. This pushes me and makes me take a second look at my work, my processes, and my results. This can be a blessing; as an artist you are often working alone with little feedback, so any feedback can be taken and used as a stimulus.

JC—Is your inner critic a friend or foe?

AF—Maybe I am lucky, but I love my inner critic. I became friends over the years with this spunky little voice. It keeps me in check, even though we argue once in a while (I usually win).

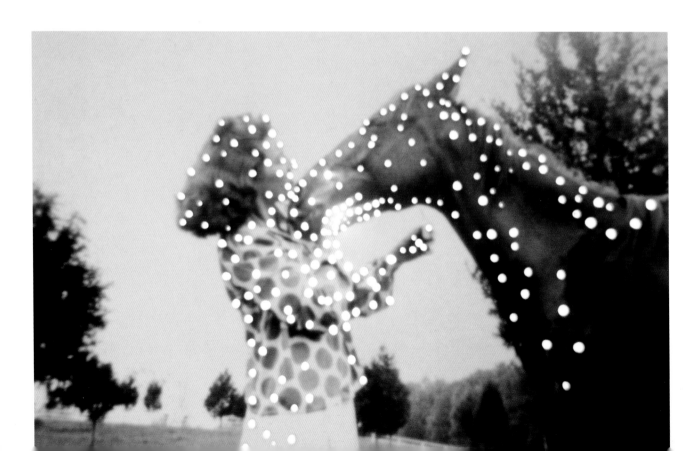

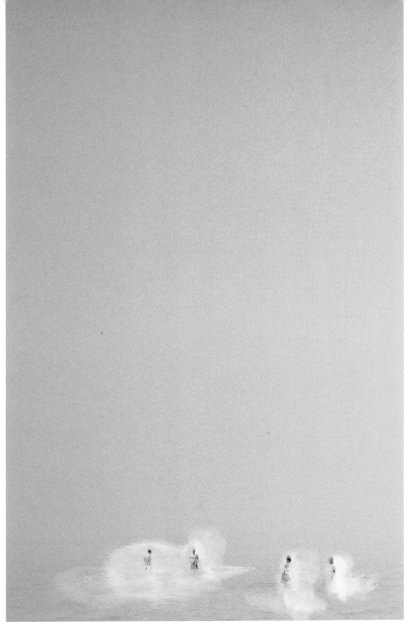

There is a level of infiniteness to the arts that always impressed me— the possibilities are endless, and I love that.

*I love my inner critic. I became
friends over the years with this
spunky little voice. It keeps me
in check, even though we argue
once in a while (I usually win).*

HOLLIE CHASTAIN

COLLAGE/MIXED MEDIA

USA

HOLLIECHASTAIN.COM

Old paper, vintage book covers, found images, and delicate drawing. Ah, the simple, yet striking work of Chattanooga, Tennessee-based artist Hollie Chastain. She is a self-taught collage artist who has made an amazing career for herself. She has had exhibitions at galleries all over the world, her work has been published in several magazines (including *Lilith* and *Fine Line*), and boutiques—from Tennessee to New York and all the way to Spain—carry her work. Because of this success, she is now living the dream of so many artists: Hollie was able to say good-bye to her career as a graphic designer, and hello to being a full-time artist.

JC—**What pushed you to quit your design job? When did you know it was the right time to make that jump?**

HC—Well, the decision was made for me in a way. My full-time job in graphic design and marketing was moved across the country, and I definitely did not want to follow it. I honestly hadn't considered making the jump to full-time art, and didn't even at that moment. I just knew that I needed a change and didn't want to go back to a corporate desk just yet. My full-time art career started with that thought: "Let's just see what I can do with this, and go from there."

JC—**At what age did you start to feel like you were an artist?**

HC—I started to feel it in high school. That's when it moved from being my favorite obsessive hobby to something that I truly knew I could do for a lifetime. The start of the study of art history made me feel like a part of a special, ancient group. It was very exciting.

JC—**Do you have a favorite artist that you look to for inspiration?**

HC—It's so difficult to name just one. I have the most adoration in my heart for Outside artists, and Henry Darger has always been a constant favorite. His prolificness and self-taught techniques, combined with his motivation to tell a story and create a world for himself alone to live in, is completely mind-blowing and inspiring to me.

JC—**What are your tips for dealing with collages that are causing trouble?**

HC—Well, If I am having problems with the overall composition of a piece, I often pull away from the big picture, and work on a detailed element for a bit. Tedious, tiny work helps me organize my thoughts and clear up the fog.

JC—**Would you ever give up on one of your pieces?**

HC—I think my medium allows me a lot of space to work through difficulties. I work entirely in paper collage, and typically I don't glue anything until I'm at least 90 percent sure I'm pleased with the composition. I have never thrown a piece away, but I have reworked the entire thing.

JC—**When you spend your days on commissioned projects, does it drain or fuel your personal projects?**

HC—I believe that once it's flowing, then it flows in all directions. If my work is at a full stop, then all creativity stops. It makes for very boring times until I can recharge again.

JC—**Do you ever equate your self-worth with your artistic successes?**

HC—I think as an artist it's very easy to do this because of the nature of the work. If you think of art as a job, then your product is so much more than hours invested. The product is a piece of yourself, so of course if the reception is not the greatest, then it can feel like a direct hit to who you are as a person. I think this happened a lot more when I was younger and still finding my way around. I would doubt my direction when a viewer wasn't thrilled. The trick for me is not to put *more* distance between my work and myself, but to close that gap completely. I can see myself in the art that I create, and that builds a wall of confidence.

JC—Does criticism bother you?

HC—I'm a sensitive person, so I have to admit that I am immediately affected by it. But at the heart of the work that I do is the wish to make things that I myself enjoy and love. If others love it as well, then that's absolutely wonderful—and I accept that not everyone will.

JC—Does your inner critic get to you?

HC—It does get to me, more than it should. Second guessing myself is a constant trait of mine. Overthinking. I try to make the best of it and use it as a tool. To me that "when it's right then it's right" feeling of being *finished* with a piece is so much stronger when you have a tendency to question the journey along the way to that point.

JC—When you're blocked, do you ever just force yourself through it?

HC—No, if I try to force work, then the work doesn't make me happy or doesn't seem true to me. The best way I have found to deal with it is to step away completely and focus my attentions on something else. I come back when I feel inspired, or feel like I can sit down and slip easily back into a piece, and never before.

JC—How do you feel when things are truly flowing for you?

HC—I find it hard to talk about. It's an almost indescribable feeling to me, and if I can't sit down to a sketchbook right then and get some things down, then it often leaves me. When I can't act on a sudden burst of inspiration, I feel a little like I've held in a sneeze.

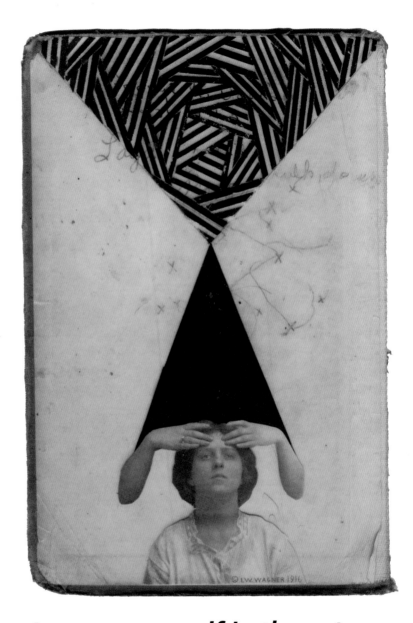

I can see myself in the art that I create, and that builds a wall of confidence.

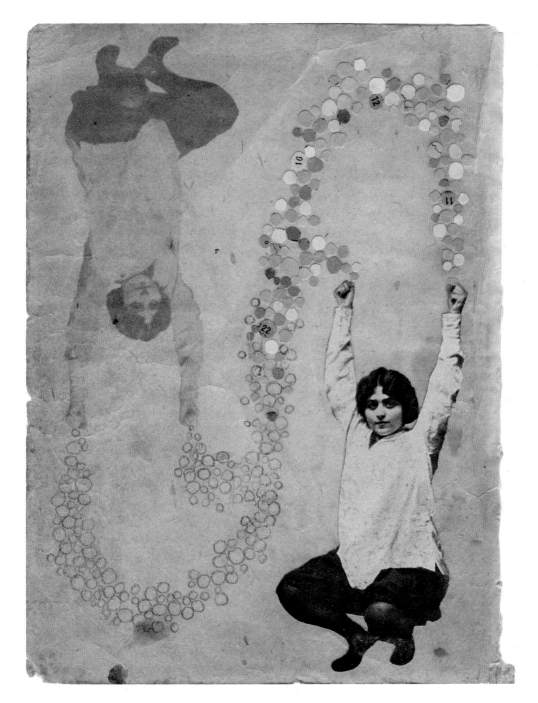

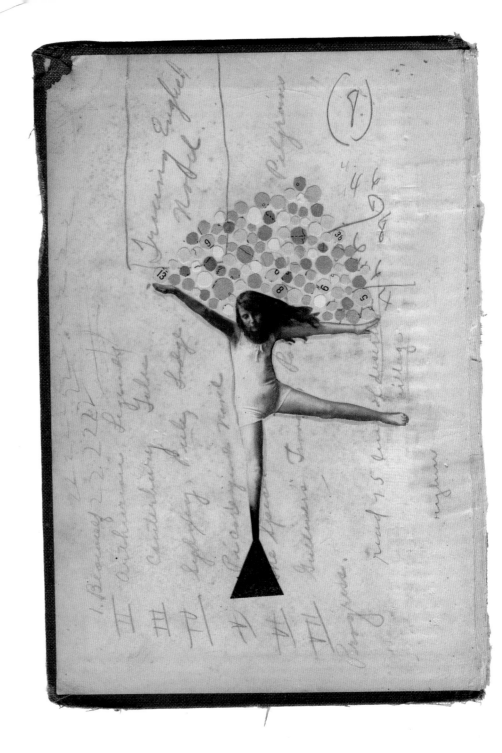

When I can't act on a sudden burst of inspiration, I feel a little like I've held in a sneeze.

Even when I don't *feel* like I am in a rut, I always have these wonderful experiences with breaking out of my comfort zone when I take on a commission that is a very specific subject. Ask someone close to you to give you an "assignment," whether it's a song lyric or a sentence from a story, or even something as simple as a specific animal. Make sure it's not an idea that you have frequented on a regular basis in your work. Keep true to your vision and technique as you work.

JULIA ROTHMAN

ILLUSTRATION

USA

JULIAROTHMAN.COM

Julia Rothman lives and works from her studio in Brooklyn, New York. She attended the Rhode Island School of Design, and graduated in 2002. Julia has created illustrations and pattern designs for newspapers, magazines, wallpaper, bedding, books, and subway posters. She is part of the award-winning three-person design studio called ALSO, and runs the blog Book By Its Cover. Speaking of books, she also authored *Farm Anatomy* and *Drawn In*, and coauthored *The Exquisite Book* and *The Where, the Why, and the How.* Yes, she is a superstar.

JC—You make so many things—what's your favorite medium to work with?

JR—I like drawing with just a plain uni-ball pen in my sketchbook best.

JC—What made you feel like you really were an artist?

JR—The first time I had my work published in a magazine—I felt like I was actually going to make it as an artist. This was during my junior year in college and I had interned at a magazine. I made them an illustration for their back page. It was a thrill seeing the magazine in shops, and showing friends.

JC—Why did you pursue a career in the arts?

JR—Drawing was something I was always good at. I think in pictures, and remember things visually, so it came naturally to go in that direction. I'm not nearly as good at anything else as I am at being creative. I also like impressing people, and this is definitely a way I can do that!

JC—If you weren't an artist, what would you be?

JR—Lately I have been thinking I might have liked to do something in psychology. I've become really interested in learning about how our brains work, human behavior and personality traits.

I also still dream of becoming a mail carrier. It seems like it would be relaxing to sort papers and walk around neighborhoods all day. When I tell people this, they often remind me that there is a lot of bad weather and that postal workers are always grumpy and unhappy. And then there is that term "going postal" . . .

JC—Did you ever experience a particularly work-halting creative block? How did you push through it?

JR—There was actually a period of about a month where I felt like I couldn't work. I wasn't excited about anything and I had no idea what to do next. When I think back about why it happened, I think it was because I was getting distracted by long-term goals, making it hard for me to concentrate on anything happening in the present. One of the things that helped me get through it was redoing my studio. I painted the walls, bought a new desk and shelves, and finally put some time into setting it up. Suddenly it became a project itself, and that made it easier to jump into the next project. Also, once my studio was all set up, I really wanted to be in that room. It seemed only natural to start working again if I was sitting at a new desk.

JC—Do you ever reach out for feedback or advice?

JR—Yes, I usually ask for advice from my ALSO partners, Jenny [Volvovski] and Matt [Lamothe]. Sometimes I can't tell what a piece needs, or what to do to make it better. They can always help me see things I'm missing and calm me down if I get frustrated or want to give up.

JC—Speaking of ALSO, you have to be very creative all day long—does that drain or fuel your personal projects?

JR—It's definitely a drain for creative personal projects. I don't have a well-decorated home, or knit, or even know how to sew. I don't cook either. All of my creative energy goes into my workday, so I don't have any to spare at the end of the day. I just want to zone out and

watch TV, or meet friends and have a glass of wine.

JC—Do you think that you're overly hard on yourself as an artist?

JR—Sure, I am always beating myself up about not doing enough, or not doing better. I think when you put so much of yourself and your time into something, it's hard to separate it from who you are. I'm not sure how to get past that, because I'm not sure I ever will.

JC—How do you handle criticism if it comes your way?

JR—I cry. Ha-ha! And then when I am finished I become energized to do better.

JC—Which artist's work/life/career has inspired you the most?

JR—I often look through Vera Neumann's book that came out a few years ago [*Vera: The Art and Life of an Icon* by Susan Seid], and feel envious of her career. Her work was so colorful and playful, and she was able to decorate so many kinds of products with her signature style. I love that she started making scarves because she couldn't get linen for housewares and there was an abundance of silk during World War II. She was able to adapt her work and then become amazingly successful. It's very inspiring.

JC—Yes it is! So besides Vera's book, what inspires you the most?

JR—I find a lot of inspiration from walking around New York City. I look at what people wear, the architecture, shop windows, etc. I've lived here almost my entire life, and I still am fascinated by the energy in this city.

Once my studio was all set up, I really wanted to be in that room. It seemed only natural to start working again if I was sitting at a new desk.

I am always beating myself up about not doing enough, or not doing better. I think when you put so much of yourself and your time into something, it's hard to separate it from who you are.

Creative *un*Block
Project No. 25

Sometimes when my drawings start to feel tight and rigid, I will do a blind contour drawing to loosen up. You just need a pen and paper. Pick something around you (a person, a still life, a landscape) and start drawing without looking at the paper and without lifting your pen. Try to draw as many details as you can. When you are finally finished you are allowed to look at your paper.

JESSE DRAXLER

COLLAGE/MIXED MEDIA

USA

JESSEDRAXLER.COM

American artist Jesse Draxler has a BFA in illustration, fine art, and design from the College of Visual Arts (CVA) in St. Paul, Minnesota. He has combined all of those disciplines, and now specializes in collage. He creates striking compositions made up of only two or three found photos. Jesse's simple yet stunning collages have been exhibited all over the world, and his work has been commissioned by a long list of amazing brands, including *ELLE*, Target, and the *New York Times*.

JC—**Do you feel like an artist?**
JD—I'm still earning that title.

JC—**Why do make art?**
JD—I like to make things to look at.

JC—**How do you get inspired?**
JD—The best inspiration comes from doing—being inspired by process—creating an organic, cyclical energy/inspiration supply.

JC—**Would you toss a collage that's causing trouble?**
JD—I rarely throw anything away. I never know if my future self will see something in a piece that my present self does not. That being said, if I'm downright disgusted with something I'll toss it—that can be liberating.

JC—**Which artist's work/life/career are you most jealous of, and why?**
JD—I'm "jealous" of many, but for the sake of answering this question I will say Richard Prince. The breadth of his body of work is outstanding, and I like the way he thinks.

JC—**Do you ever equate your self-worth with your artistic successes? How do you get past that?**
JD—Is it something that needs to be gotten past? I don't know if equate is the right word, because self-worth should be made up of many things—and if one of those things is one's artistic successes I think that is OK.

Though first the definition of success needs to be defined. There are many levels of success. Success can be if you create something you are happy with. To some success is if other people dig the work, and to some success means money.

A quote I've always liked from Steve Kim: "I've found failure—and therefore success—to be emotional in both origin and makeup."

JC—**What is your view on criticism?**
JD—Everyone has an opinion. Sometimes it's a good one, sometimes not. Consider the good, discard the not. I rarely ask for feedback directly, but the act of putting your work online or in a gallery is inherently opening your work up for feedback. I appreciate thoughtful praise and constructive criticism.

JC—**Does your inner critic ever show up when you're working?**
JD—It comes, it goes, it comes back, and leaves again. It can both help and hinder—telling the difference between the help and hinder is the hard part. Knowing when to acknowledge the inner critic and when to ignore it is essentially instinctual.

JC—What advice would you give to someone who's struggling with a collage?

JD—Mess it up. Flip elements. Flip the whole piece. Cut something. Replace elements. Etc. Basically reorganizing the composition— a lot more action than thought—waiting for everything to click.

JC—Do you ever just force yourself through a creative block?

JD—No, I never force myself into anything. I've found nothing good ever comes from that.

Read a book, page a zine, go on a bike ride, watch a documentary, scribble, swim, clean, sweep, walk, smoke a joint, blast music, dance. Stay open.

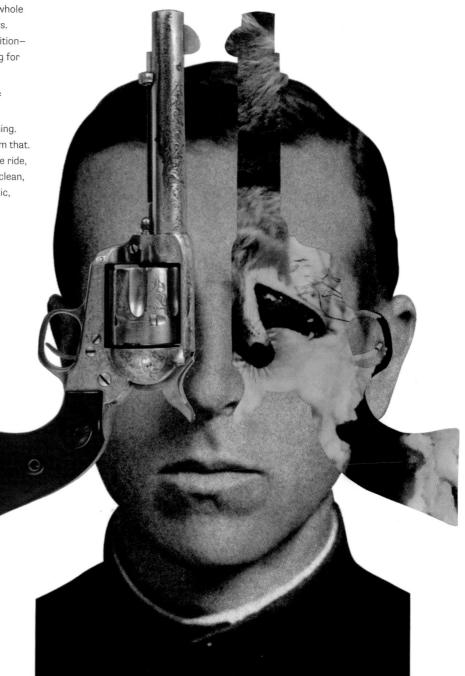

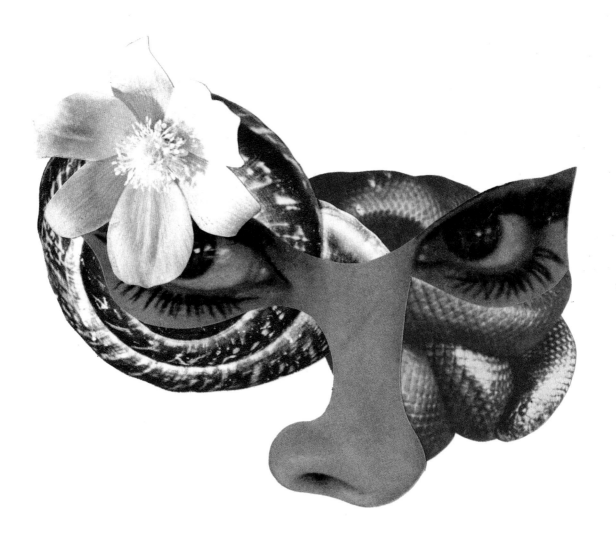

I rarely throw anything away. I never know if my future self will see something in a piece that my present self does not.

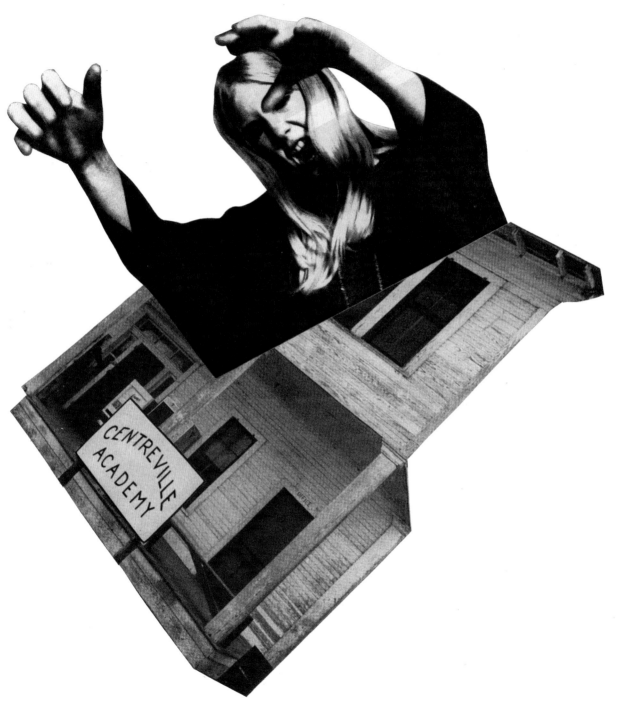

The best inspiration comes from doing— being inspired by process—creating an organic, cyclical energy/inspiration supply.

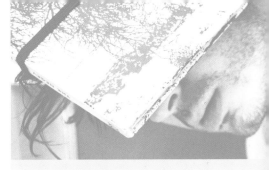

Creative *un*Block Project No. 26

Organize objects.

Find some objects you have around your apartment, home, studio, etc. (the more unique the better), and organize them in different ways. Stack them, rest them upon each other, arrange them in a pattern, etc. I find this to be a great exercise in composition—something that is integral in all art forms.

Secondly, photograph the compositions. Several shots from several angles to capture things that normally would not be taken note of: the makeup of the arrangement, the structure, the physics of why the arrangement is working.

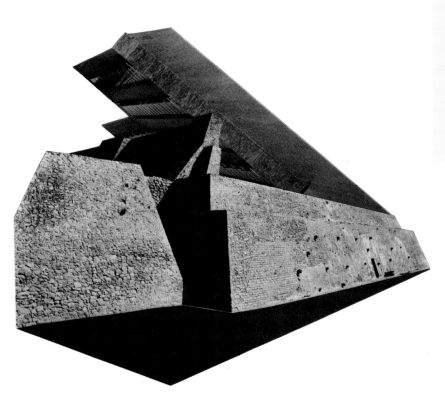

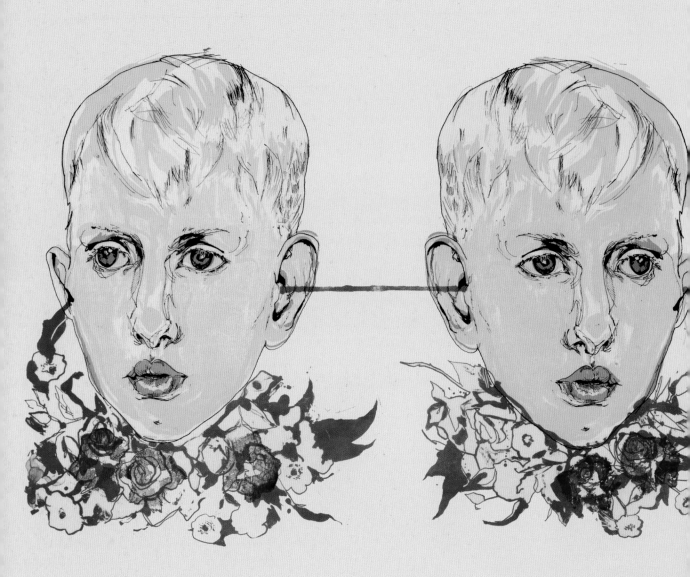

PEREGRINE HONIG

MULTIDISCIPLINARY

USA

PEREGRINEHONIG.COM

After reading this interview, "poet" should definitely be added to the description of American artist Peregrine Honig. Also on that list: painter, sculptor, drawer, and master of gorgeous installations. She was one of the artists on Bravo's first season of *Work of Art*: her exquisitely bizarre, carnival-themed show then being exhibited at the Brooklyn Museum was in the final episode. Peregrine's work is thoughtful, considered, and beautifully executed—poetic, one might even say.

JC—**Do you remember the first time you felt like an artist?**

PH—I remember drawing in the sun on my mother's apartment porch when I was four. My hand was cooperating with my mind. A Belgian man and his girlfriend were staying downstairs. He was smoking near me. He looked at what I was drawing and told me I was too good to draw on both sides of a sheet of paper. The memory of this moment is fresh: the airborne dust, the smell of tobacco, the texture of the wood under my paper. I had never been praised in the form of advice.

JC—**Did you ever want to be anything else?**

PH—My mother would let me walk to the Castro Theater and watch *Thin Man* movies. I wanted to be a spy or the wife of a spy—until I saw a scene where a dead body fell out of a shipping crate.

JC—**Where did you study art?**

PH—I went to the Kansas City Art Institute (KCAI), where I learned how to speak and write in art. I had amazing teachers, but I didn't graduate. I dropped out during my fourth year. Academia is about disseminating ideas, not about teaching people how to create or be creative. If you are a creator, you must create. No amount of academia can produce someone with an innate ability to create. There are some days I am ashamed by my lack of degrees, and other days I wish I were less hindered by academia.

JC—**Who were those amazing teachers, and what did you learn from them?**

PH—Jack Lemon, the founder of Landfall Press, and his trusty sidekick Steven Campbell, and my early advocate and translator Melissa Rountree—all came to me through hard work, incredible timing, and good luck. Russell Ferguson taught me, "Draw what you see and what you know." My favorite teacher, Lester Goldman, died in 2005, and I very much miss learning from him. His celebration of mundane material allowed me to work fearlessly with grocery bags and paper doilies.

JC—**How do you know if a piece is heading in the wrong direction?**

PH—If the start is a struggle, I am in the wrong place. I prefer to start many times with the muscle memory of failure rather than push out what I am not interested in making. I go through a lot of material if I don't take a moment and pay attention to whether or not I am in a space to produce.

JC—**How do you respond to criticism?**

PH—If the writer has a solid handle on their point and their criticism is fresh, sharp, and considered, I experience their criticism with grace and confidence. If the critique is bland and self-centered, with a dated agenda, I respond to it with disdain. Either way, criticism is nerve-wracking. When the work comes down, criticism and show postcards are all that remains.

JC—What does your inner critic sound like?

PH—The clock ticking. Time is my loudest and most influential critic.

JC—Are you bothered by creative blocks? How do you get through them?

PH—Blocks are part of my creative process. I cannot always make and generate without addressing the spaces in between tactile progress. The pause is important to honor, no matter how different it feels in comparison to the rich and fruitful harvest where my body falls into place with my mind and the material. I love graffiti in small towns—"Sex, Drugs, Rock 'n' Roll" sprayed on a rock or scratched into a tree near a pile of rusting cans, sun-bleached labels fluttering off glass. Perhaps my taste is more refined, but the sentiment remains. Intimacy, cocktails, and music are excellent lubricants in and out of a rut.

JC—Describe how you feel when your creativity is truly flowing.

PH—Being in a state of creation is a serious turn-on. I'm vulnerable, and when I finally fall asleep, I have fantastic dreams.

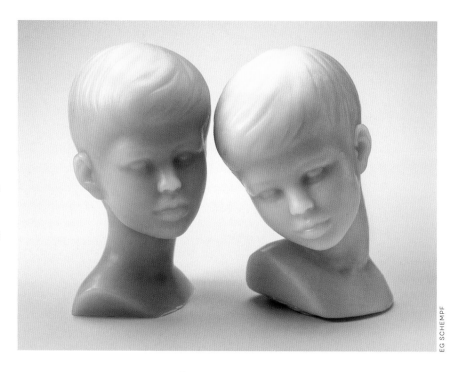

EG SCHEMPF

Intimacy, cocktails, and music are excellent lubricants in and out of a rut.

Mother Hood

she married the woodsman in his moment of fame but she dreams of the wolf and his mothers to blame.

Edible Complex

which your way in the forest floor - the house of mice has a gingerbread door.

Creative *un*Block
Project No. 27

Enter a storefront you have always been curious about. Hand-painted signs, neon time has forgotten, an old cat pushing against the glass, and major window ferns are good markers. A cobbler, a bookbinder, a silver platter, something obscure that offers a service you weren't aware you needed are gems. Bring in your shoes, make a weird calling card, commission an object you have always wanted. Be polite and try not to be shy. My first name is obscure so I like to get things with my name on them out of these scenarios. Pin the receipt to your wall. Enjoy the piece of time you had putting yourself into a new space.

KELLY LYNN JONES

MULTIDISCIPLINARY

USA

KELLYLYNNJONES.COM

Kelly Lynn Jones has been making art since the moment her mother gave her a crayon. Being an artist is a way of life for Kelly, and so it was natural for her to go to art school. In 2002 she received her BFA from the California College of Arts and Crafts, and in 2010 she graduated with an MFA from the California College of the Arts. Since her BFA, she has shown her work all over the United States and Europe.

After graduating from art school, she wanted to create an online platform where she and her friends could sell their pieces to help support their individual art careers—and so, in 2004, Little Paper Planes (littlepaperplanes.com) was born. She now divides her time between running and curating LPP, and her personal art practice. She works in all mediums, but tends to focus on sculpture and installation. She takes a very conceptual approach to her work, so the idea comes first and the medium comes second.

JC—By day, you run Little Paper Planes. Does that influence your personal work?

KLJ—In some ways Little Paper Planes is an extension of my practice. My role becomes curator, which is being just as creative as making work. It is different, but still using a lot of that creative energy. I feel incredibly lucky to do what I do, but sometimes I wish I just had a job I didn't care about so I could save all my ideas for my personal practice. Though all in all, most days I am completely inspired by all the artists I work with, which directly relates back in the studio.

JC—You see amazing art every day. Have you been influenced by anyone specific?

KLJ—There are so many artists who have influenced my practice along the way, but one who always stands out was Gordon Matta-Clark. The way Matta-Clark used existing structures like houses to create new spaces was incredible. He stripped down the "persona" of these places and opened the viewer's eyes up to the actuality of the materials, which lent for a space of openness within the viewer's own personal perception.

JC—Do you ever have creative blocks? How do you get through them?

KLJ—Of course, I have them all the time. Sometimes I have a mini-tantrum inside my head and need to leave the studio. Though usually all I really need is a break, and when I come back to whatever it was I was working on, everything feels better.

JC—How long are those breaks? What do you do during the break?

KLJ—It really just depends on the situation. It can be a day, a week, or longer. One of my professors in grad school suggested that whenever things are not completely working out with whatever piece you are working on, you should start another side project. This project doesn't have to relate at all with your practice, but the idea was to let your mind be open so it will be easier to see things clearly. Often when you are working on something and it isn't coming together or translating the way it was intended, it is good to step away. Basically, I have about a million side projects.

JC—Would you ever throw your work away?

KLJ—I have no problem with throwing away work or remaking it. I think some pieces just need to be thrown away. However, I am the kind of person who doesn't get emotionally attached to my work. I see everything as a whole and that all that I have ever made and will make are contingent on one another.

JC—Do you ever equate your self-worth with your artistic successes?

KLJ—There are times when I struggle with that. I try my hardest to not let external factors like the "art world" affect how I make work, or how I am navigating my practice in the art world. I always try to remind myself that none of that stuff matters, especially when I am in the studio. The studio is my sacred place.

JC—How do you feel about criticism?

KLJ—Let's be honest, no one likes it. However, not all criticism is bad, and it often has truth. I think dialogues are crucial around art. I welcome conversations around my work. I need them.

JC—What was the most enlightening piece of feedback you ever got from one of these discussions?

KLJ—Well, I never would have started working with photography or video if one of my professors in grad school hadn't mentioned it. He was looking at my work, which was mainly arrangements of sculptures, and pointed out that there was so much action in my work that it lent itself to video and photography. I won't go into all the details, but that was such a breakthrough for me for my practice. Two years later I am working with those same ideas and relating the sculptures to video. If I had not had that conversation, I am not sure if I would have gotten to that conclusion on my own.

JC—Do you have a relationship with your inner critic?

KLJ—Sometimes I just want to bitch-slap that critic. I think it is important to listen to my gut as well as to contradict it.

JC—Give your best analogy to describe the artistic process.

KLJ—I often relate art-making to the act of climbing a mountain. While struggling to go up the mountain, you wonder if it is worth it, and just at the moment you want to quit and go back, you reach the top. The top is spectacular. The view is endless, which words cannot describe; however, you can only stand there for so long before you have to make your descent. As you walk down, the high you experienced moments prior slowly disappears as you see the next mountain in the distance.

I think it is important to listen to my gut as well as to contradict it.

Creative *un*Block
Project No. 28

Most people will not want to do this.

Take a piece that you have had for a while
that you hold as an example of a work of art
that you feel is successful.

Tear it up, break it apart. Place the various
pieces in different spaces or places, not just
your home or studio.

Create little interventions with these pieces.

TRY
A LITTLE
TENDERNESS
AS PAINFUL
AS IT
SEEMS

BEN SKINNER

MULTIDISCIPLINARY

CANADA

BENSKINNER.COM

Ben Skinner went to the Nova Scotia College of Art and Design, and then received his MFA from the School of the Art Institute of Chicago. He spends his workday designing stunning retail window displays, which are true works of art in themselves. Ben's personal work, usually text-based mixed media, is filled with wit and is executed beautifully. However, it's his amazing use of materials that sets him apart—glitter, light tubes, candy sprinkles, gold leaf, and yes, even the occasional banana.

JC—Why so many materials, Ben?

BS—I find inspiration in the perfection of materials, and the processes to disguise or hide them. I love it when I'm at an art gallery and I can't tell how something was made, or what material it's made from. This happens just as often with objects and surfaces of architecture, design, and signage. It makes me giddy with intrigue, like working out a puzzle or cracking a code.

JC—Are there any artists that "wow" you with their use of materials?

BS—Off the top of my head—Olafur Eliasson, Anish Kapoor, Charles Ray, Tony Craig, Cornelia Parker, Mona Hatoum, Robert Lazzarini, and even Jeff Koons. They are like art magicians whose process is hidden and obscured by the work itself.

JC—Your text pieces are witty, thoughtful, and even hilarious sometimes! Where do those phrases come from?

BS—They come from all over the place really: popular culture, things I've said or overheard someone else say, old adages or common phrases I've twisted up a bit to make them new again. For a long time, I've been interested in language and the comedy that can result in its misinterpretation, multiple meanings, etc. A common phrase like "It was nice while it lasted" becomes sexually suggestive when the "it" turns into pronouns like "You were nice while I lasted." I also love the ambiguity of language—how there are so many ways of saying something without coming right out and saying it.

JC—Have you always wanted to be an artist?

BS—As far back as I remember, being an "artist" was the first thing I ever wanted to be when I grew up. I've never given much thought to doing anything that wasn't art related. Artists see the world differently. Learning to draw at a young age honed my visual perception skills, and college added an important layer of criticality to that perception.

JC—Describe the first moment that you truly felt like an artist.

BS—I guess it was when a pen-and-ink drawing I did of a red-tailed hawk was used for the cover of a birding journal my father subscribed to. He was extremely proud. Around that same time I was drawing birds from his bird book, and trying to hock them in the streets of Petrolia, Ontario. I was twelve.

JC—Do you have any tricks you use if you get stuck mid-project?

BS—I use the Google technique. When I need to learn more about the material or technique I'm using, I need to research and learn all there is to know about it. I usually watch YouTube videos, read message boards, or order books on the subject. All that on top of asking anyone I can who might be an expert or "master" about the specific material. Recently I've been slowly teaching myself the craft of gold-leaf glass gilding. Both lettering and images. It is a very technical process and heavy material to work in, as well as being expensive and almost archaic. As far as having trouble with a piece conceptually, I negotiate with myself and that either results in me forgiving myself for making something less than my own personal expectations, or shelving it for later use.

JC—Your window displays are ridiculously creative—do these "9 to 5" projects drain or fuel your personal work?

BS—Yes, they drain me—until I have a personal art deadline like a commission or exhibition. In those cases I find it hard to focus on my day job, and all my free time gets spent in the studio. But I do believe they fuel and drain each other in ebbs and flows.

JC—Is your ego affected by criticism?

BS—It all depends on where it's coming from and in what context. It's always hard to completely separate the ego from the work. I would say I'm not as bad as some artists, but I can get pouty if someone whose opinion I hold in high regard responds badly to an idea I thought was something great. I think it's healthy for artists to get those little humbling checks.

JC—Does your inner critic ever play a part in those humbling checks?

BS—In regard to concepts, it's more like an inner 1984 Big Brother censor. Keeps a lot of the drivel out of the way. I don't have the time to pursue every idea. As far as a finished piece goes, all I see are the imperfections. I smile and keep quiet, pretending they're not there and that they don't bother me. I'm always compromising somehow and settling for less than perfection, otherwise I don't think anything would ever get done. There is a side of me that takes over and says, "All right already, enough's enough, there is nothing more you can do. Just let it go."

JC—Do you have any advice for getting through a creative block?

BS—I don't have any little tricks to hand out, but what I usually do is move on, distract myself, and wait for it. I know that forcing something is not going to create anything beyond mediocre, so I step aside and work on a different project until it hits me.

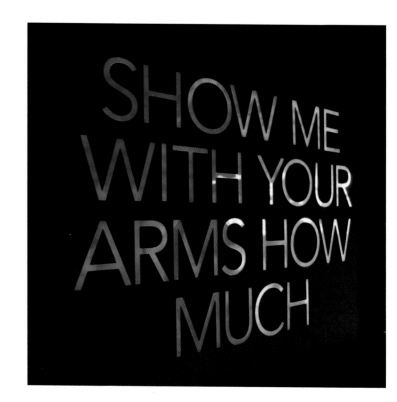

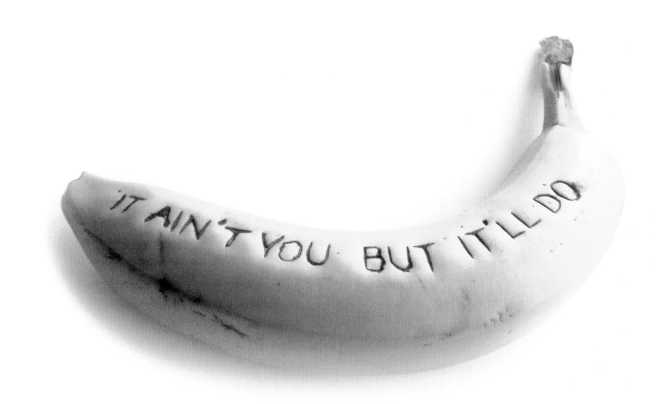

As far as a finished piece goes, all I see are the imperfections. I smile and keep quiet, pretending they're not there and that they don't bother me.

As far back as I remember, being an "artist" was the first thing I ever wanted to be when I grew up.

Creative *unBlock* Project No. 29

Stretch the boundaries of a material you are unfamiliar with. The less tradition the material has in art-making the better. Learn how to manipulate it in ways it wasn't meant to be, until it is almost unrecognizable. No paint allowed. Hold the purity of the material in high regard and try not to use anything other than itself.

Examples would be: a foam-core globe, a plate of spaghetti made from steamed shavings of plywood, a unicorn horn cast in sugar. The pairing of the subject and the material should resonate as a new and interesting object that gives their marriage meaning.

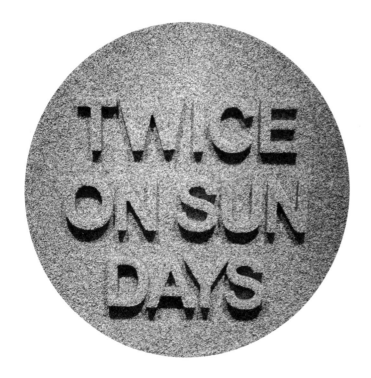

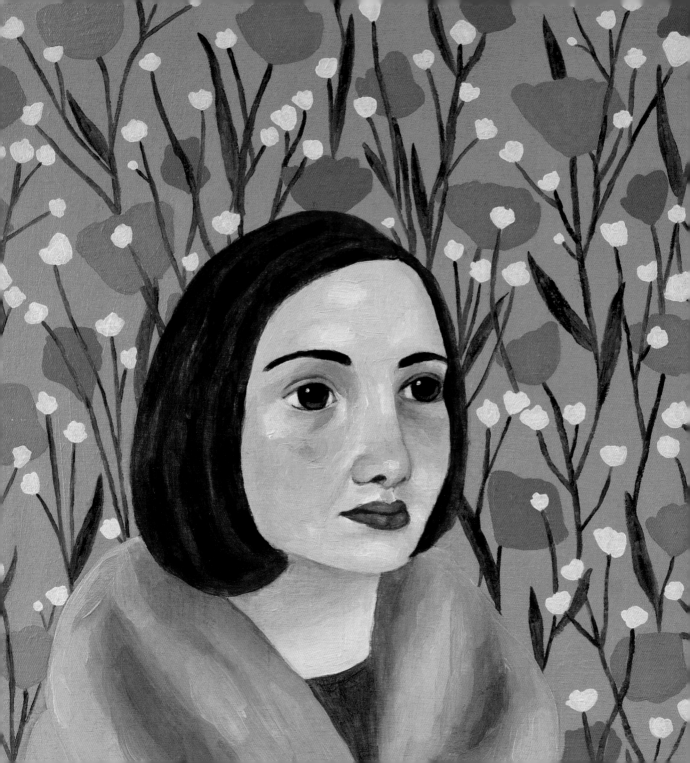

KATE PUGSLEY

PAINTING

USA

KATEPUGSLEY.COM

Kate Pugsley is a painter, illustrator, and printmaker living in Chicago. Her training in art came from years of classes as a child, a formal education in illustration from the Rhode Island School of Design (RISD), and years of experimentation on her own. The result is a huge body of work that is instantly recognizable as "Kate Pugsley." When asked what inspires her, Kate answered, "fresh paint, lakes, travel, family photos, lists, childhood, office supplies, coincidences, children's books, nature and sea life, history, fiction"— all of which is evident in her work. All right, maybe not the office supplies.

JC—**What's your favorite medium to work with?**

KP—I like ink and gouache for illustration, and oil paint when I'm working on personal pieces.

JC—**That's interesting—why oil paint only for your personal work?**

KP—I have a love/hate feeling toward oil paint. I love the richness and amazing colors that can be achieved, but the fumes bother me and the slow drying time makes it impossible for illustration projects. Even though I like working in gouache, I still always wander back to oil paint, because it really is so lovely.

JC—**Describe the first moment that you truly felt like an artist.**

KP—I was writing an essay about *Ethan Frome* in high school. I remember feeling frustrated because I wasn't a great writer, and I could have better expressed how much I liked the book through a drawing or a painting. Maybe I didn't truly feel like an artist, but it was the first time that I felt like I should pursue art in college.

JC—**What advice would you give your younger self about life as an artist? Pitfalls to avoid? Things to focus on or ignore?**

KP—I'd tell myself to be more bold, and less cautious. When I was younger I was afraid of experimenting and used to get stuck a lot. I would also say, work harder to avoid isolating myself—to share more with other people. The joy of working has gotten more intense as I've gotten older, and my younger self would probably like to hear that too.

JC—**What was the best bit of advice you ever got from a teacher at RISD?**

KP—I can remember one of my professors telling me not to listen to comments or criticism from friends and family who don't work in a related field. I like this advice.

JC—**Which artist's work/life/career are you most jealous of, and why?**

KP—I admire Beatrix Potter's life and career for many reasons, namely because she was a conservationist with an interest in science and nature, and because she was a strong woman who really made it happen for herself. I also think her books are timeless.

JC—**How do you push yourself through creative blocks?**

KP—I just have to keep working. It's not the easiest thing to work when I'm feeling uninspired or want to give up, but working through it is the only way I know to actually get better.

JC—**Have you ever given up on a painting?**

KP—I've discarded many paintings entirely or covered them to start over. Sometimes I know it's just not going to happen, no matter how many times I mush the paint around.

JC—**Do your commissioned projects drain or fuel your personal work?**

KP—The personal projects and commissioned projects work together to make each other better. The things that drain me are daily tasks around the house—but I can work all day and night if there are no interruptions!

JC—Do you ever equate your self-worth with your artistic successes?

KP—Of course. Maybe not "successes," but it's hard not to feel like the quality of the work I make reflects me as a person. I don't think it's really necessary (or possible?) to separate self-worth from artistic success. But it can certainly get you down when it just isn't working. The best thing to do at that point is try to ignore the pressure from your family to get a "real" job.

JC—How do you handle criticism, if it comes your way?

KP—It's never the easiest thing to hear, but I try to remember that it's just the opinion of one person. Everyone has different opinions and preferences, which is usually a good thing.

JC—Is your inner critic around when you're working?

KP—My inner critic is always around with something to say, and all of those things are true. Sometimes I can ignore it, sometimes I have to be talked down, and sometimes I can make it go away with careful concentration.

JC—Describe how it feels to be knee deep in a creative zone.

KP—It reminds me of receiving a fresh box of colored pencils and paper as a kid—feeling full of optimism!

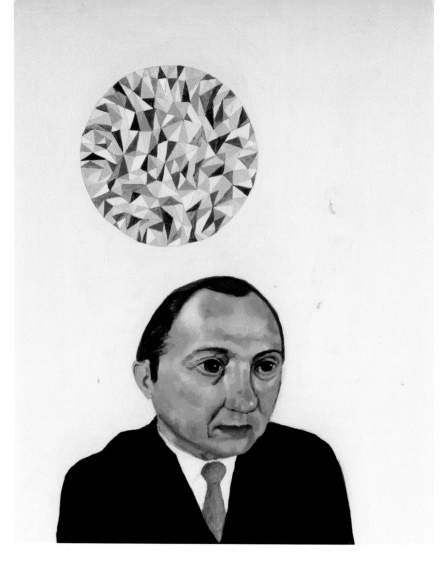

I don't think it's really necessary (or possible?) to separate self-worth from artistic success.

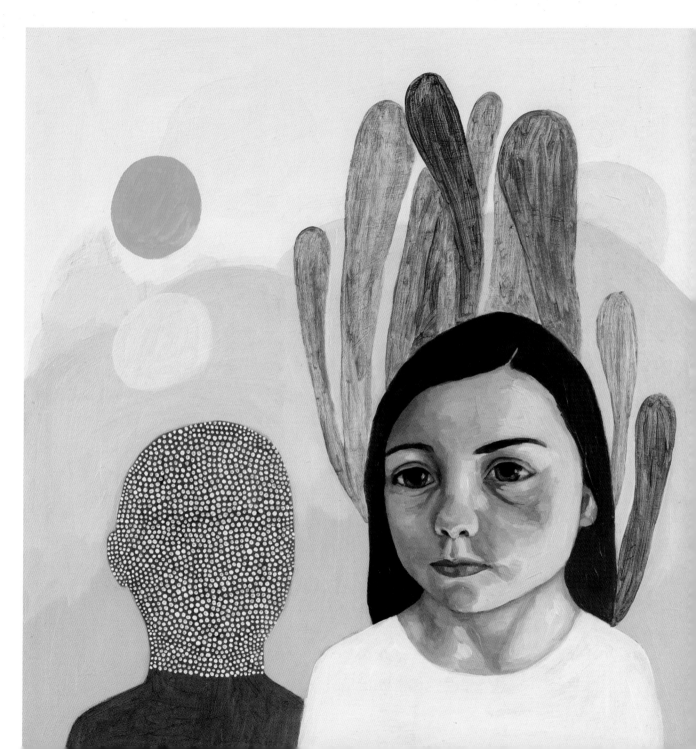

Creative *un*Block
Project No. 30

When I am in a creative rut this simple activity always helps me to get excited. Start with a stack of white or off-white papers. Sometimes I use scraps, or sometimes I take large pieces of drawing paper and cut them into pieces around 8" × 10".
Then get out your watercolors, acrylics, or other paint and mix up some of your favorite colors. Paint the surface of the papers. Sometimes just seeing all the lovely colors together on the papers inspires me. Once the painted papers have dried, get some scissors or an X-ACTO knife and cut out some shapes. They can be totally arbitrary or recognizable as objects, animals, faces, etc.

Open your sketchbook or get a blank sheet of paper and start arranging shapes. Just play with the shapes and colors, layering until you see interesting combinations. You can start gluing them down in your paper or book, painting on top of them, or just save the pieces you like. I keep envelopes around full of colored pieces for loosening up when I am stuck. Working with these painted shapes helps me see things that I may not see by just drawing or painting directly, because my mind wanders, and there are always a lot of surprises.

WENDY WALGATE

CERAMICS

CANADA

WALGATE.COM

Toronto-based artist Wendy Walgate is definitely educated in the arts. She received her BFA from the University of Manitoba, where she studied ceramics and printmaking. At Cranbrook Academy of Art she earned a MFA in ceramics, and then did a masters in the history of art at the University of Toronto. Well, all of that hard work definitely paid off because her work is absolutely stunning! Her ceramics have been exhibited (and purchased) all over the world— Toronto to Montreal, Brussels to Dubai, Miami to New York, and countless other stops along the way.

JC—When did you know that art was the right choice for you?

ww—During my first year at University of Manitoba, my rather stern drawing teacher had us do gesture drawings of a model. He marked this series of drawings and, a couple of weeks later, I walked into his classroom and my drawings, alone, were pinned up on an entire wall. He told the class that this was the way to do a gesture drawing. That certainly validated my choice of taking art.

JC—Why are you an artist?

ww—Because I can't do anything else. For financial reasons, I've done administrative work, service work, film industry work—and nothing lasts for long. The only place I can sustain my interest, a feeling of accomplishment, and longevity is in the studio, making things.

JC—Is there a particular artist that you admire?

ww—The German artist Katharina Fritsch is my idol. I love the monumental scale and striking color of her work, along with the iconic objects she produces.

JC: How long have you been working with ceramics?

ww—I've worked with clay for thirty years—moving from stoneware to porcelain, then to earthenware. The lower firing temperature of earthenware allowed the use of vibrant colors and thicker, more spontaneous construction (that wouldn't blow up in the higher temperatures firings!).

JC—Have you ever experienced a creativity-halting block?

ww—Oddly enough, I've being going through a big block over the last year. The style and technique used in ceramic work seems to be too repetitive now, and I feel that this series is finished. To move forward, I closed down my ceramic studio for a year, and now I'm renting in a collaborative space with other artists and starting to paint. I'm excited because I don't know what the end result will be—it's a mystery, and it's hard to do. That's probably a good thing.

JC—Did your inner critic have anything to do with this block?

ww—Once my inner critic gets going, there is no escape. Yes, when my ceramic pieces started to become familiar and too studied, the voice started: time to change—and how to do that? This dilemma went on for a couple of years until I acted, shut down my ceramic studio, and spent some time thinking about what to do next.

JC—Will your paintings be similar to the look and feel of your ceramics?

ww—Many of my ceramic pieces are about storytelling, particularly early children's fables, Aesop, etc. The use of animals in my work is part of my interest in animal welfare and vegetarianism. Today I am thinking more about landscape, sky, and openness. After years of tightly packed work, I want to have expansion and breathing room in my paintings.

JC—Do you have any tricks you use if you're having trouble with a piece?

ww—I usually start with color—either grouping monochromatic hues together or scattering many bright colors on the table in front of me. My ceramic pieces are built incrementally, and the gradual addition of colors on top of each other is a really exciting development to watch.

JC—Do you ever equate your self-worth with your artistic successes?

ww—Because I was older when I took the MFA at Cranbrook, the progression of my work was the most important thing to me. I had worked at many jobs and studios before I had the opportunity for graduate study. Getting into exhibitions and having my work noticed by galleries came naturally after my work reflected a mature and solidified idea.

JC—What is your advice for handling criticism?

ww—Go with it, and try to understand *why* it's being said about your work. I'm no genius and my work is only a reflection of my quirky insides—you just can't take offense at what others think.

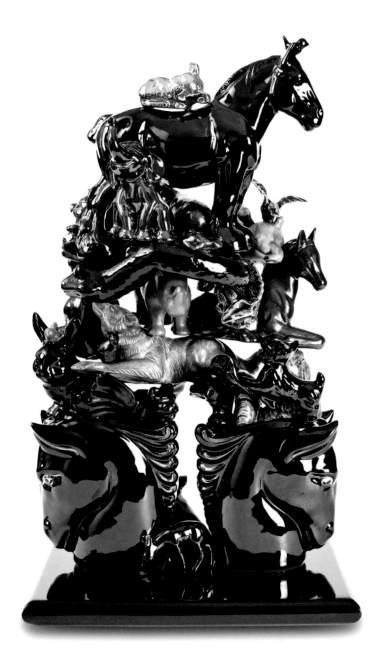

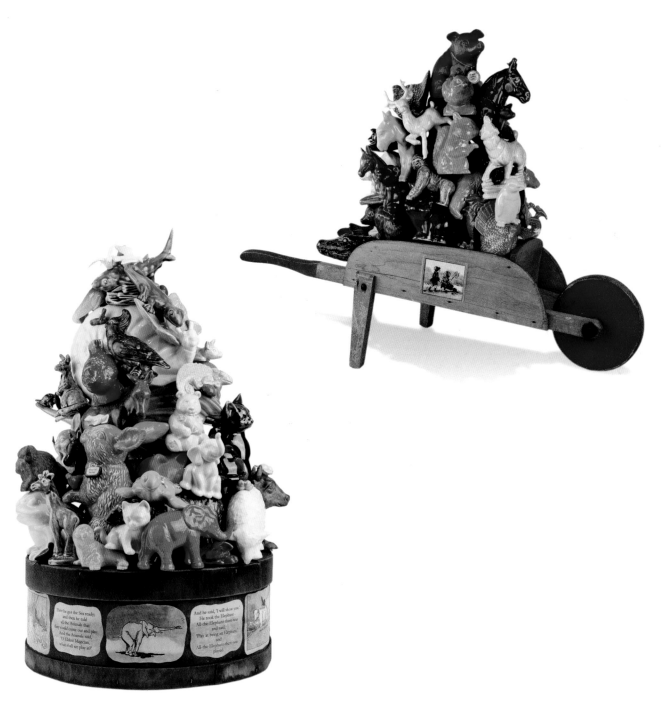

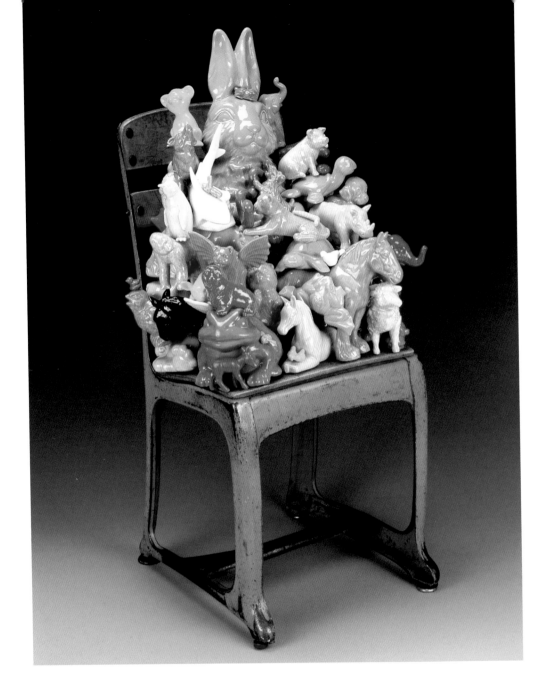

**Creative *un*Block
Project No. 31**

Make a piece that is generated from a narrative that you base on a medieval image, such as a fantastical animal, object, or person. Use found objects, manufactured objects, text, color, and assemblages to tell the story. Practice telling the story out loud when you show someone the finished piece—like a fable or fairy tale that is being passed along by word of mouth.

I'm no genius and my work is only a reflection of my quirky insides—you just can't take offense at what others think.

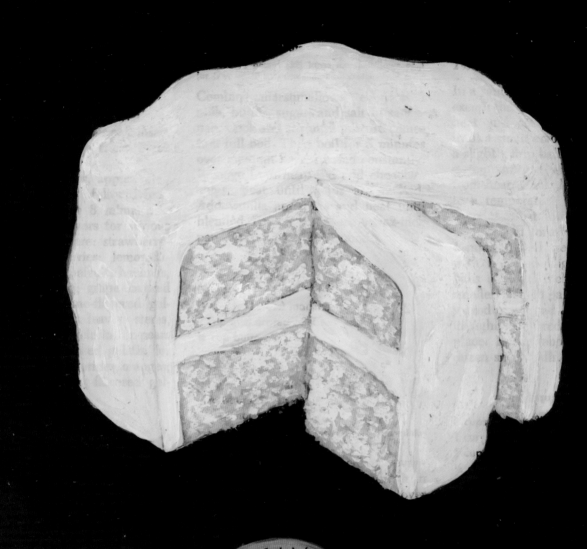

HOLY MOLY

MARTHA RICH

PAINTING

USA

MARTHARICH.COM

Martha Rich lived the typical suburban life—until she followed her husband to Los Angeles where, just short of a picket fence and 2.5 children, her average American life unraveled. To cope with divorce, fate led her to a class taught by painters, and brothers, Rob and Christian Clayton. They persuaded her to quit the corporate world and become an artist full time. She graduated with honors from Art Center College of Design in Pasadena. She now lives in her hometown of Philadelphia and, in 2011, received her MFA in painting from the University of Pennsylvania. She draws, paints, and uses words, all the while being absurdly funny.

Her commercial clients include *Rolling Stone*, *Entertainment Weekly*, Penguin UK, *McSweeney's*, the *Portland Mercury*, the *Village Voice*, *Bon Appétit*, the *San Francisco Chronicle*, Henry Holt, and Country Music Television, to name just a few. Her work has been featured in the Beck video "Girl" and a book, *Sketchbook Expressionism*, featuring artwork from her sketchbooks was published by Murphy Design. Martha's artwork has been shown in galleries throughout the United States and internationally.

JC—How old were you when you felt like you had become an artist?

MR—It is just starting to happen now—and I'm not telling you how old I am.

JC—Why are you an artist?

MR—So I don't have to work in a cubicle.

JC—If you weren't an artist, what would you be?

MR—Working in a cubicle.

JC—Congratulations on finishing your MFA! Did it have an effect on your work?

MR—I don't think it was dramatic at all. All it did was set in motion microscopic changes that are just now surfacing, but more in my attitude than the work. My MFA made me feel much more FU-ish about things.

JC—Yes. Art school can do that sometimes! Your work, before and after the MFA, is always filled with so many crazy things—what inspires your choices?

MR—Watching the *Real Housewives of Any City*. Ha! just kidding (well, not really). I find inspiration in everything: cake, wine, eavesdropping, riding the train, cities, ads, being annoyed and cranky, absurdity, lowbrow humor, laughing, lobster.

JC—What do you do if a piece isn't going the way you'd hoped?

MR—I just put it aside and start something new, or I'll do something dramatic to ruin it, like paint over it completely. You can't throw it away, because you'd be wasting materials. I use old stuff all the time for new projects.

JC—What is it you love about using old paper as your base?

MR—A clean white piece of paper or canvas is intimidating. I don't like to be intimidated.

JC—Which artist's work/life/career are you most jealous of, and why?

MR—I would say Gertrude Stein, mainly because of her salon in Paris. To be able to experience that would be insane! Bringing together creative people is something I love to do and wish I could do more.

JC—You make art and you also teach—do you find that creatively draining, or does it recharge you?

MR—My day job is being an artist. Yes, sometimes I teach, but that is usually only part of the day. I do have to say that teaching is completely draining.

JC—Where do you teach?

MR—I taught at Art Center College of Design for a while, then University of the Arts, and currently at Tyler School of Art, Drexel University, and Fashion Institute of Technology.

JC—What advice would you give to a student struggling with a block?

MR—I usually tell the students to set it aside for a bit and do some mindless doodles. If that doesn't work, then ruin it. It is freeing to ruin something. This often doesn't work with people who procrastinate, however, because you need to have time to make something new.

JC—Do you ever have creative blocks? How do you find your way through?

MR—Of course, but they don't usually last that long. I'll do something else to distract me, like take pictures, hang out with friends, go to a museum, eat at a good restaurant— and then something in my brain usually pops back into place.

JC—Do you ever equate your self-worth with your artistic successes? If you don't now, have you ever done that?

MR—I used to more, but getting older helps with that. I know my own worth, but I definitely have relapses. When that happens, I make up a fun project for myself.

JC—Can you give an example of one of these little projects?

MR—One was saving everything in my feeds (Facebook, Twitter, blogs) for one hour and then painting the random words to make something, which turned out to be a weird and random piece of art and a little slice of history.

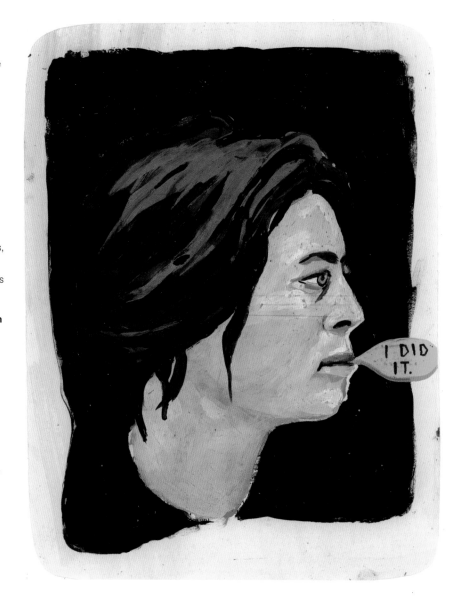

A clean white piece of paper or canvas is intimidating. I don't like to be intimidated.

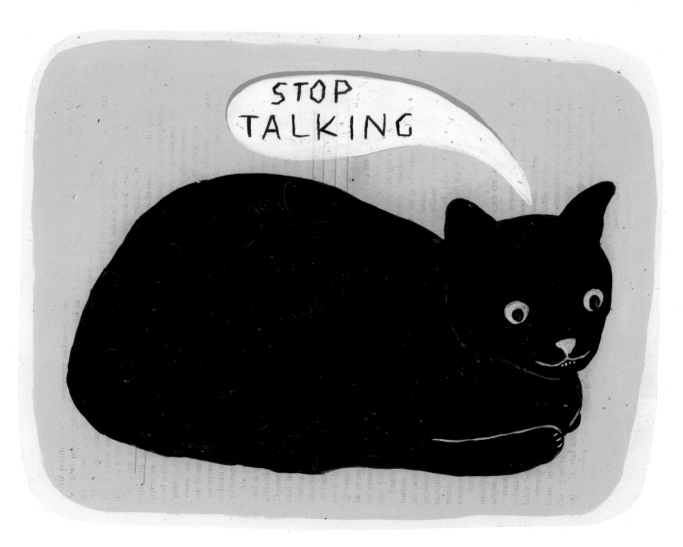

CHAIN SAW

Creative *un*Block
Project No. 32

Pick an interesting object and, in one sitting, draw/paint/represent it in a minimum of a hundred completely different ways. I use the example of a "ring." So you start by drawing a diamond ring, then maybe you draw a ring around Saturn, or ring around the rosie, and so on. Things get interesting when you start running out of ideas and are forced to get ridiculous and stop thinking so much!

LAURA MCKELLAR

EMBROIDERY/FIBER ARTS
AUSTRALIA
LAURAMCKELLAR.COM

By day, Melbourne-based artist Laura McKellar is a graphic designer—a graphic designer who grew up in a family filled with people who were constantly sewing, embroidering, and creating. It's no surprise then that her personal artwork begins on the computer, but ends up on fabric. Simple, graphic, bold images completely covered in skillful, delicate, stunningly beautiful embroidery. Ah, yes, the wonderful marriage of craft and design.

JC—Your work is a beautiful combination of techniques. What do you love about mixed media?

LM—I really love working on my computer, but I also find I need time away from the screen, and need to use my hands in a more creative way. Doing my embroideries, I spend the first half of my time on the computer and then move to working with the textile. It's a good combo for me and I can sit and embroider on the train! I believe mixed media is a way of giving depth. It creates a texture that you want to touch. Embroidery adds beauty and a personality that wouldn't necessarily be there otherwise. It's a time-consuming technique, and I think visually the audience gets a lot of feeling from that handmade aesthetic. Hand-embroidered pieces always have a lot of love put into them.

JC—Do you describe yourself as an artist?

LM—I've always been a creative person, and have always known I would be making artwork, whether it's personal work or as a career, for the rest of my life. I've never told anybody that "I am an artist," but I suppose I have known that I am since I could use a pencil!

JC—Why are you an artist/designer?

LM—Art and design are what I am interested in, and I find they both influence my everyday life. I didn't consciously choose to be an artist. I enjoy the way pictures can tell a story, and making pictures makes me happy.

JC—Where do you find inspiration?

LM—I find inspiration when I travel, around nature, in books, online, blogs. I like to discover new places and find new cultures. Being out in the world, far from home, realizing there is so much more [than the Internet]—those are the most inspiring times of all. Locally, I enjoy spending time at thrift stores looking through old books, going to the beach, and in the work of my sisters and friends.

JC—Do your artistic successes affect your self-worth?

LM—No, I don't feel it affects my self-worth. I am grateful when I can say I've been successful with some of the work I have done. I have learned it is not fair to compare myself to others and their artistic successes; it is detrimental to my own progression as an artist. Art is a very, very personal thing, and I am completely aware that it should never be something that brings me down. Everyone is on their own individual path, and my journey is my own.

JC—Do you think criticism is helpful?

LM—I think it's healthy to receive constructive criticism. In graphic design it is very important because you are designing for people; it is important to know how they feel about it, whether it's positive or negative. It can bum me out for five minutes if I am really happy with how something is going and it is criticized or the client doesn't like it, but I would rather receive criticism than do something that is not going to be a success.

You should never be afraid to experiment; that is how you become a genius.

Creative *un*Block
Project No. 33

1. Find a nice clean piece of fabric—the fewer bumps and fuzzy bits the better. Measure it up against a thickish piece of paper that will fit in your printer. Cut it with an extra two inches on either side—you will be taping these to the paper to secure the fabric.

2. Put the paper on top of the fabric with at least a 2½-inch gap of paper at the top. Tape the sides down on the back of the paper. The fabric is now secure and smooth so the printer will recognize it as paper!

3. Find a picture or photo or create an artwork in Photoshop! Put the paper into your printer, with the big gap of paper to go through first (at the bottom), and print. If the printer rejects it as first, try and try again.

4. Your picture has now printed onto your fabric. Give it a couple of light sprays with fixative—don't drown it or the picture will run.

5. Pull all of the tape off. You could now stretch it around a premade canvas—or try something fun! Do some embroidery, sew on some beads and sequins, color in some areas with pencils or fabric markers.

6. You should never be afraid to experiment; that is how you become a genius.

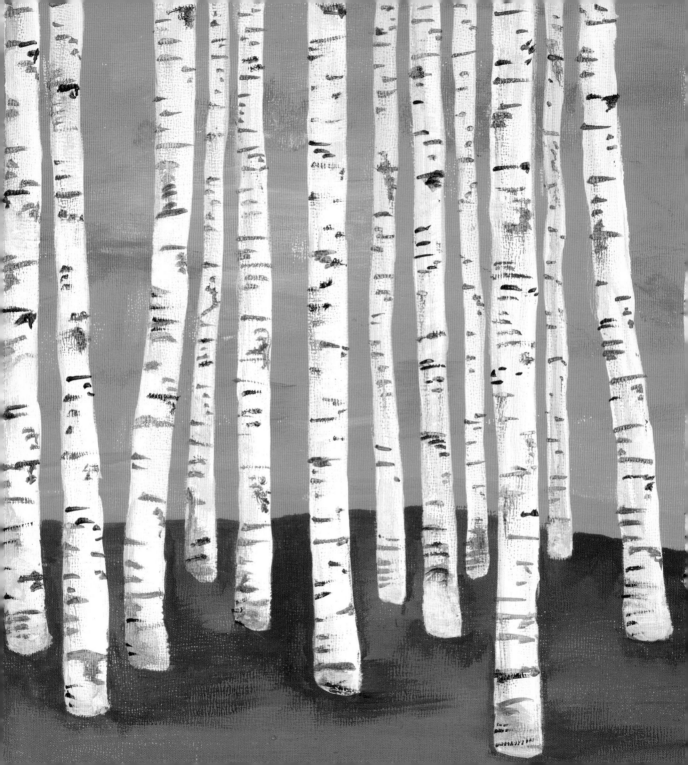

LISA CONGDON

MULTIDISCIPLINARY

USA

LISACONGDON.COM

Painting, drawing, mixed media, illus-tration, hand-lettering—Lisa Congdon does it all, and she does it all very well. She was an elementary school teacher for years, and didn't take her first painting class until her early thirties. She now makes a living solely from her artwork, which includes both commis-sioned illustrations and personal art projects. She has done an amazing job of promoting herself—not always an easy task for an artist! Lisa has created a huge online following through her blog and her Etsy shop. She now spends her days in her lovely studio, where she illustrates books, designs wallpaper, creates custom fonts, and paints her heart out. Oh, and she also happens to have a couple of her own books under her belt . . . with a few more underway!

JC—When did you start to feel like an artist?

LC—I didn't start making art until I was about thirty-two years old. I was asked to show my work publicly for the first time when I was thirty-seven. I remember the day I got the e-mail from the small shop and gallery in Seattle where I had my first show. I was at my job, behind my desk in my little office, and I remember totally freaking out, and thinking, "OK, *now* I'm an artist," even though I had already been making work for five years.

JC—Would you ever give up on a piece? If not, how do you push through?

LC—I have become really good at pushing through! I took a couple painting classes from this guy about ten years ago who used to talk about "the painting curve," which looks like a "U." He said when you start out, you are at the top, everything looks good at first. And then you start adding layers, and it gets messy and things might even look distorted and horrible. This is when you are at the bottom of the curve. This is also where you need to push through to get back to the top. I have learned to push through the bottom of the painting curve after years of practice. And that most of the time it pays off. There are rare occasions where paintings or drawings or collages aren't successful after working at them for a long time, but those times are rare. I am always pretty determined to keep going.

JC—Is your day job as an artist/illustrator a creative drain, or is it fuel for your personal work?

LC—I think *because* I spend most of my time illustrating other people's ideas or words, I am so motivated to work on my "own" stuff that I am completely excited to draw from my own inner landscape, when I have the time. I think it's important for me not to think of my per-sonal work as something that I do only when the illustration work is finished or when I have an upcoming show at a gallery. I need to make time for personal work all the time, *especially* if I'm feeling drained from the other stuff. That is easier said than done, but I'm working on it.

JC—How do you deal with your inner critic?

LC—My inner critic talks to me every day. I do lots of inner pep talking to combat the voice that tells me my work sucks, or that so-and-so isn't going to like it. I have been doing this art thing for a few years now, and one thing I have learned is that by the time I finish a piece I usually hate it, because I have been staring at it and belaboring over it for so long. But most of the time I show it to the art director or client or my friend, and they like it. Sometimes they *love* it. And that gives me some perspective. I realize now that what I'm critical of in my own work, other people don't see. Most of the time, they see what's beautiful. And that's the great thing about being an artist. Your own inner critic is always going to be overshadowed by the love that other people have for your work.

JC—Where do you find inspiration?

LC—As a regular part of my art and illustration work, I reserve days just for gathering inspiration and brainstorming ideas. I make mind maps of potential imagery or materials, make lists, scour images on the Web, go to bookstores, etc., etc. I have to think about it as part of my job, because it really is part of my creative process that leads to the making of things.

JC—How do you navigate your way through a creative block?

LC—Getting through a creative block can be a really agonizing experience. Sometimes I don't do anything but sit and stare at the floor or wall in my studio for a period of time until I get some inkling of resolve to take a certain direction or make a certain leap. I find that just sitting with my discomfort for a while and trying to figure out where it's coming from can be helpful. I think a lot of the time creative blocks are caused by simple, solvable things like hunger or sleep deprivation. But they can also be bigger things like fear of the unknown, or not having the right skill set, or of making something ugly. So my first step is to figure out if I need a snack, or a nap, or if I am really scared of something. If I'm scared, I try to remind myself that if I end up failing, only I need to know about it; my studio is a safe place for experimentation and failure.

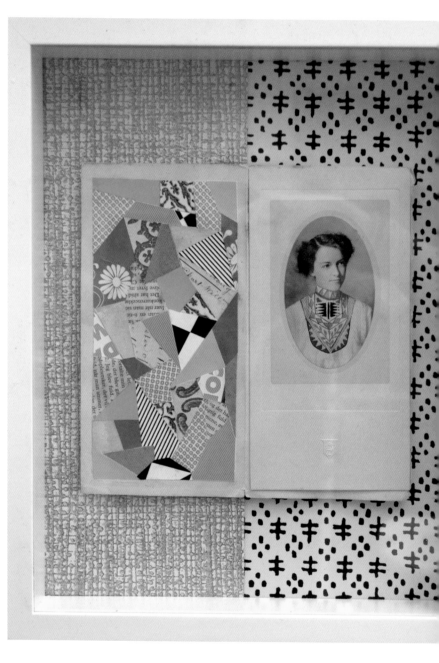

If I end up failing, only I need to know about it; my studio is a safe place for experimentation and failure.

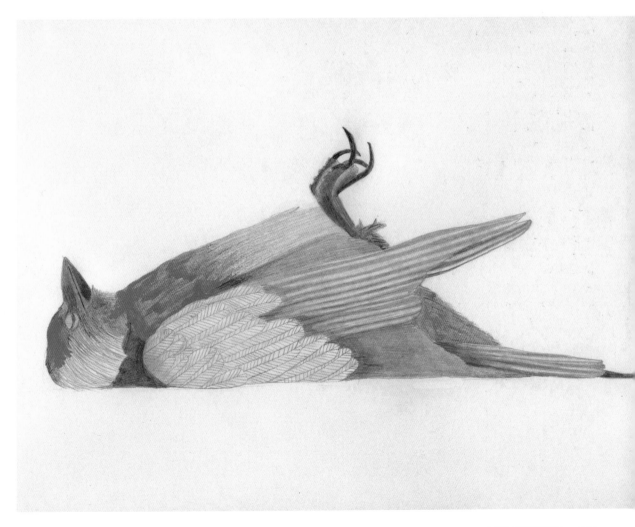

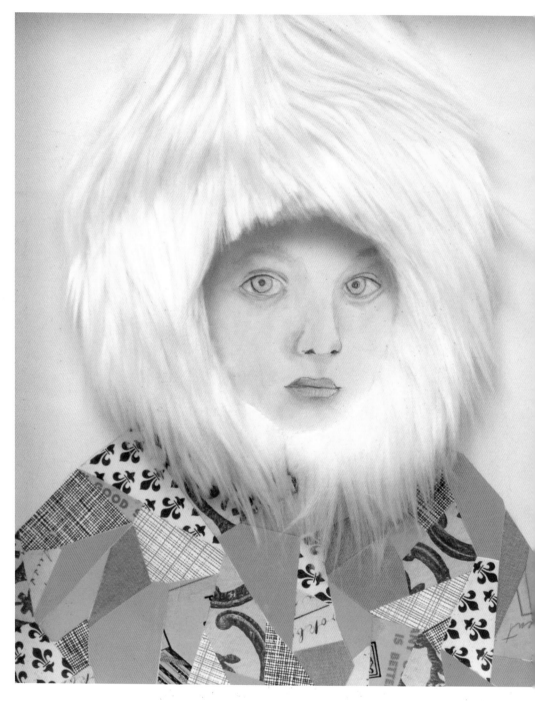

I need to make time for personal work all the time, especially if I'm feeling drained from the other stuff.

LESLIE SOPHIA LINDELL

Creative *un*Block Project No. 34

Choose one thing you love to draw or paint (and feel comfortable drawing or painting) already: an animal, object, a person, whatever. For thirty days, draw or paint that thing thirty different ways, a different way every day. You can use different mediums, expressions, positions, colors, whatever. Each day, push yourself to do something much different than the day before, but keep the subject the same. See how keeping one element constant (in this case, the "thing" you love to draw or paint) can allow you to break out creatively in other ways.

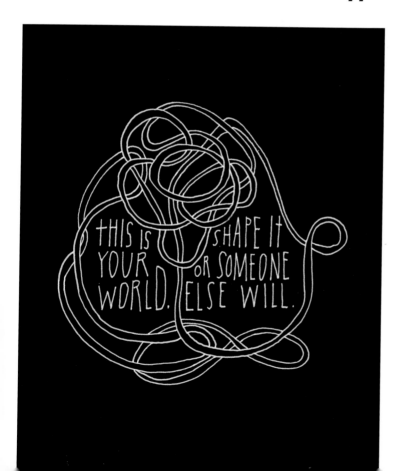

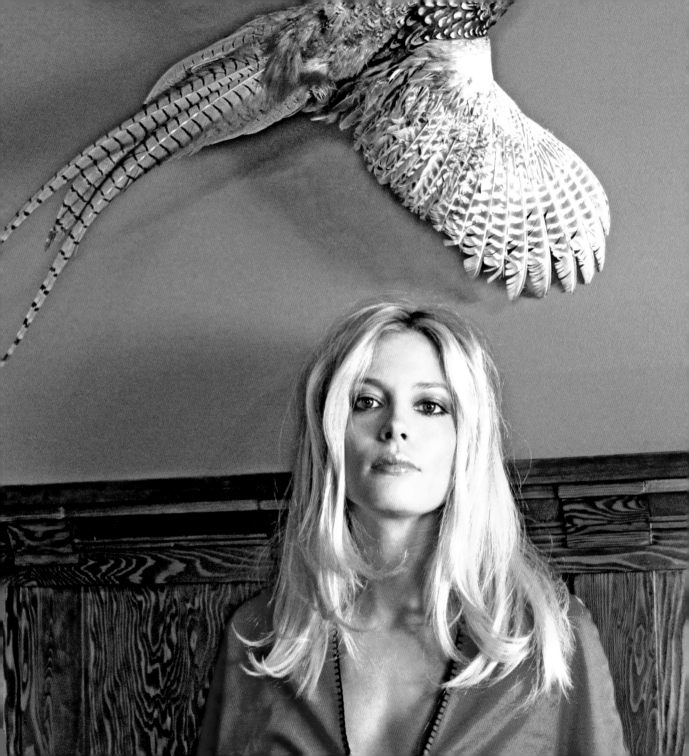

STEPHANIE VOVAS

PHOTOGRAPHY

USA

STEPHANIEVOVAS.COM

American photographer Stephanie Vovas has been a lot of places and seen a lot of things. After traveling around Europe and the United States, she decided to pursue her passion for photography, and went back to the East Coast to study at the Maine Media Workshops. She got an AA in photography, and then moved to Portland, Oregon, where she started a gallery called Barcalounge. She exhibited her own work and curated shows of other artists—and loved it! However, after three years Stephanie wanted a change, and so she made her way to Los Angeles. She started working as a designer for several magazines, and like many part-time artists, no longer had time for photography. Luckily, she changed that. She is now a full-time photographer who specializes in celebrity shoots. That's right—she's taking photos *for* magazines instead of designing them!

JC—Why do you take photographs?

SV—Because it feels awful and depressing not to make pictures. It's a very painful feeling to not make stuff. I get edgy and lose self-esteem when I am not making anything new. I went for a number of years without really making much work, and I felt so empty, as if life was passing me by. I would wake up in the middle of the night in horror at the realization that all I was doing was working, and I was letting my art and passion slip away, neglected.

JC—How did you make the time and space to start creating again?

SV—It's kind of funny, because it wasn't me that changed it. It was the recession! I lost my great-paying job (designing men's magazines). All of a sudden, I had time! No more ten-to twelve-hour days working. Around the same time, a friend asked me to take a photo class with her. I spent my last $800 on it, and started shooting again. I bought a digital camera with the very last of my credit. I figured I was broke and jobless anyway, why not go for it full force! I scraped by and put shoots together on a shoestring budget.

I started making work that surprised even me—I didn't know if I had it in me anymore, but it was coming out with a passion. After a year, I got some photo assignments shooting celebrities! And then I got a show, and now I am slowly building up a client base of magazines and doing clothing campaigns. The crash was hell, but it kind of saved my life. I am now doing what I want to do—and I don't wake up in horror anymore.

JC—Do you consider yourself an artist now?

SV—It wasn't until quite recently that I felt even an inkling of being an artist. I've always put that term on a pedestal. I also never thought photographers were "artists"; they were "photographers." It was a separate thing in my mind. But I have come to realize that all the work it takes to make a vision come to life in a photograph is definitely an art.

I guess the first moment I felt like "an artist" was during my solo show in 2011. Age forty-two! After working so hard, and then seeing the gallery with all my pictures on the walls, that was it. It gave me some confidence that I didn't have before. It's a great feeling, but it is a fleeting one. Maybe in a couple more years I will wear that badge without feeling strange.

JC—Which artist's work/life/career are you most jealous of, and why?

SV—Helmut Newton. His pictures bring you into a world like no other. One where women are incredibly intriguing and mysterious, and the locations are foreign and exotic. There is something you can't quite figure out, like you are only getting a small portion of the story, and you want to know more. He had an amazing life, and created an incredible and completely original body of work. It doesn't get much better than that!

JC—What inspires you?

SV—The culture of the 1970s, in the form of interior design, films, TV shows, music, movies, beauty ideals, fashion, and the changing social landscape of that era, thrills me. People were trying new things, new behaviors, new clothing, new drugs, new ideas, and they looked so wild and funky doing it.

I am also inspired by people, especially funny people who are uninhibited. Being with uninhibited people is so liberating to me, because I wish I were that way. I am a pretty shy person, and can be anxious about being around people. Spending time with outgoing people who don't care what people think of them makes everything seem possible to me—free from my inhibitions. I thrive on that kind of energy. It's like a ticket to Freedomville.

JC—Do you ever have creative blocks?

SV—Yes, unfortunately I do. Luckily, blocks are temporary, and you need to either wait them out or beat them away aggressively. Talking about it with people helps. Taking my mind off it also helps, especially watching movies. And, some of my best ideas have come to me while running and listening to Janis Joplin or Led Zeppelin.

JC—How do you think artists should handle criticism?

SV—Openly, and thoughtfully. I take in what someone says to me, think about it a lot, and decide if there is learning to be had from it. Usually there is. If not, then you can brush it aside.

Thoughtful criticism can hurt, but it is the most precious gift—it helps your art grow and change into something better. It kicks your butt and makes you want to work much harder.

I bought a digital camera with the very last of my credit. I figured I was broke and jobless anyway, why not go for it full force!

Creative *un*Block
Project No. 35

Take one object you are drawn to, and make a piece out of it.

If you paint, make a painting about it; if you photograph, make a photograph about it, etc.

When I was in school, I was looking at a scarf that was on a fellow student's neck. For some reason, I felt obsessed with it. I borrowed the scarf, and did a whole shoot with only the scarf as inspiration. It worked. This can become a big project, or at least get you into the habit of paying attention to the things you are drawn to—you can then use it as a way to break down that nasty creative block. Your attractions to small things are little gifts, or clues, as to what you should be exploring further. Delve deeper.

DOLAN GEIMAN

COLLAGE/MIXED MEDIA

USA

DOLANGEIMAN.COM

A three-month hiatus in a small town on Chesapeake Bay changed the life of Dolan Geiman. He and his wife (and business partner), Ali Marie, decided to take a break from the city to clear their heads, gain perspective, and put a life plan together . . . and that they did. After reconnecting with the country-side, restocking materials, and, most importantly, fine-tuning a business plan, they returned to Chicago with purpose. Since then, Dolan has been hugely successful with his mixed-media pieces, all of which are created from found materials—wood, aluminum, ancient tin from a barn roof—even old tractor parts, which he flattens with a mallet, become his canvas. Each piece has its own personal history, and its own beautiful story to tell.

JC—Are you formally trained or self-taught?

DG—I'm glad you brought this up because it gives me a chance to soapbox for a second. Ha-ha! Creative education is an ongoing process. Over time, the individual gains the tools, techniques, and such ingredients that eventually become the bread that is slowly rising. To think of it a different way, if there is no creative egg in the individual to begin with, I believe there will be no hatching of art. So . . . where was I? Oh, yeah, I'm kind of self-taught, with a little training thrown in.

JC—Describe the first moment that you truly felt like an artist.

DG—My mother is an artist, and I grew up knowing that I was an artist as well. She always affirmed that for me. However, I had a realization in college, probably my first design class. I saw one of the other student's sketchbooks, which he made out of an old telephone book, and I thought, "Wow. You can do that?" Every day in school and life, you are being told all of the rules. Math has rules. Science has rules. The bus driver has rules—the recess class even has rules. There are rules posted everywhere in life—signs telling you what you *cannot* do. Then you have the artist, who is trying to eliminate the rules and use this freedom of expression. So when I got to that first design class, I finally found my tribe, and my mind opened up—I was like a little fish thrown into a giant sea.

JC—What do you do if you're having trouble with a piece?

DG—If the piece I'm working on starts to look horrible, I grab a graphite stick, scribble over it like a big kid, and then paint over it. I get a really great feeling when I paint over a piece that's gone wrong—it's almost magical, and usually the second attempt comes out much more successful. There's no such thing as saving a piece from certain death. Once it's on the edge of the cliff, it's best just to push it off the edge. I refuse to let something live in my studio if it looks wrong to me. It's bad karma for the rest of the children. (I call my art pieces "children." That's not creepy, right?)

JC—Well, maybe a little! So, as a full-time artist, do you ever feel pressure to be creative all of the time?

DG—Selling art is how I pay my salary, my wife's salary, the salary of our few employees, and, most importantly, our cat. When placed in a situation like that, if I don't produce art-work at the drop of a hat, I'm fucked. What this has done over time, however, is to put my creativity into a sort of exercise mode. I use it every single day, and the more I require of my creativity, the more it must respond. I do, however, allow myself the time to have creative blocks. For example, if I have a strict deadline for a client, I will build the creative blocks into the deadline, i.e., two weeks for creation of the piece plus three additional days for creative blocks, projects mishaps, etc. In this way, I adjust to the block by accepting it as a normal part of the creative process, so that it becomes more of a hurdle than a wall.

JC—How do you jump those hurdles, a.k.a. creative blocks?

DG—My creative blocks are usually in two categories: Sector One or Sector Two. Sounds intimidating, doesn't it?

Sector One blocks are the ones I get when I start feeling a little burned out and don't really have any new ideas. The way I deal with these is to work on small pieces or do tedious studio work, just something that can be productive. I may mop the studio or something like that.

Sector Two blocks are the heavy bastards. These are the debilitating ones, the ones that make me not want to come in to work, and so . . . I don't. When I get swept down by these it's best to just stay down. These are the kinds of blocks I get after a huge project is finished, and I'm starting three more huge projects. I've found that these usually occur because I need to recharge, i.e., time to go hiking or camping or fishing or something involving trees, and water, and no people.

JC—When do you get your best ideas?

DG—Usually when I'm just waking up. I think it's because the brain is in a state of rest and has no real outside distractions. It's easier to pull the ideas out of the swamp when the mosquitoes and frogs aren't jumping around.

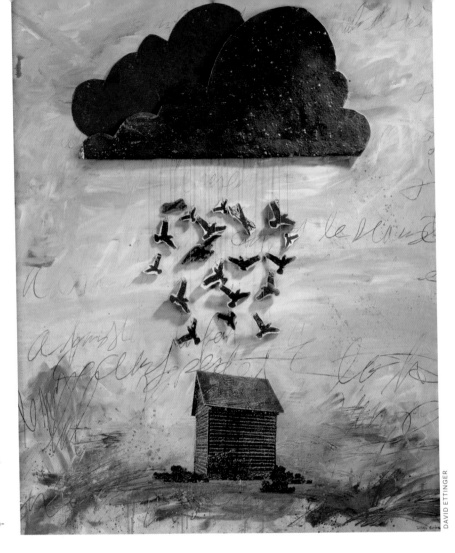

DAVID ETTINGER

I adjust to the block by accepting it as a normal part of the creative process, so that it becomes more of a hurdle than a wall.

There's no such thing as saving a piece from certain death. Once it's on the edge of the cliff, it's best just to push it off the edge.

Creative *un*Block
Project No. 36

Take a walk with a paper bag and a pencil or pen. On your walk, look for rocks that are chicken-egg size or a little larger. Pick up sixteen of these in different shapes and put those in your bag. Once you have the rocks, find a place to sit in the sun. Tear open the paper bag so that you have a relatively rectangular piece of paper. Lay out the rocks in a grid on the paper, with plenty of space in between each rock. Trace the outline of each rock. While the sun is out, leaving the rock where it is, also trace the rock's shadow. Next, move the rock and fill in the shadow part with your pencil or pen. In the inside of the rock outline, write down all of the colors you see on the rock and the most accurate description of the placement of those colors. Try to be as creative and descriptive with the color names as possible, for example: burnt pumpkin-colored stain on the lower part of rock, wet moss color in rock dimple, etc.

Once you have done this for each rock, make a little rock cairn, and leave it behind in the forest for someone else to discover.

MEL ROBSON

CERAMICS

AUSTRALIA

FEFFAKOOKAN.BLOGSPOT.CA

Mel Robson is a ceramics artist based in Brisbane, Australia. She has a bachelor of visual arts from Southern Cross University, Lismore, and an advanced diploma of arts (Ceramics) from the Southbank Institute of Technical And Further Education (TAFE) in Brisbane. She works mostly in porcelain, and creates gorgeous work that is both functional (e.g., bowls, cups, plates) and nonfunctional (e.g., guns, pigeons, and flowered cutlery!). Mel has exhibited her work extensively, both in Australia and overseas, including stops in Korea, Japan, Sweden, and the United States, just to name a few. She attributes her inspiration to some wonderful women in her family—charming characters who have been the starting point for much of her lovely work.

JC—Have you always wanted to be an artist?

MR—I never really planned on being an artist. It was a surprise to me. And probably to most people who knew me. I'm not quite sure how it happened. But I guess it's the way I process things. Making things helps me process my thoughts and experiences.

JC—When did you start to think of yourself as an artist?

MR—I think it was when I sold my first works in an exhibition while still a student. I was euphoric that someone would actually pay money for something I had made. That made me an artist! It was a short-lived sense, however, when I found out the next morning that it was my *mother* who had bought the work (bless her cotton socks)!

JC—That is fantastic! Well, clearly she loves your work! Which artist's work do you love?

MR—An Australian ceramicist named Kirsten Coelho. I have two of her pieces, and they thrill me on a daily basis. It's hard to put my finger on it exactly—everything about them just speaks to me—the forms, the surfaces, the simplicity, the nod to nostalgia and days gone by. There is a serenity in her pieces that just makes me take a big, deep breath and stop for a moment.

JC—What inspires you?

MR—I am mostly inspired by the very daily things around me. No great wild inspirations. Just the simple stuff. It's easy to overlook that for seemingly bigger and greater things. But there's a lot of meaning in the ordinary, the small, and the everyday.

I also spend a lot of time in libraries. Sometimes I go to research a specific thing for my work. Other times I just go and browse, and graze, and wander. There's always something weird and wonderful to be found among those shelves—endless sources of inspiration. Sometimes the most unexpected things jump out at me and take me off in a new direction. Every time I walk into a library I get butterflies in my belly.

JC—Besides a visit to the library, do you have a trick for getting "unstuck"?

MR—Yes. Talking out loud. Sometimes just saying things out loud can give you a little more clarity than the masses of foggy things floating around in your head. It's nice to be able to talk it through with someone, but if no one is around I'll talk to myself. I think it's just verbalizing the problem that seems to shift things for me.

JC—Is that your main method for getting through a creative block?

MR—I don't have one method for pushing through—each time is different. Sometimes I shove things into the back of my mind and let my subconscious do its thing. Other times I have to just keep making and making and push through it. I often have breakthroughs in my sleep. I put it in my mind as I nod off and then wait for those lucid dreams in the wee hours of the morning. It works surprisingly well. Those lucid hours can result in some remarkable ideas and answers and unblockages. Deadlines are also effective!

JC—Would you ever give up on a piece, or do you persevere?

MR—One of the difficult things in working with clay is that it can look really ugly until it has gone through the final firing process. Then it is transformed. So mostly I try to persevere and not give up too early. Give the piece a chance. But, sure, sometimes you have to just accept when something is not happening. I am pretty tenacious though. I don't like a material to get the better of me and will persevere until I figure it out.

JC—Do you ever equate your self-worth with your artistic successes?

MR—I think I probably did a little when I was younger, and when I first started out, but not so much now. Making art is only one part of who I am and what I do. It's important to remember that, but easy to forget, because so much of who you are and what you think is invested in what you make. It is a reflection of yourself in many ways. But like anything, it's about balance and about keeping things in perspective. I try not to take it all too seriously.

JC—What's your advice for handling criticism?

MR—I think it's important to remember that making art is a process. It is never finished. The occupation itself is one of process, exploration, and experimentation. It is one of questioning and examining. Each thing you make is part of a continuum, and you are always developing. You don't always get it right, but I find that approaching everything as a work in progress allows you to take the good with the bad. You're never going to please everyone. Take what you

can from criticism, and let go of the rest. When it comes to constructive criticism, I welcome that and think it is important to have people you can discuss your work with who will give you honest and constructive feedback. It's not always what you want to hear, but that is often exactly what is needed. It can be very confronting, but very useful.

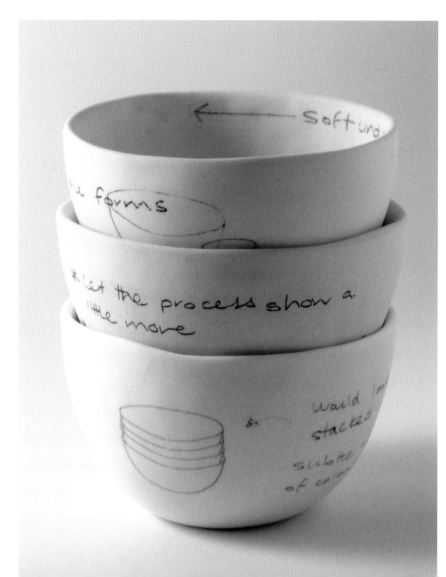

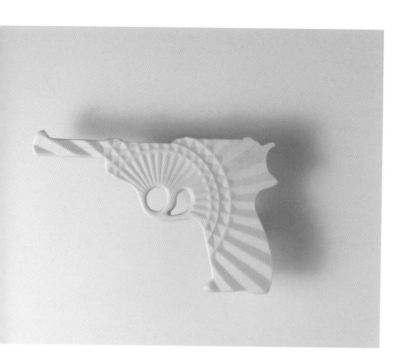

Choose a mode of transport—bike, train, foot, bus, car, roller skates, unicycle. Throw a die to determine how long you will stay on that mode of transportation. A 3 followed by a 2 means you stay on for 32 minutes. A 2 followed by a 4 means you stay on for 24 minutes.

Ride for this amount of time, and then stop. This is where you can spend the next hour (as long as you feel safe). Explore. Observe. Collect. Walk around, watch, draw, talk, sing, listen, sit, take photos, record sounds—whatever takes your fancy. Just explore somewhere new. Really take notice. The idea is just to let something completely random perhaps lead you into something new.

When you get home, choose one (or some) of these new observations—a photo, a drawing, an object. Display them in a special spot in your studio or your home. Title each one so that they become little art objects all unto themselves, and a daily reminder of the importance of taking notice.

I was euphoric that someone would actually pay money for something I had made. . . . I found out the next morning that it was my mother who had bought the work (bless her cotton socks)!

CAMILLA ENGMAN

PAINTING/ILLUSTRATION

SWEDEN

CAMILLAENGMAN.COM

Camilla Engman is a multitalented artist from Sweden. She studied painting for two years at Dômen Art School, and then graphic design at the College of Arts and Crafts in Göteborg. She has since spent many years experimenting with techniques and materials in her lovely studio, also in Göteborg. She paints, draws, collages, makes objects, assembles and photographs amazing collections of things, all of which have been exhibited worldwide. Outside of her fine artwork, she has been commissioned to create illustrations for a huge list of magazines and a number of beautiful, beautiful books. And speaking of beautiful books, *The Suitcase Series Volume 1*, published by Uppercase, is an excellent sneak peek into Camilla's lovely, creative, inspirational world.

JC—You make a lot of things. Which materials do you love most?

CE—I love paper! Paper and pen, nothing beats that. When I paint, I use acrylic colors. I like how it looks, but I would never say that I love it. I might say that I love my computer and that maybe I couldn't live without it—but just maybe.

JC—Which artist's work/life/career would you like to have?

CE—Hmm . . . Why not Pablo Picasso, for his long career and to have been around when so much was happening in the art scene? To sit at a café in Paris, talking to Jean Cocteau about Igor Stravinsky. To have Gertrude Stein introduce me to Henri Matisse. To be in the middle of such an exciting period, and to live such a long life.

JC—Describe the first time that you truly felt like "an artist."

CE—I still have my doubts.

JC—What brings on a creative block for you? How do you get through it?

CE—For me, a creative block usually means that I am tired, that I've worked too much for a period and just need to take it slow for a day or two. Sometimes it's that I lack confidence, so I'll have to make myself so inspired that I don't notice the scariness. I start in a new direction, change the material, or work with old stuff until I relax again.

JC—Where do you find the inspiration that helps you ignore the scary part?

CE—My number-one source is film. Looking to a film filled with pictures, colors, and feelings—nothing beats that. Number two is music (I'll get that too watching a film, if I'm lucky), but that takes more effort to absorb. And then, of course, the Internet, books, and magazines.

JC—Do you ever get overwhelmed by the amount of amazing artwork that you can find online, in books, and in magazines?

CE—I usually don't get overwhelmed, but I often feel like I want to be part of *everything*. And that I want to do so much more, try more materials, work in other directions, and so on—because of all the great work out there.

JC—You are an illustrator by day—does this drain you creatively, or does it fuel you?

CE—It depends on the assignment, and where I am in the process. Getting started is the most time- and energy-consuming part. I think the illustrator steals from the artist (time and ideas), and since illustration assignments often involve other people, it will always come first, and the art part last. Painting needs so much time and "air" around it—it's almost impossible to do something else at the same time. It can also feel like my hand and brain are set in illustration mode, and if I am supposed to do art I'll just have to wait. So I guess the simple answer would be yes, it somewhat drains me, but I wouldn't like to have it any other way.

JC—Could you give one little trick to use when a painting isn't working?

CE—Sometimes it's hard to see what's wrong, what needs to change. That's when turning the painting upside down, or looking at it in a mirror, is a good trick.

JC—How do you deal with criticism—positive and/or negative?

CE—Positive criticism I don't trust, and the negative sticks . . . that says it all, I'm afraid. I wish it were different, but it's not. I'm not good at getting criticism, so I try to avoid it.

JC—Does your inner critic ever get to you?

CE—Yes, of course, it gets to me sometimes. You'll get a creative block if you listen to your inner critic too much. It can feel like you're not good at whatever it is you're doing. If that happens to me, I'll have to start over, ignore, work. I don't think it's all bad. This is also what makes me work harder, and not leave things half done.

JC—Describe how you feel when things are truly flowing.

CE—It feels like being an alchemist and that everything is possible. Maybe I could even make gold!

Sometimes it's hard to see what's wrong, what needs to change. That's when turning the painting upside down, or looking at it in a mirror, is a good trick.

Creative *un*Block
Project No. 38

Organize a collection of things.

The human brain seems to want to understand things. If you put two things together it immediately starts to think about why and what. For me that makes up a story. Collect things—it can be anything, but preferably not too big—randomly, or by color, shape, or use. Organize them in a square on your table and see what happens. Is there a story?

Draw the shape on paper and cut it out, do a new collection or collage. Or write a story—what has happened—did someone turn their bag inside out, is this what someone wants to have if the house is on fire, is this what you would need to make a machine that will take you to the future? You can continue forever. Suddenly you have found something that gets you going—then go for it. Paint, draw, sculpt, photograph, or collage your story.

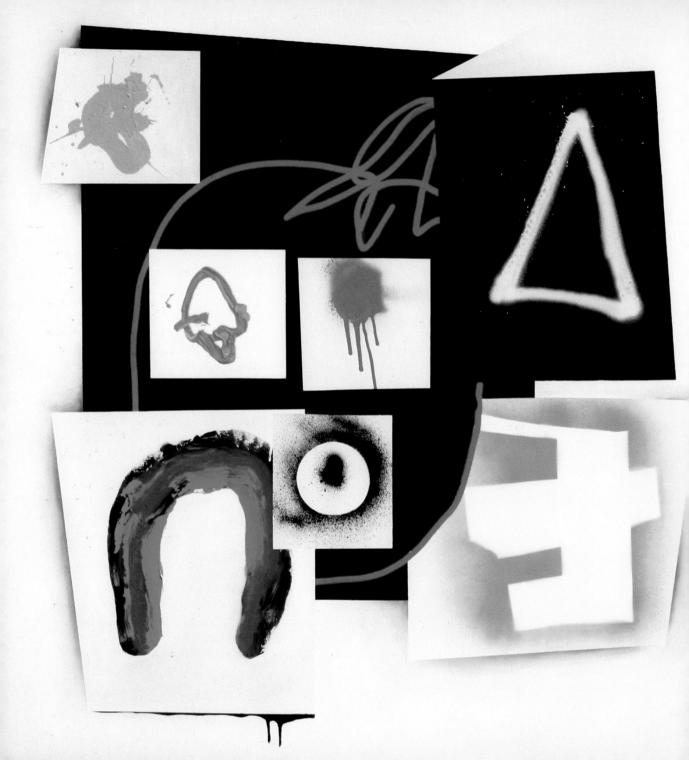

FIONA ACKERMAN

PAINTING

CANADA

FIONAACKERMAN.COM

Originally from Montreal, painter Fiona Ackerman now calls Vancouver home. She spent two years studying fine arts at Concordia University in Montreal before transferring to Emily Carr University in Vancouver, where she majored in painting and graduated with a BFA in 2002. She is now a full-time artist who creates insanely colorful, wonderfully bold, and beautifully executed paintings that have been exhibited across Canada and in Europe. She received an honorable mention for the Kingston Prize for Canadian Portraiture in 2009, and was included in *Carte Blanche, Volume 2: Painting*, a survey and showcase of painting in Canada.

JC—As a full-time artist, do you feel pressure to be creative all the time? How do you get through those "not so creative" days?

FA—I went through a period in 2004 when I was living in Berlin where I simply couldn't finish anything. I actually locked myself alone in my studio for three days and forced myself to produce something—*anything*! That strategy didn't work very well. I came out with one small black-and-white painting on paper and a feeling that I had gone to war with myself. In retrospect, I should have read a book or simply gone out looking, rather than forcing myself to meet some self-imposed expectation. I think it was a matter of self-confidence. When you begin to feel insecure, it can be really paralyzing. I was being so critical and hard on myself that I wasn't leaving any room for a creative voice to be heard. Art is play. You can play with many kinds of emotions, but you can't force play.

JC—Have you always focused on abstract painting?

FA—I've always done abstract and representational painting concurrently. For me, they represent two very different but complementary ways of approaching painting. My representational paintings begin with at least a rough plan, while the abstract work starts from complete spontaneity. When beginning an abstract piece, I usually lay a canvas down on the floor and start applying color intuitively. It's really liberating, and can be a great way to play around and make new discoveries. However, with both representational and abstract pieces, the latter stages of painting are quite similar. Even the most "realistic" painting has to be treated abstractly because, at heart, all painting is largely an abstraction from reality.

JC—Which artist(s) are you most jealous of (in a good way, of course), and why?

FA—I have long been a big admirer of both David Hockney and R. B. Kitaj. They are two master composers who dance between the lines of representational painting and abstraction in very individual and creative ways. In art school, I studied Kitaj a lot, but had not looked at him again until I saw a retrospective at the Jewish Museum in Berlin. It was probably the best show I've seen in years.

Hockney is also a big influence and inspiration, not only as a master painter but as an artist who has never shied away from following his interests in any number of directions. He has never been afraid to reinvent himself, to produce work that is completely different from what has come before. He is uncompromising and, as a result, has never stopped producing outstanding and fresh new work. I think it is extremely important and courageous to dare to keep challenging yourself—perhaps more so in the face of success rather than failure.

JC—Would you throw a painting in the trash if it's not working?

FA—Many lessons learned with this one. I would say the first ten years of learning to paint were filled with this situation. I usually took the die-hard approach, and just kept working for as long as it took to win the battle, or win the painting over. I've often looked back at a photo of a painting at a very early stage and thought, "Ah! I now know how to finish it."

But it's too late by then because I'd already made so many changes that it had become an entirely different painting, with totally new problems. I now know that it's not a bad idea to just let an unfinished painting sit, and come back to it when I've learned the lessons to solve that particular problem.

JC—Do you ever ask for constructive criticism or advice from others?

FA—In order to learn, you need a lot of guidance from someone whose opinion you respect. Ideally you find a teacher or a mentor who can guide you through the process. But there comes a point where the advice or criticism you seek out has to be taken only as a comparison to what your gut is telling you. There's a lot to be gained from the experiences and expertise of others, but if you don't know how to take the advice and relate it specifically to your work or path, then the advice is misunderstood and not that useful. Even positive feedback doesn't feel good if your gut doesn't believe it.

JC—How do you handle negative criticism, if it comes your way?

FA—There is a difference between solicited and unsolicited criticism. I've not really had much unsolicited negative criticism, but I've had a lot that I asked for. Sometimes it's pretty uncomfortable, but if you want to learn, you need to just suck it up.

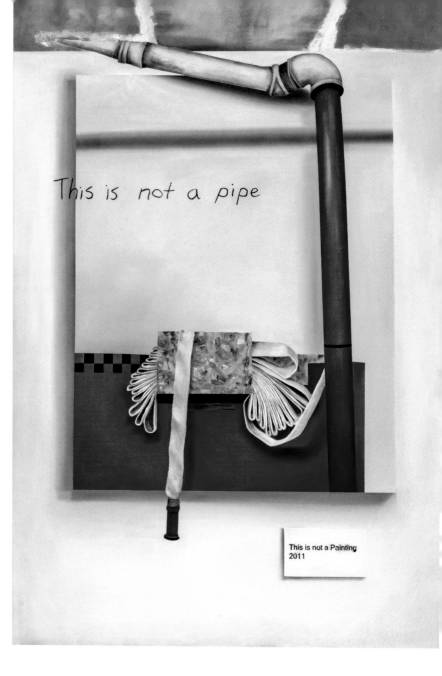

This is not a Painting
2011

I was being so critical and hard on myself that I wasn't leaving any room for a creative voice to be heard.

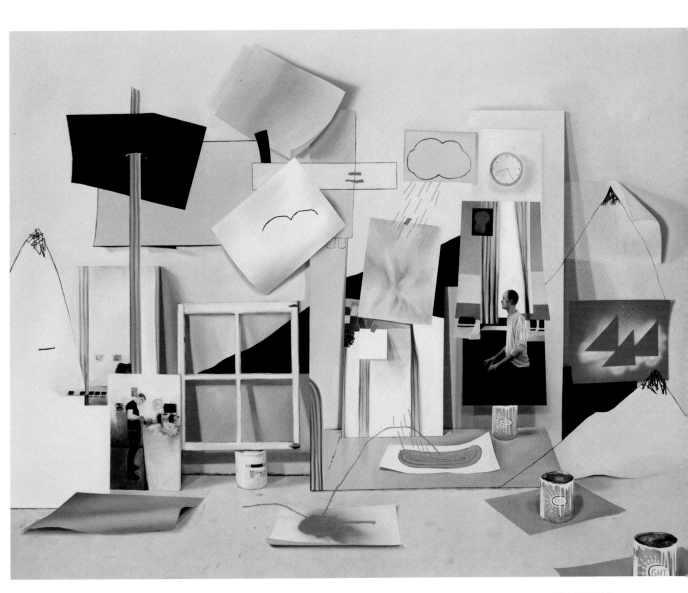

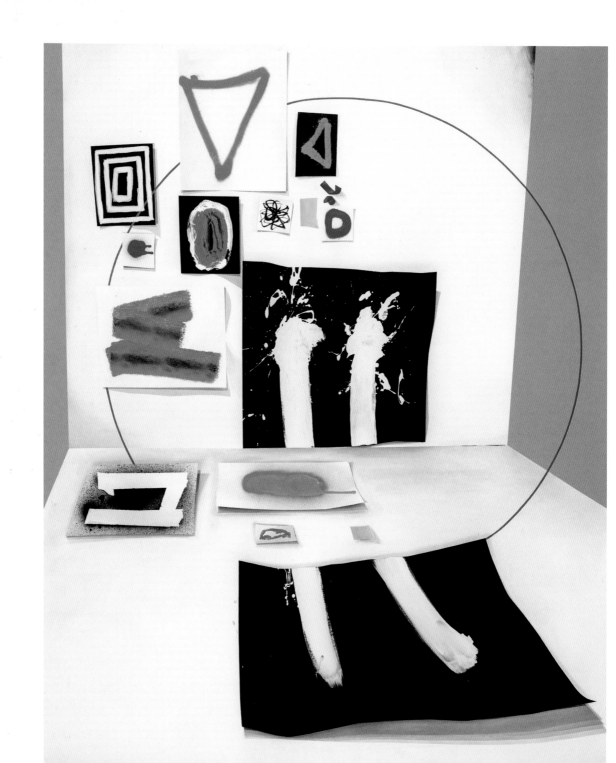

Creative *un*Block
Project No. 39

Okay, this challenge is one I've given myself many times, and every time it has inspired something new: Do a painting that is nothing like anything you would usually do. Make marks that feel awkward, use colors you would never reach for, use materials you don't necessarily know what to do with, dare to go against what you know. If you are an artist who works a lot, you've probably developed a certain style that is unmistakably yours. Your creative muscle has become strong, maybe overbearing. It's time to stretch! Try to do something that no one would recognize as yours, that people would look at and say, "Really? You did this?" (And they need not mean it as a compliment!) This exercise always helps me break out when I'm feeling bored by myself. It has radically changed my work many times over the years, and I'm counting on it to continue doing so. The rolling stone gathers no moss.

It is extremely important and courageous to dare to keep challenging yourself— perhaps more so in the face of success rather than failure.

KATE BINGAMAN-BURT

ILLUSTRATION

USA

KATEBINGAMANBURT.COM

There is something so inspiring and creative about a person who can commit to a one-a-day project—enter Portland-based illustrator, artist, and educator Kate Bingaman-Burt. She is a professor of graphic design at Portland State University, but in her own art practice she draws. A lot. Her black ink drawings on paper are hilarious, honest, and smart, and have been compiled and published in a gorgeous book, *Obsessive Consumption: What Did You Buy Today?*, that just might make you want to run out to buy (and draw), well, just about anything. She is also a master of installation, and, of course, there's her pattern design . . . little repeating pickles? Yes, please!

IKEA

$1

5.27.11

JC—Are you formally trained or self-taught?

KBB—I have undergraduate degrees in both English and art and an MFA in graphic design. I have education coming out of my ears, but what I mostly do is illustration—and I have never had any formal training in this area.

JC—Describe the first moment that you truly felt like an artist.

KBB—I was pretty lucky to grow up in an extended family of artists so I don't think there was ever a time when I didn't feel like an artist. It seemed like a very natural thing to make things.

JC—If you weren't making things, what would you be?

KBB—A private investigator, but more Nancy Drew or Encyclopedia Brown than *Law & Order*. Or maybe I am just nosy. Wait: I like to call this "being curious about my surroundings" rather than "being nosy."

JC—Does teaching design drain or fuel your personal projects?

KBB—From October until the middle of June, I'm in school mode Monday through Thursday—and then Friday through Sunday I work on freelance or personal projects. My summers are when I try to start new projects so I can just maintain the already flowing momentum until summer hits again. Sure, I sometimes feel drained, but I think I have my hands in so many different things that working with a variety of people and projects really fuels me.

JC—If one of your design students was knee-deep in a creative block, what kind of advice would you give them?

KBB—I guess it depends on the context. If they were on a deadline I would advise them to take a short break (i.e., shower, get coffee, run around the block, pet their dog, etc.) and then get back to work. If this block wasn't tied to a deadline, I would encourage them to back away from the issue at hand and reflect. Reflect on the work they have made in the past and work they are making now, and then really investigate the ways they want to be making in the future. I am a huge fan of list making. Pushing them toward making lists for where they want their work to be, whom they admire (and investigating their processes), study projects that were successful and why, projects that weren't successful and why—and then step back and study the results. Hopefully, connections for moving forward will be made.

JC—How do you push *yourself* through creative blocks?

KBB—I have set up a number of automated projects that I have to contribute to every day or every week. This process kind of stops me from having a creative block, because I don't want to break my self-imposed rules. These rules keep me moving and making!

JC—Would you throw a piece away if it's not working, or would you just keep going until you're happy with it?

KBB—I just keep going, but imperfections are a part of my work, so conceptually it makes sense to keep going for me.

JC—How do you handle criticism?

KBB—What I tell my students is what I tell myself. Where is the criticism coming from? Is it from someone whose work and opinion you respect? If so, then you should probably listen. If not, forget about it and banish it from your brain.

JC—Does your inner critic have an opinion about your work?

KBB—My inner critic is way meaner than any anonymous online commentator could ever hope to be. I just have to ignore that asshole so I can get some work done. However, I do strongly believe in trusting my gut, and if my inner critic is really making my stomach twist, I listen and try to dissect and correct.

JC—And last, but definitely not least, where do you find inspiration?

KBB—Usually while walking. This could be walking around thrift stores or walking around the neighborhood collecting old yard sale signs. I feel my best when I am away from my computer.

BASS oxford
$55 COLOR: NICKEL
GOAT
TUMBLED
ORDERED
While Sick
in BED.
This could have
Been a Bad iDEA.
3.19.10

five spools of thread
1.99 EACH
3.21.11

Huskers

HOT DOG $4

9.1.12

I don't want to break my self-imposed rules. These rules keep me moving and making!

**Creative *un*Block
Project No. 40**

Catalog the contents of your medicine cabinet. Draw, paint, photograph, or collage everything you have, and then make a poster or small book about the objects.

Kitchen Aid

Loaf Pan $8.49
5.3.11

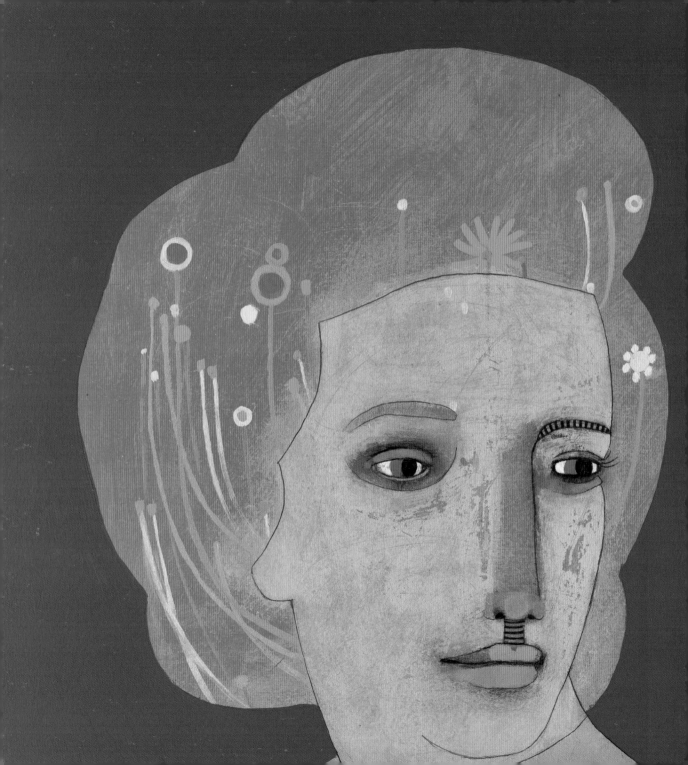

JENNIFER DAVIS

PAINTING

USA

JENNIFERDAVISART.COM

Minneapolis-based artist Jennifer Davis graduated from the University of Minnesota with a bachelor of fine arts; however, she attributes most of her real learning to some very precious alone time in the studio, with only a table full of acrylic paints, pencils, and smooth panels to keep her company. Her paintings are whimsical, bizarre, and overflowing with beautiful little details. Crazy carousels, yellow monkeys, dogs in stripy tights—clearly, that quiet studio is the perfect place for amazing things to happen.

JC—**When did you realize that you wanted to be an artist?**

JD—Art was never really part of my life until my early twenties, when I discovered art classes in college. I made a lot of art all the time, and it was making me happier by the day. When I graduated from art school in 1998 I knew it was going to be a major part of my life. I felt so lucky to gain that knowledge.

JC—**Why are you an artist today?**

JD—I am an artist because I love making art. When I don't paint, I get ornery and fussy. I am at my best when I am focused and spending a lot of time in my studio.

JC—**If you weren't an artist, what would you be?**

JD—Some of my friends call me "Detective Davis" because of my interests in investigating, researching, spying, binoculars, and being nosy. I think it would be fun to be a detective, an investigator, or a spy.

JC—**Are you quick to toss a painting that's not working the way you want it to?**

JD—If a painting is not working, I always give it one more chance. I set it aside for a day or two and take another look before deciding to toss it, rework it, or completely paint over it. This happens all the time.

JC—**Does criticism affect you?**

JD—If some criticism truly resonates, I try to figure out why and apply that knowledge to my thinking. If it doesn't interest me I'll just move along. I do my work for me, so I try not to let anyone else's opinion bother me too much.

JC—**Does your inner critic's opinion bother you?**

JD—My inner critic isn't a bad guy, so I don't ignore it. I don't dwell in negativity, but if something is really nagging at me, I will just keep working to fix it or make improvements where I am able.

JC—**Are there any tried and true techniques you use if a painting is causing problems?**

JD—Yes, I paint several layers of color onto a panel and then use a straight razor to gently shave/scrape into the layers. (Sandpaper works too.) This creates interesting textures and shapes. I call them "ghost images"; they inevitably trigger an idea.

Another exercise I do is to consult my vast collection of found images; I have boxes and piles of them all over my studio. I reach into a pile and grab a half-inch stack of found images and then force myself to make a painting or collage based on one or more of the things from that stack. I find that sometimes a bit of self-imposed limitation can be helpful.

JC—Where do you find the images that wind up in those boxes and piles?

JD—I have been collecting found images for about fifteen years. I have boxes and folders stuffed full of them, and they are organized so I know where to find each one. I revisit some of them over and over in my work, and sometimes I even recognize them in the work of other artists. My favorites come from vintage magazines. I like *National Geographic* from the '40s through the '70s best. I also like vintage *LOOK* and *Good Housekeeping*, my Sears catalog from the '30s, as well as large-format fashion magazines like *W*. Vintage children's books also trigger inspiring memories for me; I have saved some from my own childhood. I also collect scraps of paper that I come across randomly in my daily life. Sometimes there is beauty in receipts, envelopes, take-out menus, and even junk found on the ground.

JC—How do you handle creative blocks?

JD—My inspiration tends to come in waves. If I can allow myself the time to take a break from the studio during the ebb, I will do so gladly. However, sometimes, tight deadlines for exhibitions and projects make taking a break difficult. I have become pretty adept at working through creative blocks. I usually just force myself to start making something (which is the hardest part when I am blocked), and I continually remind myself that nobody else ever has to see it if it doesn't turn out well. As long as I keep working, I know the flow will eventually resume. It always does.

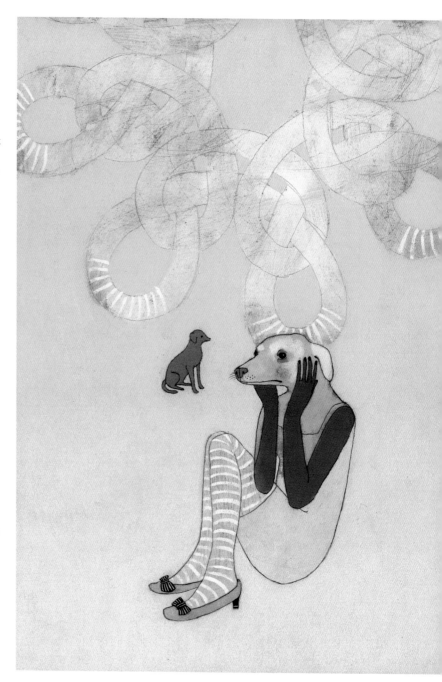

When I don't paint, I get ornery and fussy.

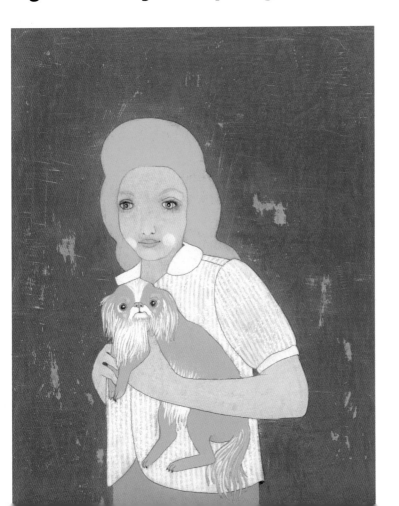

JENNY HART

EMBROIDERY/FIBER ARTS

USA

JENNYHART.NET

Jenny Hart is a Los Angeles–based artist and businesswoman. She owns Sublime Stitching, an independent DIY company that creates alternative embroidery patterns, kits, textiles, and courses. Thousands of people from around the world have been inspired to start embroidering thanks to Jenny!

When it comes to her personal art practice (which she considers completely separate), she focuses on drawing and embroidery. She has drawn seriously from a young age, when her mother would enroll her in any class she could find. When Jenny took a yearlong break from the University of Kansas at Lawrence, she lived and worked in Paris, going to open studios so that she could draw live models. As far as embroidery goes, she is completely self-taught. Her alternative education certainly paid off, because her beautiful work is now in the permanent collection of the Smithsonian American Art Museum, among others.

JC—**Why are you an artist?**

JH—It's all I ever wanted to be. My mom sent me to my first art class when I was five, and I just knew it was what I wanted to be when I grew up. My heroes weren't athletes or rock stars—they were artists. I guess I'm an artist because I hope to be inspiring, because I was inspired. I thought that was the greatest thing you could be. I still do!

JC—**When did you truly feel like an artist?**

JH—I was seventeen. I loaned a set of collages I'd made to a high school friend. Her aunt, without my knowing, took them to a gallery about thirty minutes away. The gallery contacted me and said they wanted to mount a solo show of my work. People began buying and collecting my work. That felt real to me. Even though I'd wanted to be an artist since I was little, until I had feedback it felt like I was just pretending.

JC—**You draw and embroider beautifully. Do you have a favorite?**

JH—Drawing. Once I started stitching, embroidering felt like drawing in slow motion.

JC—**Which artist's work are you most jealous of, and why?**

JH—I find the work of Yumiko Arimoto depressingly awesome. It's the work that makes you want to give up because it's so mind-blowing. But, I'm not a very envious person. When I see amazing, truly original work, it makes me feel inspired to revisit my own, and try harder.

JC—**Where does your inspiration come from?**

JH—It comes very much through music, film, books, a face I see on the street. . . . It's very difficult to describe how that turns into my artwork, but it does. I see in pictures. I can see images in my mind as clearly as if they're in front of my face.

JC—**When those images pop into your mind, do you sketch them?**

JH—I keep a sketchbook of ideas and usually put them down in a way that will remind me what I was thinking. When I do this, and go back to these little reference entries, I can remember exactly the images I had in my head. Otherwise, they're too often forgotten!

JC—**How would you describe a creative block?**

JH—I call it creative fatigue. I won't feel like working, or won't feel like working on something that has a deadline. I reach the point with nearly every work where I think it's going wrong, so I just walk away—but even just a fifteen-minute break can do wonders!

JC—**Do you think people should toss their work if they're not happy with it?**

JH—I truly believe that you should never throw your works away. Even if you're not going to show it to anyone or finish it, your abandoned works will look very different to you after time has passed. When I come across works from a few years ago, they look fresh to me, and I can't understand why I gave up on them. I think it's a very important practice, and can really boost your perspective. You'll see how you've improved, and you'll also see, more often, that it was much better than you thought.

JC—Do you ever equate your self-worth with your artistic successes?

JH—Wow. I've never been asked what I equate my self-worth with. I still feel like I've made the greatest personal achievement when I've made a beautiful or accurate drawing. Which is pretty silly, because a beautiful drawing never saved anyone's life. But if I do a bad drawing, or I really struggle with something I want to create, the thoughts of "who am I kidding, I'm just a hack" arrive instantly.

JC—Ah, your inner critic! So, are you able to quiet that pesky voice?

JH—My inner critic doesn't tell me to give up, but I rarely look at my own work and feel satisfied. I always see what's wrong with it, where I feel I fell short. When someone is complimenting me, it can be hard for me to say thank you—I want to say "No! It's not really very good, I wanted it to be much better!" I've had to make that voice shut up on more than one occasion.

JC—What was the most helpful bit of *constructive* criticism you've ever received?

JH—A really good friend of mine was looking at my work and said, kind of amused, "Boy, you *really* don't like negative space." Meaning: I tend to fill up every area of the image, sometimes when it's really not necessary. He said it made it look overly busy at times. I had never realized that before, and he felt my work would benefit from visually breathing a bit more. It's stuck with me, and it's been really helpful when I find myself struggling.

When I see amazing, truly original work, it makes me feel inspired to revisit my own, and try harder.

Creative *un*Block
Project No. 42

Try an unknown medium or activity that inter-
ests you, but you've never tried for fear of
failing at it or for total lack of knowing "how
it's supposed to be done." It could be leather
tooling, silk-screening, pastel painting, any-
thing. Make it something you've admired and
had a curiosity about, but don't know how to
do. Get the supplies, and learn just the very
basics to get yourself going. (All I was taught
to get started in embroidery was by my mother:
how to put fabric on a hoop, where to start
with the needle, and a couple of stitches.)
Just get yourself started, and then *go*. See
what comes out of it, and see how it inspires
the work you are already comfortable with!

ASHLEY GOLDBERG

ILLUSTRATION

USA

ASHLEYG.ETSY.COM

Ashley Goldberg is an illustrator based in Portland, Oregon. Outside of a few community college classes and the odd workshop here and there, Ashley is completely self-taught. She believes that what you're happiest doing at five is what you will be happiest doing your entire life, and for Ashley that has been a true love for arts, crafts, creatures (both imaginary and real), and nature. Her artwork tends to be narrative and simple, but with a sophisticated color palette. Her body of work includes paintings, illustrations, pattern design, and portraiture.

When Ashley is not creating and drawing she can be found thrifting, drinking too much coffee, staying up too late, and working on home improvement projects on her Cape Cod revival.

JC—As an illustrator/artist, what's your favorite medium to work with?

AG—Drawing will always be my first love. Give me a sketchbook, a pencil, an eraser, a pen, and some trashy TV, and I'm ready to go! Over the last few years I've come to love Photoshop and my Wacom tablet. Painting will always be more of a challenge for me—but in a good way.

JC—Why are you an artist?

AG—I can't imagine having a day go by and not creating something. I think that is true for most people, not just "artists." One of my best friends works in an office and doesn't love her job, but it pays the bills. Every night she comes home and *has* to cook dinner for her family. It relaxes her. I personally would find it a chore, but that is her form of expression. It soothes and satisfies her creative needs.

JC—Do you ever need or want "outside validation"?

AG—It would be a lie to say I didn't. Any job that has a self-appointed title—artist, writer, musician—is a tough spot to be in. I think we have all rolled our eyes at the girl or guy at the coffee shop who introduces herself or himself as an artist. I need proof that I am one—exterior proof. That is not to say that some of the most talented artists ever got that validation, but it is nice when it comes.

JC—Whose work are you most jealous of, and why?

AG—Oooohhh, that's a tough one. There are so many to choose from! The first on my list is Yoshitomo Nara. I have drawn naive little girls or animals in girls' clothes my whole life. And to discover that there was an *amazing* artist making a career out of this sort of blew me away. I think he has perfected that style. So, sometimes it's hard knowing he already exists . . . no one (in my opinion) is going to do better.

JC—Where do you look for inspiration?

AG—It sounds like such a cliché, but inspiration really is everywhere. I always say the weather inspires me. I never feel as creative as on a chilly, overcast fall day. Or when you can feel spring in the air. I am lucky to live in a city that has so much nature. I can drive an hour to the ocean and look at rocks and driftwood, or take a walk and see trees I didn't even know existed.

I also find the Internet so inspiring! But sometimes, once I go down that rabbit hole, I do more looking than working and have to shut down the technology for a while.

JC—Does the amount of amazing artwork that can be found online ever overwhelm you?

AG—Oh, of course! Especially if I am thinking about something and then, bam, there it is already completed, and done really well. *Every day* I discover someone infinitely more talented than me. It often makes me equal parts jealous and inspired, but no matter the ratio, jealousy and being inspired both fuel the desire *to be better*. *Do more.* That is the most important thing—to keep creating.

JC—Does your inner critic have anything to say?

AG—Ha! Why, yes, yes it does. Every day . . . every moment of every day, usually. I let it talk, but if I waited for perfection to create, I would never create. I like having the goal in the distance of *believing* I can be the artist I want to be. Even if I never reach that point, having a goal is what propels me forward. I have pieces that I do enjoy, but I don't think I will ever love my whole body of work. I don't even know if that's healthy. Where do you go from there? It's finding the balance that keeps you motivated, but isn't destructive.

JC—How do you find your way through a creative block?

AG—Magazines, the Internet, thrift stores—anywhere that I can overwhelm myself with visual stimulation. Then I'll see something—a color, a pattern, someone's home—and it will get the wheels turning. And when all else fails: coffee, coffee, and more coffee. The ritual of brewing it at home puts me in work mode.

　　If it is a bigger creative block, I try to ride it out and just let it happen. I will still draw, but most pieces will end up in the trash, and that's OK. I think some of the biggest bursts of creativity and artistic growth I've had are usually preceded by a big creative block.

I think some of the biggest bursts of creativity and artistic growth I've had are usually preceded by a big creative block.

Creative *un*Block Project No. 43

Take ten pieces of scratch paper and just draw—doodle all over like it's a seventh-grade notebook. Cover all the space—draw over things—no rules! Then when you are done, go back through and look at what you drew. What are the recurring motifs? Why do you doodle what you doodle? Find the connections, the patterns, and you may become a little more conscious of what you have been unconsciously creating for years.

Do the same thing with inspiration images. Go online and pull twenty to thirty paintings or dresses that you love. Put them in a folder on your desktop and then go back through them all. Do the dresses have the same sleeves or silhouette? Do the paintings all use a certain color palette or subject matter? We tend to gravitate to the same things over and over again without knowing why. This is a good chance not to just discover *what* you like, but *why* you like it.

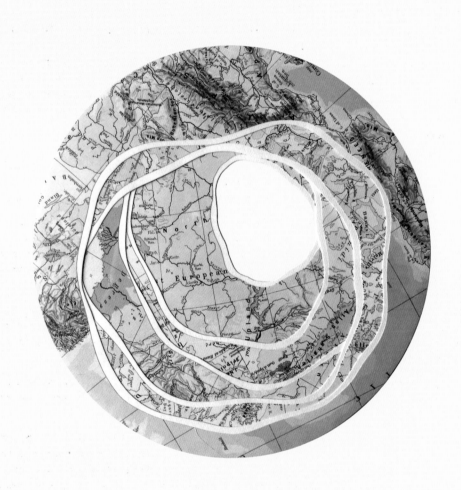

SHANNON RANKIN

PAPER-CUTTING/INSTALLATION

USA

ARTISTSHANNONRANKIN.COM

If you're looking for American artist Shannon Rankin, she's probably either cutting and folding maps, or she's cutting and folding vellum. And if she's not cutting or folding anything, that probably means that she is outside, taking long walks and breathing in the fresh air of Rangeley, Maine, where she now lives. In 1997, she received a bachelor of fine arts degree from Maine College of Art in Portland, Maine, and has gone on to create some stunning, large-scale cut-paper installations, along with a huge number of smaller pieces. She has exhibited nationally and internationally, and her work is included in private and public collections all over the world.

JC—Describe the first moment that you truly felt like an artist.

SR—About twelve years ago I made a conscious decision to dedicate my life to making artwork. I've always been creative, but it wasn't until I began exhibiting my work that I truly felt like an artist.

JC—What was it that made you make that jump? How did you do it? Did you have a plan?

SR—I worked as a graphic designer for a few years following art school. After some time passed, I simply realized that I wanted to make my own work. I found an affordable studio and gave myself permission to make anything, without question. I experimented with various materials and just allowed myself to play. The only plan I had was to dedicate as much time as I possibly could to working in the studio.

JC—What keeps you motivated and making?

SR—There are many struggles being an artist, but I think the thing that keeps me going is the never-ending search for some glimpse of what I already know. For me, making art is a process of remembering, and I feel like I am slowly beginning to piece the puzzle together.

JC—Would you ever want to be anything other than an artist?

SR—Fortunately, as an artist I am able to explore my varied interests through the research for and making of my work. If I weren't an artist I might be happy as an astronomer, psychologist, geologist, dancer, physical therapist, cartographer, herbalist, healer, farmer, or archeologist.

JC—Is there an artist that truly inspires you—who and why?

SR—The work of Cindy Sherman has always been a huge inspiration to me. I'm envious of what seems to be a kind of freedom she has with her work and process.

JC— Are you bothered by creative blocks?

SR—No. I savor when the creativity flows, and know that if I'm blocked, it will eventually pass. It's important to keep pushing through, to keep working. If that doesn't work, I get out of the studio for a while and take a walk.

JC—What do you do if you're having trouble with a specific project?

SR—I have a large range of interests, but I have narrowed them down to a few bodies of work. I typically work in one direction or medium at a time, but if I'm stumped in one direction, I can easily switch to a new one. I prefer working with something immediate, if possible. I will often give myself a goal to finish a series, which can help take the preciousness out of the material and keep things moving. Occasionally I will continue to work even if I despise what I am making. I do this in hopes that something in the process will resurface and inform future work.

JC—So, do you *always* persevere on your projects?

SR—No, if I create something that doesn't work for me, I usually toss it. If it's reworkable or if I can use the parts in some fashion, I will. Otherwise, I don't typically rework pieces. It either works or it doesn't. Sometimes there are works in progress that are at an in-between stage. They are often set aside and looked at later after some time "stewing."

JC—Do you ever equate your self-worth with your artistic successes?

SR—No. I know that my creativity is ever evolving. I just have to trust and be patient with the unfolding. . . . I think the key is to make what you love, and the successes will present themselves.

JC—Are you open to criticism?

SR—Constructive criticism is always welcome, even though I've been known to be a little sensitive. I love hearing different perspectives.

JC—What's the best bit of constructive criticism that you've ever been given?

SR—I was told by an art critic to allow more chaos into my work. I'm trying to listen. . . .

JC—Do you ever hear your inner critic?

SR—Always! I try to remain open to taking risks in my work because I know that failure can often lead to something amazing. So, I remind myself to move through by quieting my mind. Yoga and meditation help.

JC—When do your best ideas come to you?

SR—Anytime! Nature walks always help, but often it's late at night and I'm in the studio. I surround myself with all of my varied interests, words, and visuals. This helps trigger new ideas!

JC—How do you feel when your creativity is truly flowing—do you refer to it by name?

SR—These moments are what I live for! I call these "glimpses of insight and bliss" and "white moments." It's as if time stops when I'm "in the zone," lost and fully immersed.

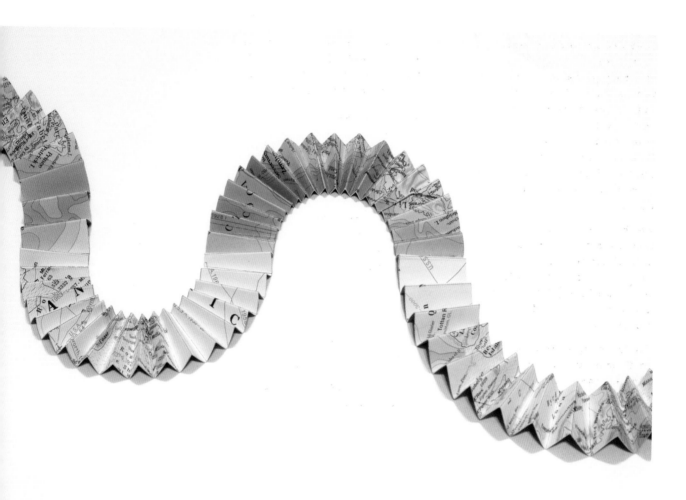

I try to remain open to taking risks in my work because I know that failure can often lead to something amazing.

Creative *un*Block
Project No. 44

Use a cropping tool to find new compositions
from an original piece. Enlarge this small
portion of the original piece; create a new
piece based on the enlarged composition.

WAYNE WHITE

PAINTING

USA

WAYNEWHITEART.COM

Wayne White is an American artist, art director, illustrator, puppeteer, and much, much more. Born and raised in Chattanooga, Tennessee, Wayne has used his memories of the South to create inspired works for film and television. He has a very long list of creative endeavors, including being an illustrator for *East Village Eye*, the *New York Times*, *RAW*, and the *Village Voice*. He was the set and puppet designer for *Pee-wee's Playhouse* (for which he won three Emmys and, oh, he even did a few of the voices); and he was also the art director for Peter Gabriel's "Big Time" music video.

Most recently, Wayne has had great success as a fine artist, creating paintings and public works that have been shown all over the world. Found landscapes from the 1970s painstakingly combined with hilariously strange text in which Wayne points a finger at vanity, ego, and his memories of the South. Amazingly, there are many, many more things on his list of creative accomplishments, all of which you can see in the 2012 documentary film about his life, *Beauty Is Embarrassing*. Yes, it's an inspiration overload.

JC—Are you formally trained or self-taught?

WW—I was a painting major at Middle Tennessee State University. It was all about abstract expressionism. Later, after I graduated, I taught myself cartooning and realist painting.

JC—You have worn so many creative hats—film, design, fine art—do you have a favorite?

WW—Drawing and painting are my favorites. They are the default position from which all ideas flow, especially drawing. I always say if you can draw it, then you can make it into any other reality you want.

JC—Where do you find all of the amazing found objects you work with?

WW—I find most cool stuff at thrift stores and garage sales. The greatest thing I ever found at a thrift store was a collection of fan photos of Jerry Lee Lewis from the early '60s . . . and I didn't buy it! I'm still kicking myself.

JC—Aside from thrift stores, etc., where do you look for inspiration?

WW—The woods of Tennessee are my church.

JC—How do you come up with the phrases for your paintings?

WW—Like a writer, I keep a journal. I write down observations, overheard conversations, and quotes from movies, songs, books, etc. I then edit them down to their essence, usually one or two sentences. Sometimes they need no change at all. I consider myself a writer, as this process is the same for all writers. But, of course, I treat the words as concrete forms, and not just symbols on a page.

JC—Which artist are you most jealous of, and why?

WW—Neil Young. He has a whole ranch to roam and a barn full of electric trains.

JC—What's your first memory of feeling like an artist?

WW—My first-grade teacher, Mrs. Stoddard, got me up in front of the whole class after seeing my crayon drawing of a school lunch, and told everyone I was going to be an artist one day. It was the first day of school. Something about being proclaimed like that in front of a room full of strangers made it seem very real. I was seven.

JC—Do you have a technique that you use if you're having trouble with a piece?

WW—Not really. Sometimes I'll destroy part of it and see what happens, or I'll sit and let the piece talk back to me for a while. You have to believe your creations have a mind of their own and can talk to you.

JC—Would you throw a piece away if it's not working, or would you just keep going until you're happy with it?

WW—I rarely throw anything away. It will work eventually if you just step away and let it simmer.

JC—You seem to constantly be making things—are you drained or fueled by that?

WW—Oh, it drains me. Every day. If it doesn't, I'm not working hard enough.

JC—Do you ever equate your self-worth with your artistic successes? How do you get past that?

WW—My self-worth is definitely tied up with artistic success in many ways. But I also have a family I'm very proud of and that balances it out.

JC—How does criticism affect you?

WW—I brood and get my feelings hurt, and then I try to forget it.

JC—And your inner critic—do you ever hear him?

WW—My inner critic never shuts up. Ever. I don't know why. I just shove him back in his box, and sit on the lid.

JC—Do you ever experience creative blocks?

WW—I don't believe in blocks. You just make yourself work.

JC—And finally, why did you want to make your documentary, *Beauty Is Embarrassing*?

WW—I didn't want to make a movie about myself. It was the director Neil Berkeley's idea. He talked me into it. I honestly thought it wasn't such a great idea, and I'm still not so sure. It distorts your reality in ways I'm still trying to get over. It's hard to explain. I do know I have a newfound sympathy for public figures. It's pure anxiety sometimes, being held up as an example. It also can go to your head, no matter how humble you think you are. That said, I'm very grateful for the art sales it has brought me. I also get very lovely fan mail from people who feel inspired and motivated after watching it.

I always say if you can draw it, then you can make it into any other reality you want.

Cut something in half, and connect it to
something else to form a new whole.

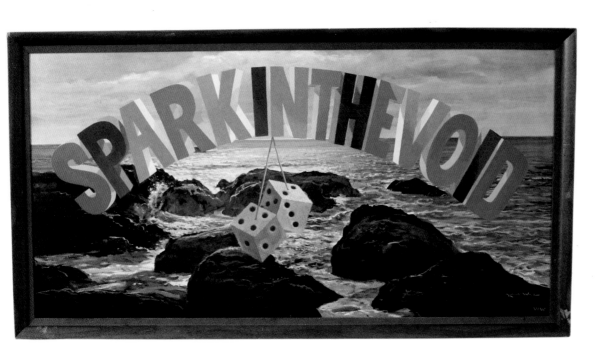

JULIA POTT

ILLUSTRATOR/ANIMATOR

UK/USA

JULIAPOTT.COM

Julia Pott is a British artist who lives in Brooklyn, New York. It might be tempting to call Julia an illustrator, although that wouldn't be quite enough. Her drawings are fantastic, but you should see what happens when she brings these little critters to life through her quirky, beautiful, award-winning animations. Actually, you could go and look right now on her website.

JC—**Are you formally trained or self-taught?**

JP—I went to Chelsea for foundation, then Kingston University for a BA in illustration and animation, and then an MA in animation at the Royal College of Art. Years before all of that I would buy *Beano* comics with my pocket money and redraw every single page, detail for detail, then resell them to my parents for 30 pence. It was the most intense training I had, and it was also a harsh introduction into the world of the struggling artist.

JC—**Which artist(s) do you admire most?**

JP—It would have to be between Wes Anderson and Woody Allen. I would love a career where I could both write and direct my films, and people would have the confidence in me to let me try new things, explore unchartered territory, but still have a very distinct voice— which I think both these directors encapsulate in their own way.

JC—**What inspires you?**

JP—I love fiction and have favorite authors who create incredibly visual worlds and can perfectly express a very specific feeling in just one sentence. John Irving, J. D. Salinger, and Kurt Vonnegut are among those writers. I keep a book of quotes from books I like and will look through it when I'm feeling particularly stumped.

Live-action films are another big go-to for me—narratives that mix very human emotions with horror and humor and also have wonderful aesthetics, films and shows like *E.T.*, *Gremlins*, *Harold and Maude*, *Twin Peaks*, *Buffy*, *When Harry Met Sally* (although not a heck of a lot of horror in that one . . . perhaps they missed a trick there!), and anything by Woody Allen. Radio shows like *Radiolab*, *This American Life*, and *The Story Collider* are a great source for ideas.

Just being out and about with people I connect with can have a huge influence on my thought process—someone can tell a funny anecdote and it sparks a new idea.

JC—**Have you ever thrown a drawing away?**

JP—My most popular print, *Wooly Bear* (opposite), is something that I almost threw away because I didn't like how it was turning out. I was on the last page in my sketchbook so I had no choice but to power through, and it taught me never to give up on a drawing.

JC—**How do you handle criticism?**

JP—*Not. Well.* When someone criticizes you it can be crushing, and can sometimes stop you in your tracks. It's the old cliché that you need a thick skin, and it's true. You also need to know whose criticism is worth listening to. Some people *do* know better, and you should seek these people out early and keep them around—show them everything you do. It can be so difficult to take something completely personal and show it to someone and *ask* what's wrong with it. But if you don't do it, what's wrong with it is going to stay in there, and you won't know because you're too close to it.

Criticism when something is finished is a whole other story. At the end of the day it's all a matter of taste; not everyone is always going to like what you do, and hearing people critique it can feel degrading and unnecessary because there's nothing you can do to change it. But you can learn for next time—every piece of work is an opportunity to improve, and

becoming accustomed to criticism is one of the biggest lessons you can learn. Also, don't listen to Internet trolls.

JC—Describe how you feel during a creative block.

JP—Whenever I'm in a creative block, it can feel like it will never end. I start Googling alternative careers. In the beginning of a creative block I have a tendency to think back on past jobs and remember how I got started, where I looked for inspiration, how it all got made. I always remember it as this idyllic, hazy memory with rainbows and singing birds where inspiration struck me on my walk home for lunch: I rushed home and the film just flew out of my pencil while I laughed and watched *Buffy*.

Of course, that is never the case—every time you start a new piece of work it's torturous. Everything you come up with seems rubbish, pointless, you second-guess yourself every step of the way—and this kind of thinking can eventually lead to a roadblock in your brain where you just shut down.

It is never very helpful to try to compare it to past work and try to one-up yourself. It puts an overwhelming amount of pressure on, and stress and creativity is not a great mixture. In reality, the first film I made probably was the easiest, the most natural to make, because I had no yardstick to compare myself to. So if you approach every film like that—with the openness and excitement you had in the beginning of your career—then the block can be pushed through.

Also watch a lot of movies and read a lot of books—there may be an idea nesting in that brain of yours that just needs a little bit of a push. The more things you expose yourself to, the more your work will benefit.

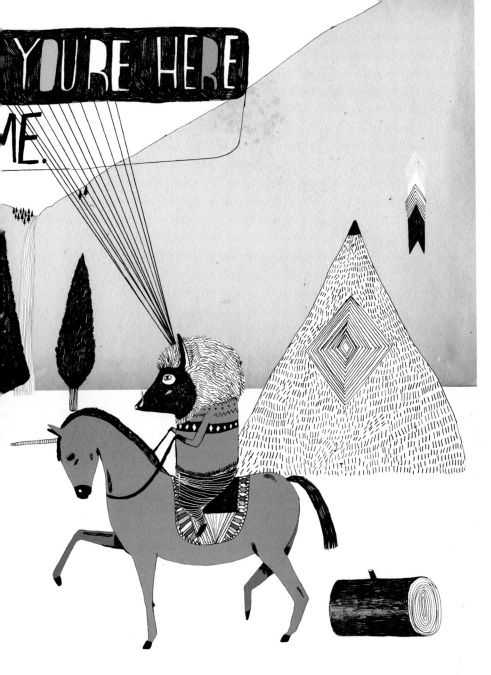

Whenever I'm in a creative block, it can feel like it will never end. I start Googling alternative careers.

Creative *un*Block
Project No. 46

Choose a week where you don't have a lot of time commitments professionally and make plans every day—even if it's going to the park, meeting a friend for a coffee—and don't cancel any of them. During this week keep a diary, and don't censor yourself—write down everything that happens to you, every cool thing you saw, and, most importantly, everything you thought—all the mean, grumbly, romantic, pervy things you thought.

Read through your diary at the end of the week and choose something that's particularly funny or poignant or visually interesting and make something inspired by it.

JEN ALTMAN

PHOTOGRAPHY

USA

BYJENALTMAN.COM

Jen Altman is a photographer and writer who spends half her time in Brooklyn and the other half in North Carolina. She studied interior design and art history at the Art Institute of Pittsburgh. Her mother was an art teacher and a painter, and her father sculpts, so art has always been in Jen's life. However, she says the technical aspect of photography intimated her in college. It wasn't until her first daughter was born that she reached for her Polaroid, and started shooting film. Jen is now the mother of three young girls, all of whom continue to be her inspiration and the subjects of much of her dreamy work.

JC—Creativity clearly runs in your family—are your daughters artistic? What do they think about you being an artist?

JA—*Yes!* They are incredibly artistic—always drawing, writing, or painting. They create their own books with sewn bindings, and then fill them with drawings and stories. My middle daughter is so attached to her finished pieces that she often sleeps with them under her pillow. They are so sweet, and say they want to grow up to be an artist like Mama. . . . We'll see how long that lasts!

JC—Do you describe yourself as an artist?

JA—I'm a triple Aries—it's my sun, moon, and rising sign. That is to say, I follow my heart—often blindly—and do what I feel I need to do. I write, I art direct, I style, I curate. In a way, all of this falls under being an artist. But often I struggle with this word "artist." I feel like more of a "creative" than an artist. I think that my editorial and writing work has maybe made me feel this way a bit. But when I'm photographing something I'm incredibly passionate about—whether it is a zoology collection at a museum, my daughters, or our life when we take to the road—that is when I feel the aura of artistry fall about my shoulders like a gentle cloak. I create because I'm not sure that I have a choice not to.

JC—How do you get inspired?

JA—I've tried over the last several years to pull away from the beautiful but often oversaturated online community. There are so many ridiculously gorgeous blogs out there that it can become overwhelming rather than inspiring. Now I spend time in libraries, museums, parks—and on the road. The road opens up my mind's eye better than anything else. We love to drive and explore the beach, the mountains, dusty roads, and dark forest paths—I wish we could live on the road.

JC—Do you ever equate your self-worth with your artistic successes?

JA—Absolutely. But I don't think it's a healthy way of thinking; often, however, it cannot be helped. Having a supportive, loving environment has helped see me through these trying times. Realizing that I've had to separate myself as a person from my work has been difficult—especially when you pour so much of yourself into a project that the connection in inevitable.

JC—How do you deal with criticism?

JA—Being an Aries, not well—ha! But it's something you have to learn to handle. I think, as artists, in a sense we are not creating for the world around us, we are re-creating the world around us for ourselves. So everything we share is wrought with personal energy. To have people not respond with the same enthusiasm can be heartbreaking, but I've learned not to dwell on things.

JC—Do you ever hear your inner critic? Does it ever get to you?

JA—Yes! And yes, I often tell it go to hell! But that took some time as well. I am so blessed to have an incredibly supportive family and group of friends that have always believed in and encouraged what I do.

JC—How do you push yourself through creative blocks?

JA—I walk away, whether that means simply from the subject at hand for a few moments, or putting the project aside for some time. My daughters help fill that void of emptiness that consumes me when I can't seem to find my way through a project. They fill me with light and love, and that energy has a way of forcing me to refocus.

JC—How do you feel when you experience the opposite of a creative block—when things are truly flowing?

JA—I truly feel my body physically respond when things are right on mark. I think there is a reason that people say that they have "gut feelings"—it's a cocktail of excitement and anxiety as you work it out in your head. "I *have* to do this—now, how am I going to make this happen?"

I follow my heart—often blindly—and do what I feel I need to do. I write, I art direct, I style, I curate.

My middle daughter is so attached to her finished pieces that she often sleeps with them under her pillow.

**Creative *un*Block
Project No. 47**

Get on the road! You don't have to spend a month out there—or even a weekend. A day trip will do just fine. Pack a picnic and music that encourages you to roll the windows down—the wind tangling your hair with restless fingers—and sing out loud. Take a road outside of the city—somewhere you've never set wheel to pavement. And just drive. Whether you are inspired to write, photograph, or draw, take the tools for your chosen form of expression along for the ride. Taking to the road with my camera never fails to inspire me. Sometimes it's not only the act of the voyage—however short it may be—but the state of mind that envelops you as the road widens. Some of my best ideas have come as I'm chasing the sun across the horizon.

ALYSON FOX

MULTIDISCIPLINARY

USA

ALYSONFOX.COM

Austin-based artist Alyson Fox has a BFA in photography, but that's not where her artistic talent ends. She earned her MFA at the University of Colorado experimenting with all sorts of materials, so now she draws, paints, makes objects, sews, designs jewelry, makes prints, creates elaborate patterns, and, of course, still takes beautiful photographs. In fact, in 2012, she published a book, *A Shade of Red*, with Chronicle Books, filled with stunning images of one hundred women from all walks of life wearing the same shade of lipstick. Genius. Outside of her personal artistic endeavors, Alyson has been commissioned by a long list of amazing clients including West Elm, Lululemon, Ink Dish, and many more.

JC—**Describe the first moment that you truly felt like an artist.**

AF—I was probably nineteen, and it was the first project that I got totally lost in during my time as an undergrad, when I was shooting, developing, and printing film for the first time. I lost track of time completely. I had never lost track of time before and it was a really good feeling. I'm not sure that at that moment I truly felt like an artist, but it was something that I wanted to continue to feel.

JC—**If you weren't an artist, what would you be?**

AF—An explorer—digging for treasures of sorts. Or a dancer. Or an architect.

JC—**Which artist are you most jealous of, and why?**

AF—Yikes. If I had to just name one, I would have to say Rachel Whiteread. I lust over her sculptures and the materials she uses to create them. Her subject matter is always compelling to me and leaves me with that "I wish I had done that" feeling. They are at once complex, quiet, and provocative. She makes me think about spaces and objects in a much greater capacity than I used to. I now look at the empty space under all chairs differently because of her piece *Untitled (One Hundred Spaces)*. My close second would be Louise Bourgeois.

JC—**Where do you look for inspiration?**

AF—At hardware stores, building sites, empty rooms, other people's messes, in good design, conversations, and the time right before I fall asleep.

JC—**Do you ever equate your self-worth with your artistic successes?**

AF—Absolutely. It's hard not to ask yourself "Why am I doing this?" if you feel like things are not going the way you had hoped. I'm not entirely past it so it's hard for me to answer fully, but I will say that success is a really hard thing to measure. I try my hardest to stay in the present and focus on all the positive things that I have going on in my artistic and personal life and not base my success on someone else's achievements.

JC—**How do you handle criticism, if it comes your way?**

AF—Oh, it definitely comes my way. I will get a bit of the inner whines at first, but I try to muster up some maturity and remember that I'm making things for people to see and judge in a way, and that not everyone is going to like what I make. I don't like everything that I see. That's impossible. I think criticism helps me grow and strive to make better work.

JC—**Do you ever hear your inner critic?**

AF—All the time. Sometimes it helps me reason and make a decision, and sometimes it will hinder me from moving forward faster. But for me, having an inner critic is what keeps me never fully satisfied—always wanting to make, and do, more.

JC—How do you push yourself through creative blocks?

AF—I used to beat myself up mentally over it if I had a slow week or two of not making anything. Now I still do to some degree, but I have found that what works best for me is to talk it out with my husband, and then do something outside of my work space and non-art-related for a day or two. I cook a lot of random things, I organize and get rid of things (this one always helps me), I watch a movie, I go for a hike. . . . I try to get to a place mentally where it is OK to take a break and just do something else. And a good cry always works.

JC—How do you feel when you experience the opposite of a creative block— when things are truly flowing?

AF—I feel as though time has stopped and I am possessed in some way. I feel happy, lucky to be able to do what I love, and motivated to keep going.

[I find inspiration] at hardware stores, building sites, empty rooms, other people's messes, in good design, conversations, and the time right before I fall asleep.

It's hard not to ask yourself "Why am I doing this?" if you feel like things are not going the way you had hoped.

Creative *un*Block
Project No. 48

1. Pick three random addresses from a phone book—maybe pick a name that you have always liked.

2. Write a letter to those three strangers telling them a true story of when you helped someone (it can be someone that you knew or did not know). All three letters can be the same, or different if you are a really good Samaritan. At the end of the letter ask them to please share a similar helping story with you as you are looking for inspiration to draw, write, or photograph something.

3. Decorate your letter in some way to make it special. Include a recipe or maybe some seeds they can plant.

4. Take a photograph of or scan your letters so you have a record of them.

5. Put each letter in an envelope and include a self-addressed, stamped envelope in hopes that they return a letter to you.

6. If you get something back, relish in the fact that you communicated/connected to a complete stranger. See what comes out of that.

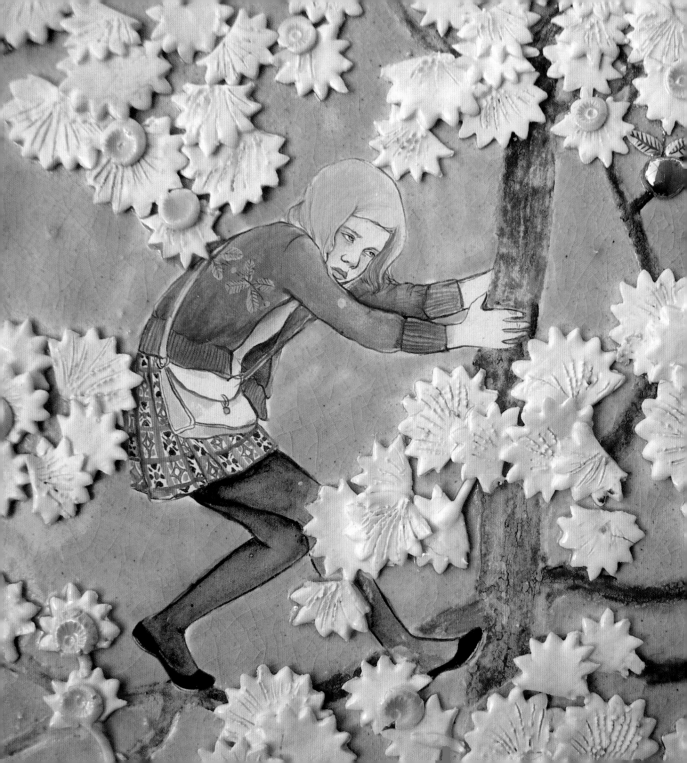

AMANDA SMITH

CERAMICS

USA

AMANDAMICHELLESMITH.COM

Amanda Smith creates intricate, delicate, and bizarre worlds. Metallics and pastels, tiny flowers and girls in knee socks—strange narratives told beautifully using slabs of clay and colorful glaze. She has a BFA in three-dimensional studies from Bowling Green State University in Ohio, and an MFA in spatial arts from San Jose State University in California. She used to be an art and ceramics teacher at Irvington High School in Fremont, California, but now she is a practicing artist, and stay-at-home mom, in Fostoria, Ohio, with her daughter, Gemma, and husband, artist Casey Jex Smith. Her lovely work has been exhibited all across the United States, and has recently made its way to Europe as well.

JC—Have you always felt like an artist?

AS—Since I was a little girl, I have always been the "artist" of the family. I was labeled an artist by my parents and sisters long before I actually felt like one. I don't think I truly felt like an artist until I decided to pursue it as a career. That decision came when I decided to major in art in college. I was twenty-one.

JC—Do you see your life as an artist and your life as a mother as two separate things, or do they go hand in hand?

AS—I see them as *totally* different. Although I absolutely love my life as a mother, and I consider it more important than anything else I do, much of my time is filled with mundane repetitive tasks like making lunch, giving baths, shuttling to doctors' appointments, or doing puzzles. On the other hand, I consider being an artist (and I hope all artists will forgive me) a pretty selfish endeavor in comparison. But for me, it's a *necessary* selfish. When I'm making art I feel like I'm getting in touch with myself. When I'm being a mom, it's all about bonding with my little girl.

JC—Do you ever feel "mom guilt" when you're away at the studio?

AS—No. I am a stay-at-home mom, and I'm with Gemma 24/7. My studio time is only around ten to fifteen hours a week at this point, so I relish my time to be creative. I consider it my ultimate indulgence. I'd rather go to the studio than go to a movie, or out to dinner, or almost anything else. The other reason I don't feel guilty about my studio time is that Gemma is with her dad when I'm in there, and she's a real daddy's girl.

JC—How does criticism affect you?

AS—I like to think I'm very receptive to criticism. I appreciate it and I learn a lot from it, but if it's too disparaging, sometimes I lose my confidence and I freeze up.

JC—Does that criticism ever come from your inner critic?

AS—My inner critic is always the loudest voice in my head. Sometimes it's a good thing because it gets me to reflect and change directions, but other times it is crippling.

JC—Have you ever been given advice on how to navigate those crippling blocks?

AS—I follow the advice of my mentor at Bowling Green State, John Balistreri. He told me, "Whether you're making good work or bad work, just keep making art, and eventually you'll start making something you are happy with again." That's what I try to do. Sometimes it takes a long time and I make a lot of bad art, but eventually it works. I have frequent creative blocks, like I think every artist does, but I learn a lot about what I want in my art from my unsuccessful work.

JC—Where do you find inspiration?

AS—My family, current events, Pinterest, museums, and the library.

JC—Do you ever get overwhelmed by the amount of amazing artwork that you can find online?

AS—Of course! You'd have to be astoundingly arrogant not to be overwhelmed and jealous of it. I just keep in mind that humility is healthy for everyone, especially for artists. The humility makes me teachable, and I learn a lot by looking. I try to turn that overwhelming feeling of inadequacy into curiosity.

JC—Would you throw a piece away if it's not working, or would you just keep going until you're happy with it?

AS—I throw stuff away all the time. I even throw away finished work if I'm not happy with it.

JC—I'm stunned by that—your work is so labor- and time-intensive! Does trashing the unsuccessful finished work feel like a relief, or is it upsetting to you?

AS—Frankly, when I throw away bad work, I feel relieved—mostly that no one will ever see it. I have *no* qualms about tossing it.

JC—Do you ever equate your self-worth with your artistic successes?

AS—Yes, but I've found that to be kind of dangerous, since success is cyclical. I don't know that it's healthy to attach your self-worth to the opinions of your critics or your fans. I feel like my performance as a mother, wife, daughter, or friend is far more important than my performance as an artist, and that is where my self-esteem is tied up.

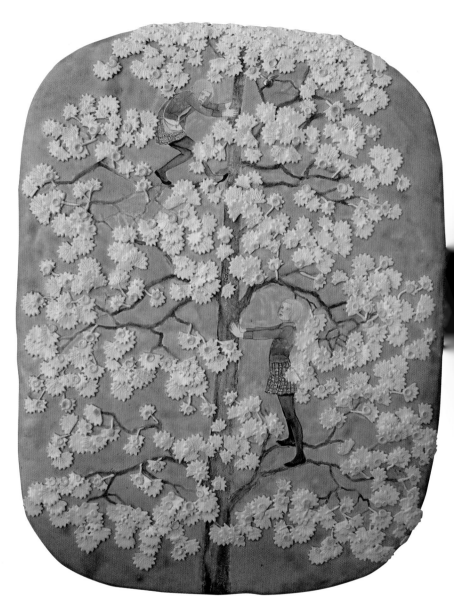

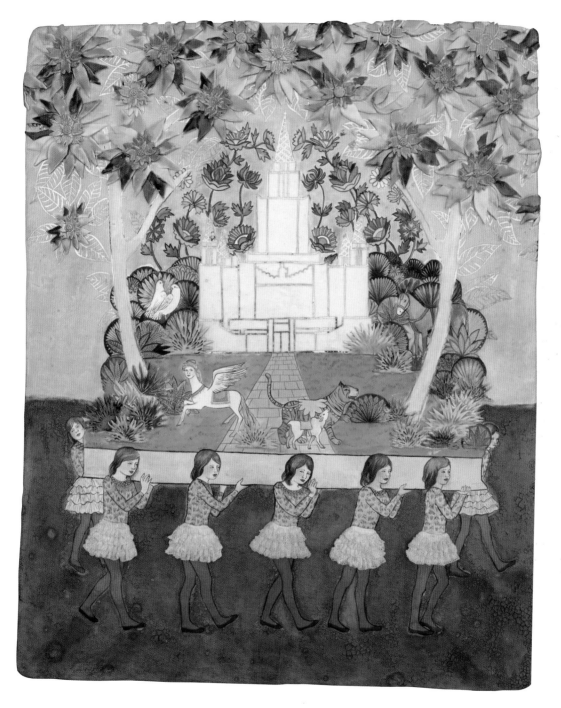

I have frequent creative blocks, like I think every artist does, but I learn a lot about what I want in my art from my unsuccessful work.

Creative *un*Block
Project No. 49

When I was in graduate school, my studio was next to an incredible eight-story library, and that is where I always headed when I had a creative block. It contained volumes of interesting material that never failed to inspire me. The challenge I give is to head to the library and walk through aisles that contain books on subjects you find interesting. It doesn't have to be just art; it could be astronomy, botany, fiction, or anything else. Find three books on three different subjects that you are somewhat unfamiliar with. The books must contain some visuals, like drawings, charts, graphs, diagrams, photographs, etc. Take those three books home and adapt one or more image from each book into a single artwork.

HOLLY FARRELL

PAINTING

CANADA

HOLLYFARRELL.COM

Vintage, everyday, domestic objects—each one like the portrait of a lovely character instead of just a simple still life. Toronto-based artist Holly Farrell is a self-taught painter. Prior to becoming a painter, she worked with teenagers who had developmental and psychological challenges. At the same time, in the late 1980s, she and her mother started to experiment with just about any form of craft—an excellent way for them to bond, and for Holly to alleviate the stress that resulted from her day job. But after a while she wanted something that was all her own, and just before she turned thirty, she tried painting. She avoided formal art classes because she wanted to find her own footing, and, more interestingly, she found the thought of being around other artists very intimidating. Thankfully, she put her insecurities about not being formally trained aside, and she now makes a successful living, very skillfully layering oils and acrylics on panel.

JC—When did you feel like you had truly become an artist?

HF—It was most likely my first show, which was at the Toronto Outdoor Art Exhibition in 1992. It's a juried show, and the fact that a group of "actual" artists felt my work was good enough to be included in the exhibition was exciting. That didn't last very long. . . . the next day I went back to worrying about people thinking I was a charlatan because I had no training. I sold my first paintings at this show but was determined to become a better painter. I decided I was going to hone my drawing skills—I felt that to be a better painter I would have to go back to basics and try to remember what I had been taught in high school, and go from there.

JC—What inspires you?

HF—Generally I am inspired by my past, your past, our collective past. This is because I like to paint the familiar. I tend to paint things that make me feel nostalgic in one way or another. It's not always a positive experience for me—sometimes I paint subjects that are grounded in difficult times from my childhood. I think it's my way of trying to come to terms with things I had no control over. My father was a violent alcoholic who died from drinking at the age of thirty-nine. My whole life with him was fraught with tension and fear. I think painting things from this time period is a way of working out the bad memories. We lived in a roadside diner/gas station along the highway. I associate the diner with my mother, who was a steady comfort in these tumultuous times, which is probably why I'm drawn to kitchen-related subject matter.

JC—Have you ever abandoned a painting midway through?

HF—I do have a collection of paintings in the basement that have been abandoned. Sometimes I am able to salvage something that's gone wrong, but I am much more comfortable starting over these days instead of working myself into a lather. I definitely learn from my mistakes and make sure I don't repeat them on the second attempt—mostly. It's liberating to make the decision to stop a painting and start over.

JC—Do you ever equate your self-worth with your artistic successes?

HF—Absolutely. It's only through painting that I have gained any kind of self-worth and confidence. Now, it's extremely difficult to see myself outside of painting—I suppose I hide behind it in some ways. As I have only found happiness as a painter, I panic at the thought of one day not being able to paint, or one day realizing nobody is interested in what I'm painting. Don't we all equate our self-worth with how well we perform in our lives, our work, our family? Painting is who I am.

JC—What causes your creative blocks? How do you get through them?

HF—I usually think myself into a creative block when I'm completing one deadline while another one is looming. Once the initial panic recedes I almost always am able to find a focus. I have an entire basement full of "things" I have picked up at antique shows, garage sales, family gatherings (always bought or borrowed), with the intention of one day getting 'round to doing paintings of them. I can go downstairs and root through the boxes and

shelves, unwrap the pottery and bowls, or flip through the many books that are piled here and there. I intend to paint my way through it all eventually. I like to feel connected to the subjects that I paint. It's that connection or reverie that brings me out of any block, or the panic from thinking that I am running out of ideas. I think that my blocks help me evolve in one way or another.

It's liberating to make the decision to stop a painting and start over.

Creative *un*Block
Project No. 50

Go into a cupboard or drawer (doesn't matter if it's in the kitchen or linen closet, utility room, or bath). Pick something you use every day, without thought or compunction—it's just functional (whether it be a towel, utensil, glass, or mug). Put it against or on a surface and draw it, paint it, photograph it . . . make it. I find, in this process, you are showing people not only how you see something, but how you feel about it. Often, as artists, our true expression is what we *present* to people in whatever medium we work in.